Fashion in Steel

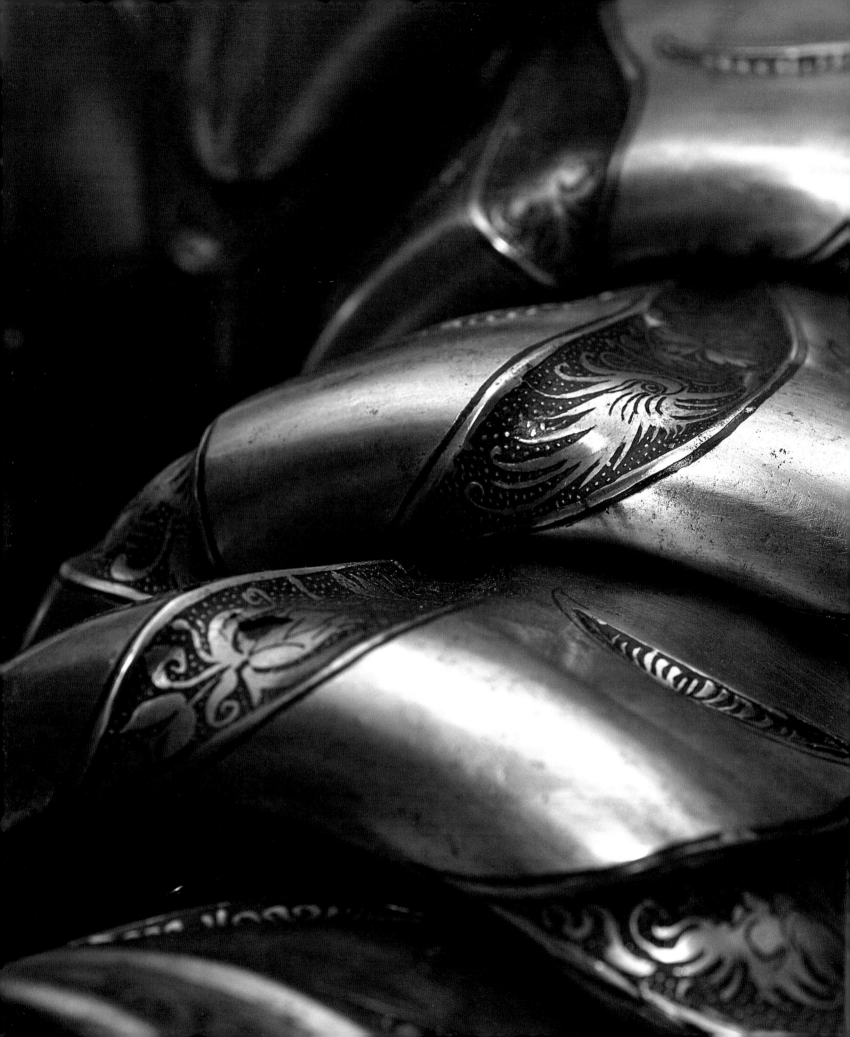

KUNST
HISTORISCHES
MUSEUM
WIEN

Fashion in Steel

THE LANDSKNECHT ARMOUR OF WILHELM VON ROGENDORF

STEFAN KRAUSE
WITH A CONTRIBUTION BY ANDREAS ZAJIC

PREFACE BY SABINE HAAG

DISTRIBUTED BY YALE UNIVERSITY PRESS
NEW HAVEN AND LONDON

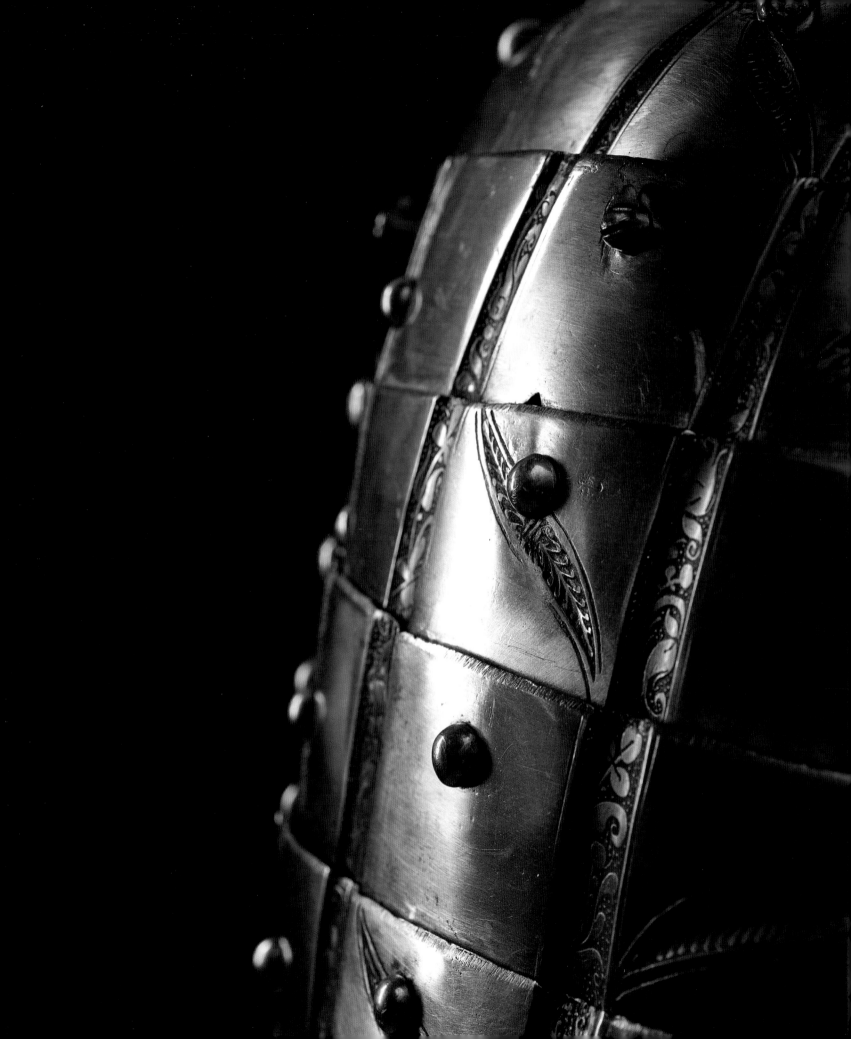

Content

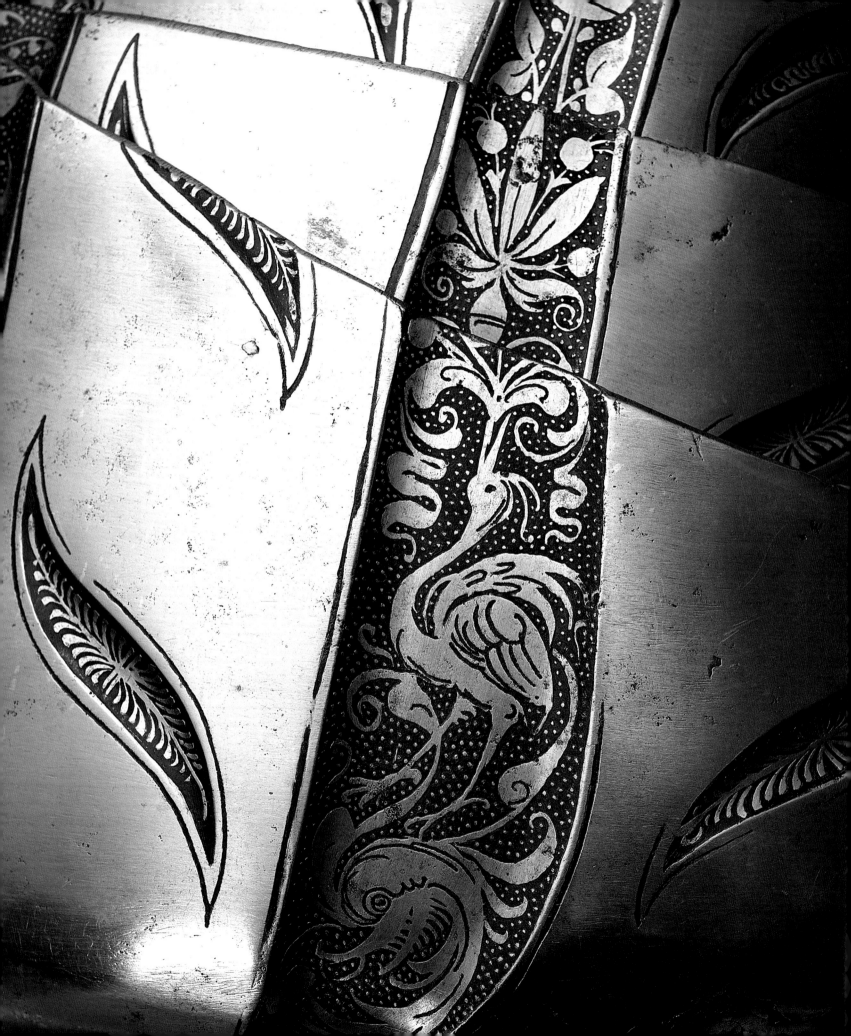

Preface

SABINE HAAG

DIRECTOR-GENERAL OF THE
KUNSTHISTORISCHES MUSEUM VIENNA

Early in 2016 one of the most remarkable artworks in the Kunsthistorisches Museum returned to the public galleries – the Landsknecht armour made for Wilhelm von Rogendorf in 1523, a truly outstanding masterpiece from the German Renaissance. Its steel sleeves drape in billowing, graceful folds as though cut from some pliable material, contradicting preconceived (and incorrect) modern ideas about cumbersome, inflexible armour. This is surely one of the reasons why the Rogendorf armour is today among the most famous and best-loved exhibits in the Kunsthistorisches Museum's Collection of Arms and Armour.

In 2005 fears about the armour's condition led to its temporary removal from the public galleries. The subsequent restoration proved extremely complex and has only been completed quite recently; in connection with that intervention the political, social and artistic context of this exceptional armour was explored in depth. This book presents the results of that research project.

I would like to thank Stefan Krause, the author of this publication, for initiating and leading this important project. I would also like to thank Andreas Zajic for his insightful essays on the Rogendorf family. Christa Angermann, supported by the sculptor Bernhard Ortner, was responsible for the restoration of the armour.

Projects like this cannot be realised without the financial support of dedicated institutions and private individuals. I would like to express my deepest gratitude to the Gerda Henkel Stiftung in Düsseldorf for their help in connection with the publication of this book. I would also like to thank the Cultural Ministry of Lower Austria for supporting both the restoration of the armour and this publication. We are also deeply grateful to Sally Metzler and George Dunea from Chicago, and Eva and Leopold Riess and Ulla Reisch from Vienna who have all generously supported the project.

I hope that this book on the armour of Wilhelm von Rogendorf will find many readers and inspire them to come and see this fascinating masterpiece for themselves.

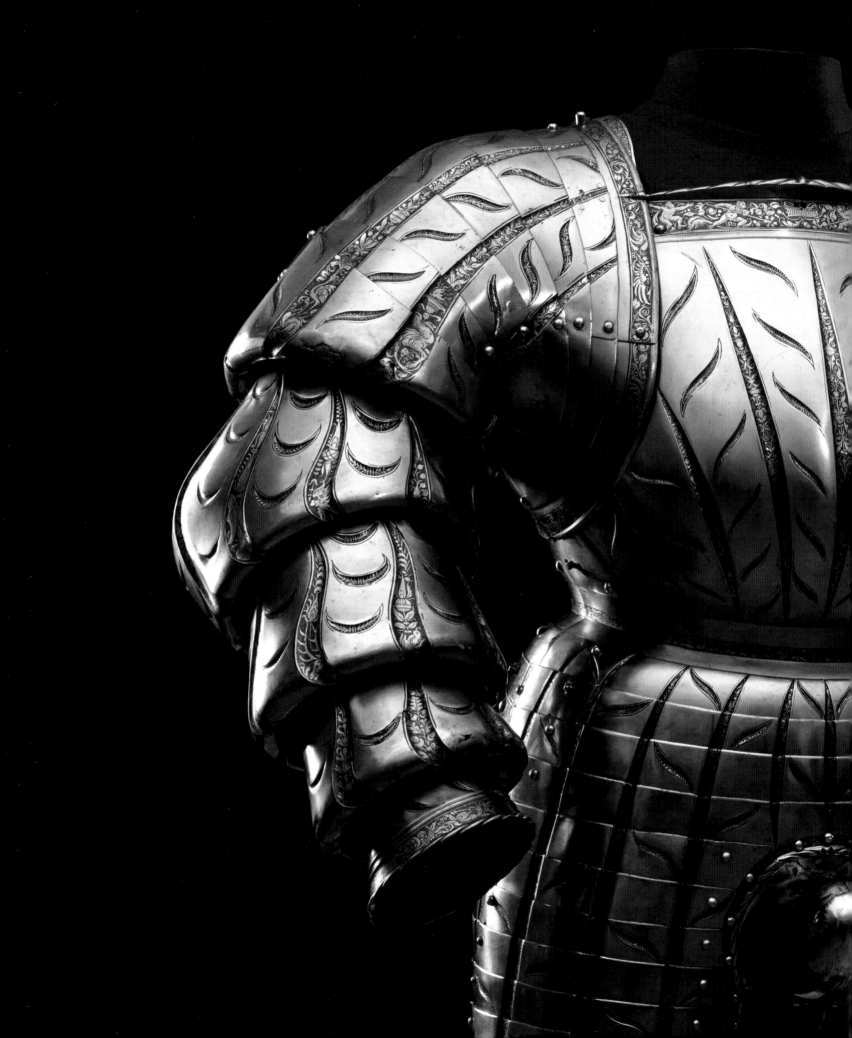

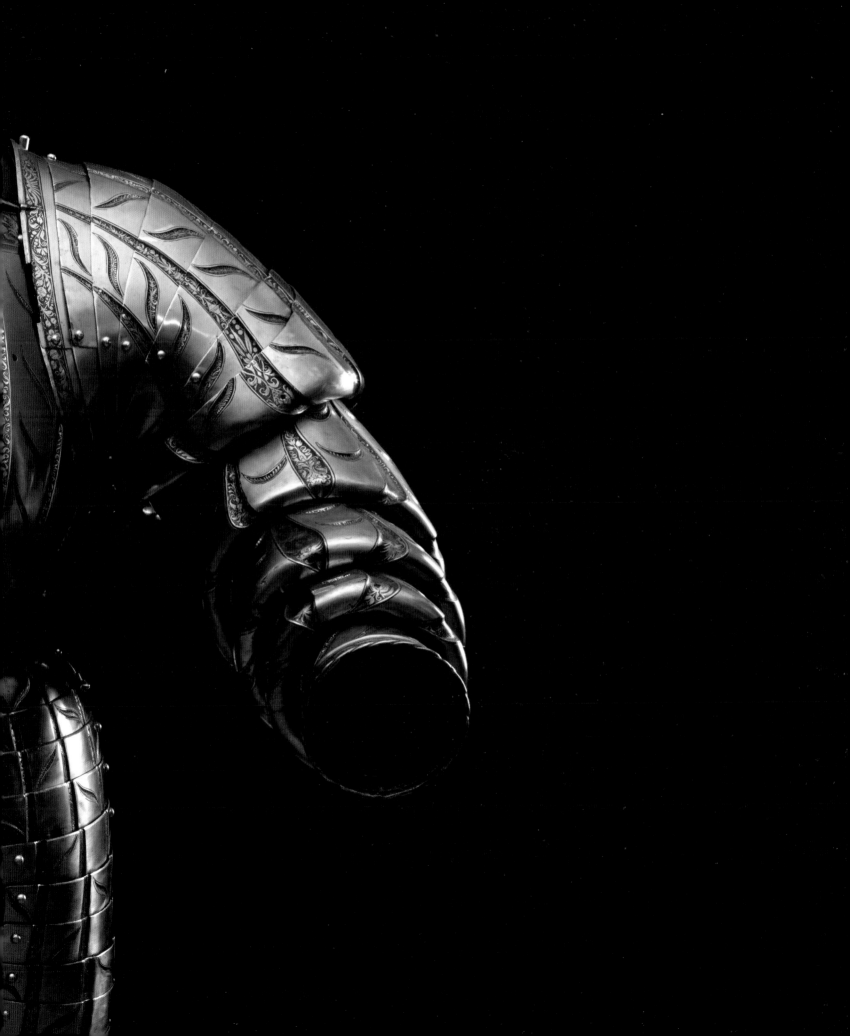

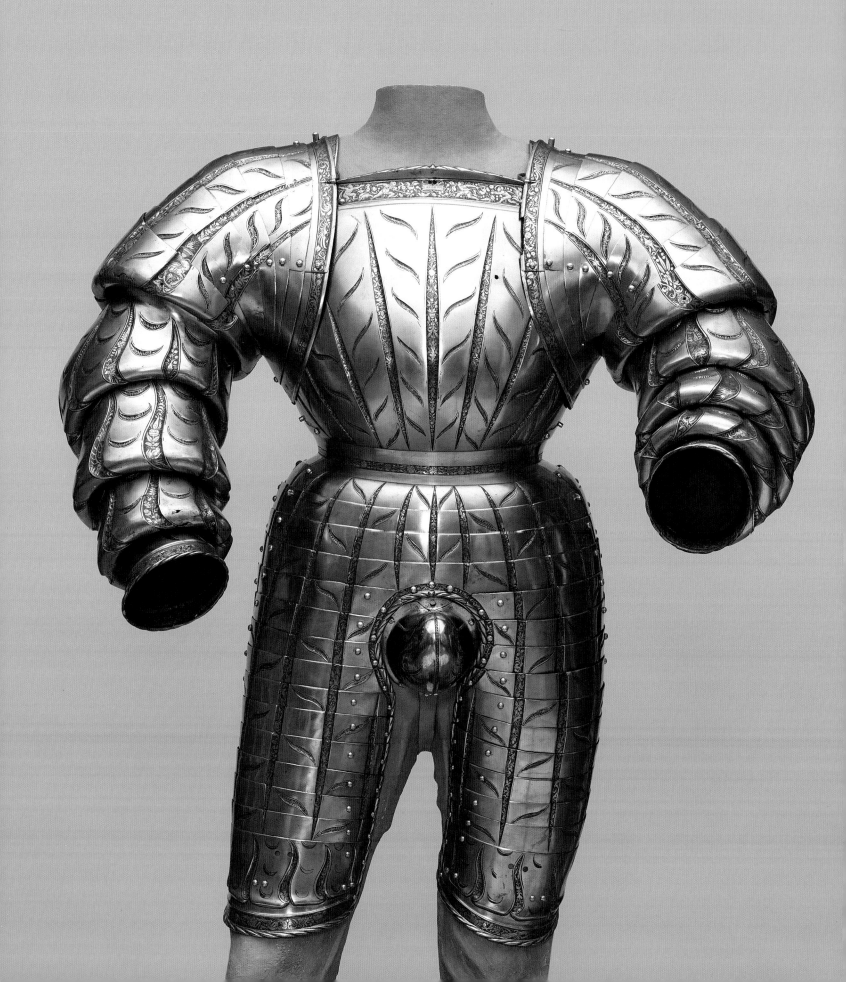

Introduction

In 1926 Bashford Dean, a well-known expert on medieval and modern armour, described the armour of Baron Wilhelm von Rogendorf now in the Kunsthistorisches Museum Vienna as "a monstrosity, something which every real armorer of the day must have resented, winking knowingly or smiling behind his hand".[1]

Rogendorf's magnificent armour is an exceptional but frequently misunderstood masterpiece of the German Renaissance.[2] Its voluminous 'sleeves' seem at first glance to be made of something like soft wool and appear to have been intentionally slashed all over, creating the illusion of being made not of metal but of a fashionably cut fabric. This book looks at the history of this armour that is made of steel but imagined in textile.

We have very few facts about this extraordinary artwork. It is dated 1523 *(ill. IX)*, an inscription on the right shoulder strap discovered only recently during the preliminary examination for the (now completed) restoration.[3] The armour is first mentioned in 1583 – six decades after it was commissioned – in an inventory of the collection assembled by Archduke Ferdinand II (1525–1595) at Ambras Castle near Innsbruck. The 1583 Ambras inventory also contains the earliest known reference to Wilhelm von Rogendorf as the armour's original owner: "Herr von Roggendorff. / Ain blannckhs geöczts harnisch mit geschobnen ermeln, ist achslen, rugg/=en und krebs alles aneinannder, an den achslen scheiblen, ain clains par halbächselen, ain par händschueh, ain par paintaschen mit kniepugglen." (Master Roggendorff. / A white etched armour with segmented sleeves, including integral pauldrons, besagews at the shoulders, a small pair of half-pauldrons, a pair of gauntlets, a pair of cuisses with poleyns).[4]

Late in the fifteenth century the young Wilhelm von Rogendorf[5] had entered the service of the Habsburgs, quickly rising through the ranks as a trusted diplomat and general much favoured by Emperor Charles V (1500–1558) in the 1520s. But as he was the scion of a newly ennobled Austrian family it has recently been suggested that the luxurious armour now in Vienna was not produced for him but for Emperor Charles V, and had been given to Rogendorf only later, making him the armour's second rather than its original owner. There are, however, a number of details that contradict this suggestion and support the armour's attribution to Wilhelm von Rogendorf:

Ill. I
Landsknecht armour of Baron Wilhelm von Rogendorf (1481–1541). Kolman Helmschmid, etched by Daniel Hopfer. Augsburg, dated 1523. Steel, some parts etched and blacked, leather (some pieces original), copper alloy rivets, total weight 19 kilograms, weight of left/right sleeve-vambraces 3.70 kilograms each. Vienna, Kunsthistorisches Museum, Collection of Arms and Armour, inv. no. A 374.

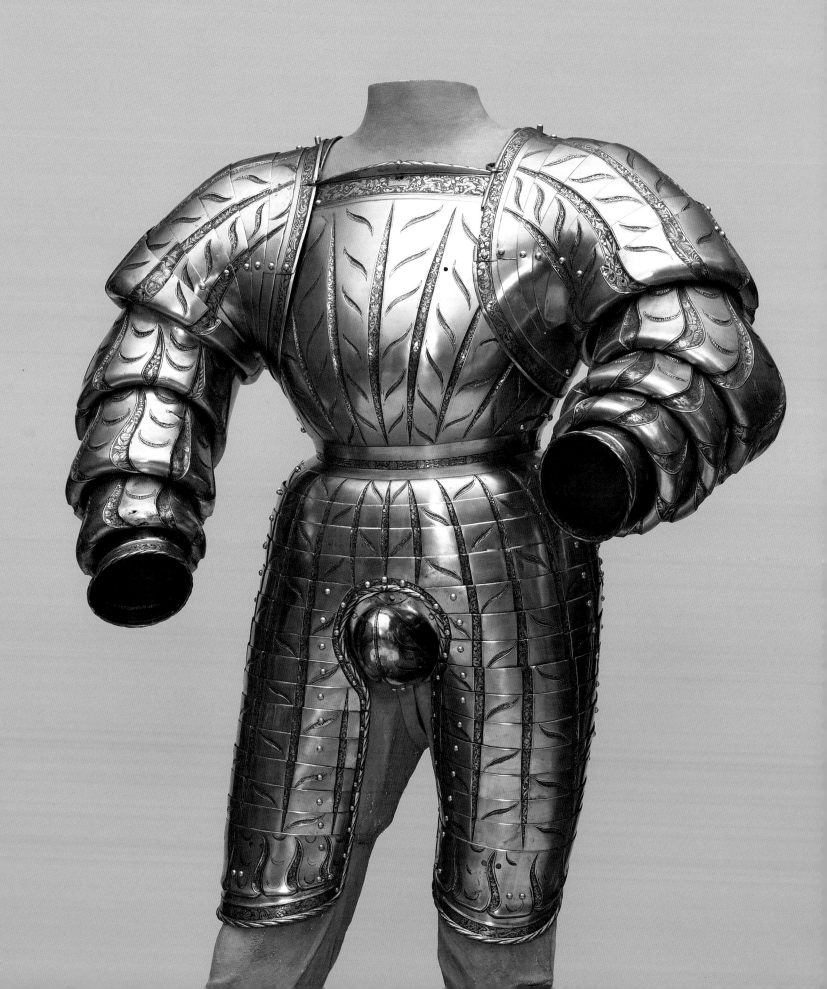

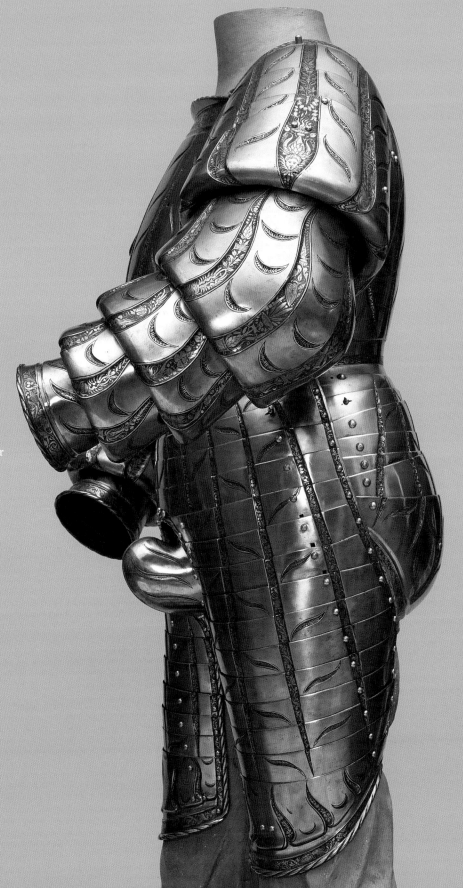

Ill. II
Wilhelm von Rogendorf's harness is the work
of Kolman Helmschmid (1471–1532), an armourer
from Augsburg. He was the favourite armourer
of Emperor Charles V in the 1520s and is today
regarded as one of the leading Renaissance
armourers. Three generations of Helmschmid
artists produced armour for members of the
house of Habsburg between the late fifteenth
century and the middle of the sixteenth century.

Ill. III
The etched decorations on Wilhelm von
Rogendorf's armour have been attributed to
Daniel Hopfer (1471–1536), an artist from
Augsburg who specialized in graphic work and
in decorating armour. We can identify armour
decorated by him that was produced between
c. 1505/10 and 1536; Rogendorf's armour is
dated 1523 (see *ill. IX*).

Ill. IV
Wilhelm von Rogendorf was a member of a
recently ennobled family from Lower Austria.
For several decades he served the Habsburgs
as a courtier, diplomat and commander of
infantry units. In the early 1520s, when his
flamboyant armour was produced, Rogendorf
was serving in Spain as one of Emperor
Charles V's Landsknecht commanders.

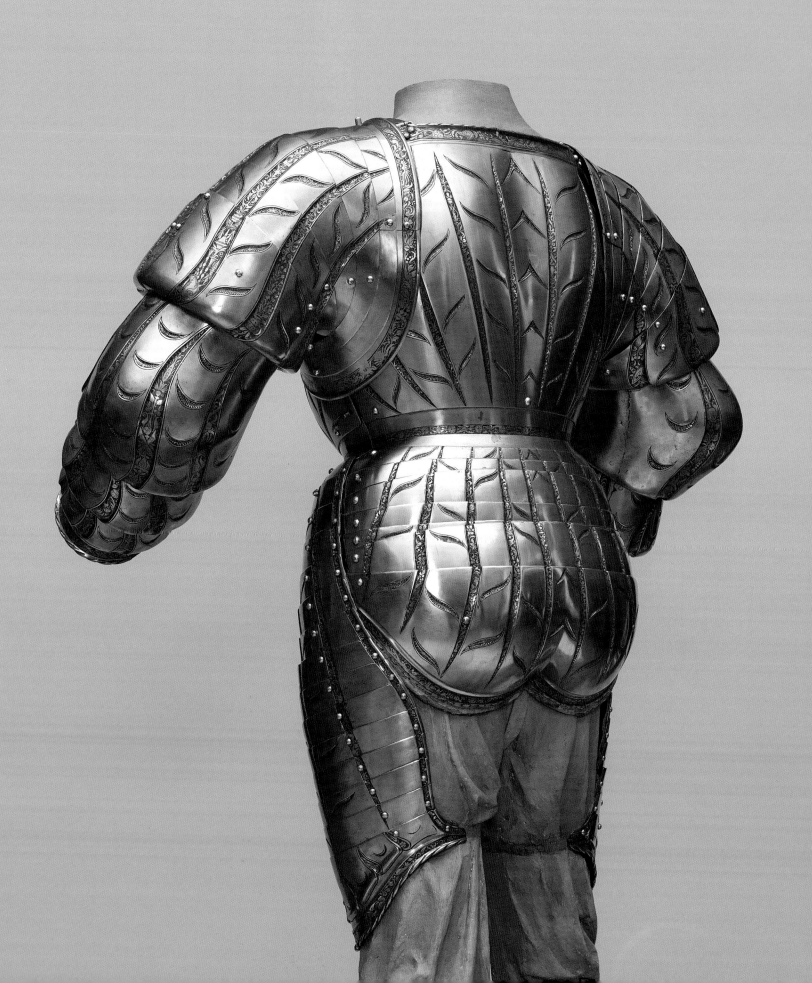

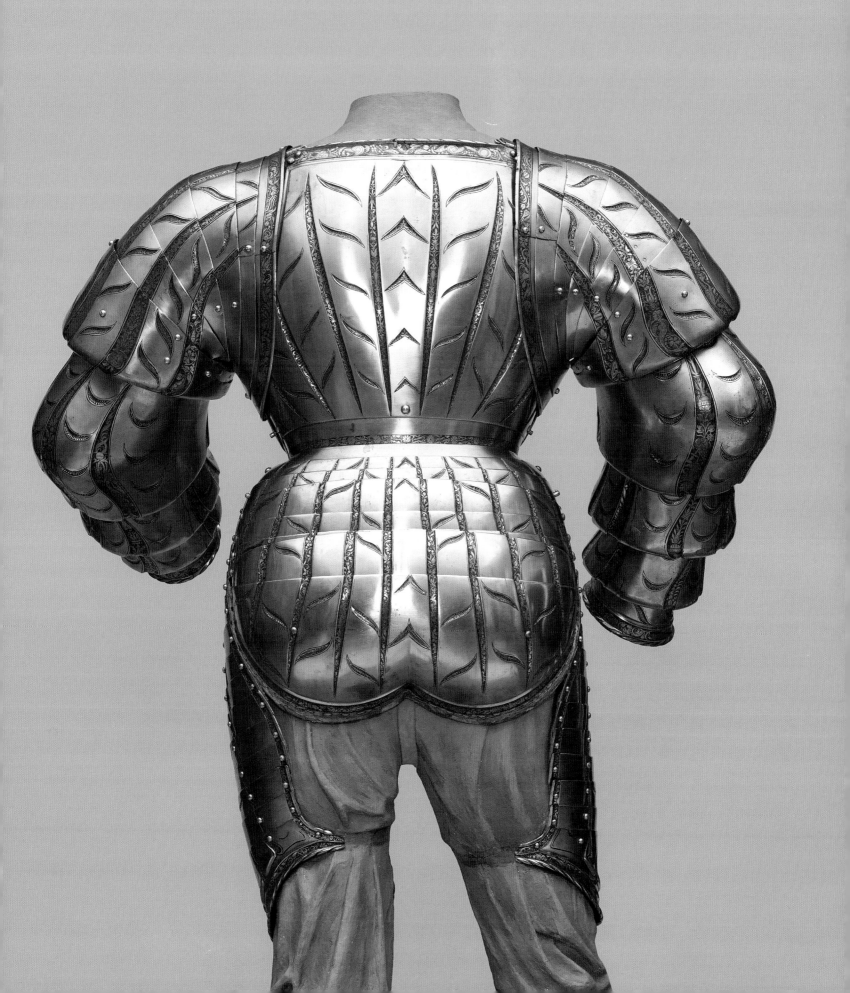

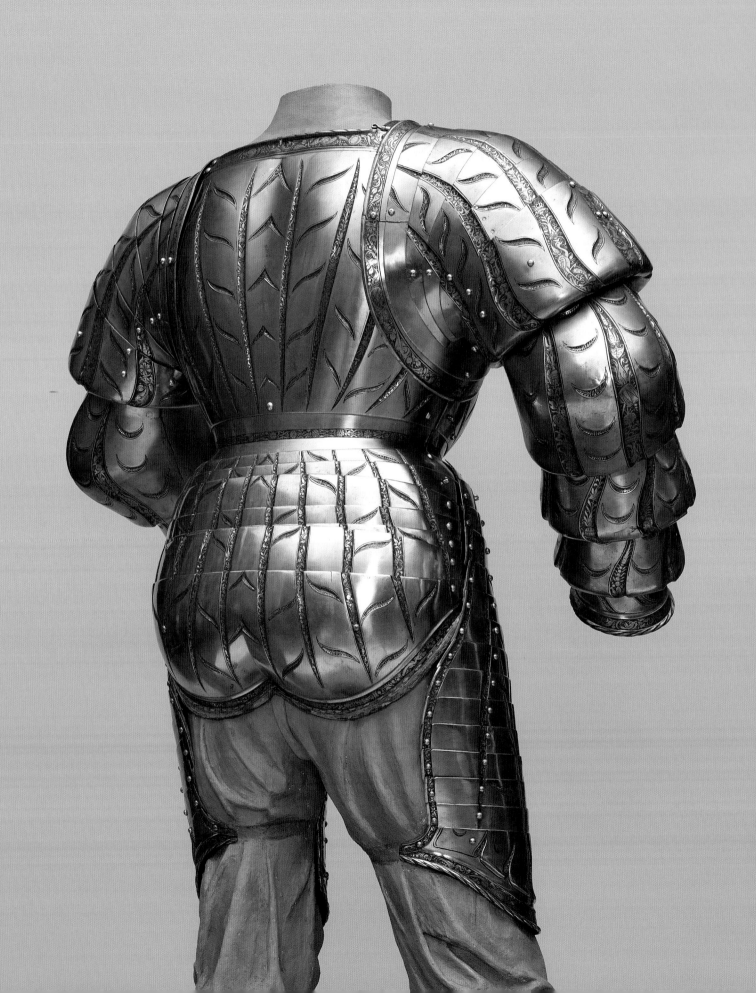

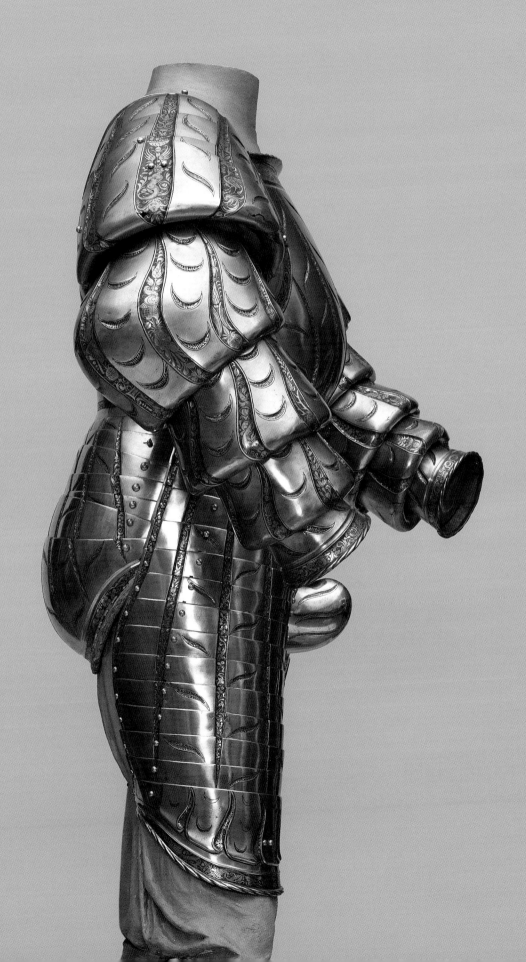

Ill. V
Rogendorf's Landsknecht armour is clearly in-
formed by the puffed and slashed fashion in vogue
in the early sixteenth century. Adopted by members
of the elite, it also became the characteristic attire
of the Landsknechts – the mercenary soldiers from
southern Germany who played such a seminal role
on Renaissance battlefields. The connection be-
tween this fashion and the Landsknechts forms the
basis for understanding this exceptional armour.

Ill. VI
Rogendorf's armour with puffed and slashed sleeves
was originally part of a garniture. This garniture
offered Rogendorf all he needed as a Landsknecht
commander on the battlefield while also fulfilling
parade and ceremonial functions. The exchange
pieces for the field belonging to Rogendorf's ar-
mour which have survived in Vienna and London
have been reunited and photographed for the first
time for the present research project (see *ills. 32
and 35a–c*).[6]

Ill. VII
The earliest extant document to mention Wilhelm
of Rogendorf's armour dates from 1583, sixty years
after it was made. At the time it was displayed in
the Armoury of Heroes installed by Archduke
Ferdinand II at Ambras Castle near Innsbruck.
In 1806 the armour was removed to Vienna with
the rest of the Ambras collection. In the 1880s it
was incorporated into the newly-founded Kunst-
historisches Museum in Vienna.

Ill. VIII
A major focus of the present restoration of the
Rogendorf armour was producing a new display
figure to provide tension-free support for its fragile
sleeve-vambraces (see pp. 120–123). The new figure
also allows us to present the armour in a more
convincing, naturalistic pose; made of beech wood,
it is based on anatomical studies from life.

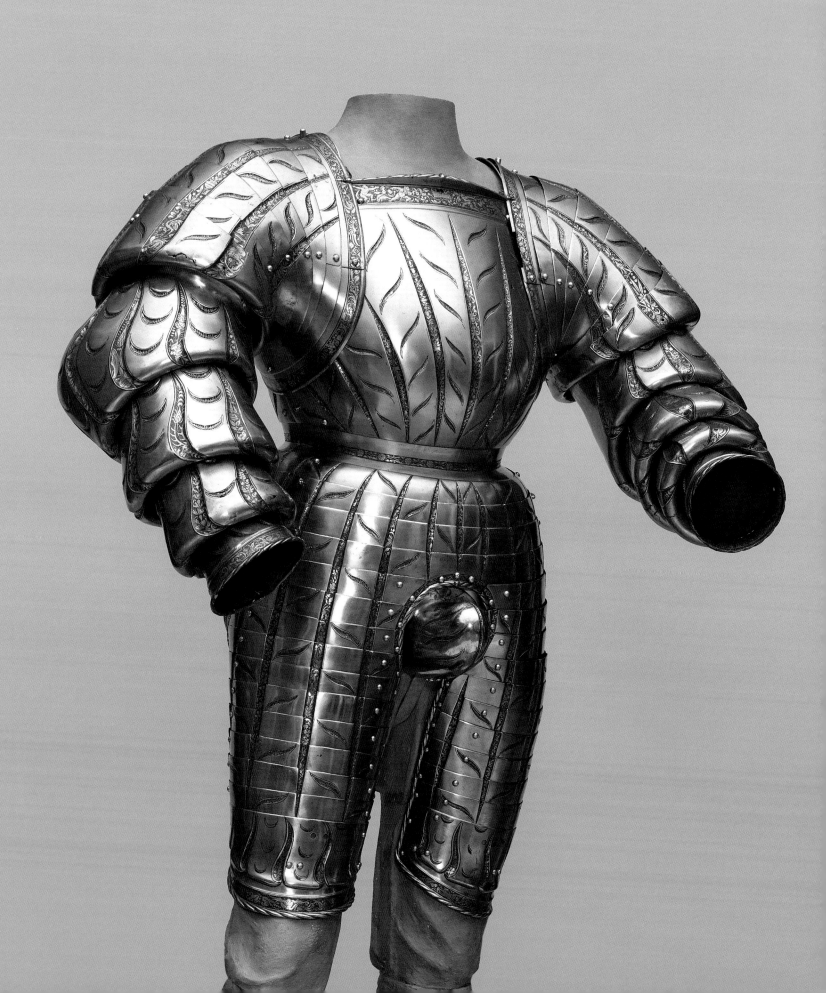

Ill. IX
The date "XXIII" (1523) on the right
shoulder strap

The intended wearer of this armour was over six feet three (c. 1.90 metres) tall, i.e. almost eight inches (20 cm) taller than Charles V;[7] clearly, the Emperor could not possibly have worn this armour. There is also no reason to doubt the armour's attribution to Rogendorf in the 1583 Ambras inventory as Archduke Ferdinand II, its first documented owner, knew and corresponded with Rogendorf's descendants. We may even assume that as a boy Ferdinand had actually met Wilhelm, then one of the most trusted advisors of his father King (later Emperor) Ferdinand I (1503–1564). And, last but not least, recent research published here[8] has shown that at the turn of the sixteenth century the Rogendorfs were prominent patrons of the arts, making the elaborate and costly armour now in Vienna anything but exceptional or unique among their many commissions, as had previously been assumed.

This book poses a simple question: why does Wilhelm von Rogendorf's armour include puffed and slashed sleeve-vambraces made of steel in imitation of some rich textile? Why does it look like this? Trying to answer this question will take us back five centuries to the political, social and cultural environment in which Rogendorf spent his life. It will take us to Spain, to the court of the Emperor Charles V, to Augsburg to the workshop of the armourer Kolman Helmschmid, and to Pöggstall in Lower Austria to the ancient castle of the von Rogendorf family.

But let us begin with a look at the Landsknechts from southern Germany, the mercenary companies who became such an important military force in the late Middle Ages. The partial leg defences of the Rogendorf armour are typical of the armour worn by Landsknechts (who, serving as infantry almost exclusively, dispensed with greaves and sabatons for the sake of practicality). Wilhelm must have owned an armour of this type in the early 1520s as he commanded the Landsknecht units employed by Emperor Charles V. And the elaborately puffed and intentionally slashed clothes favoured by Landsknechts clearly informed Rogendorf's unusual armour, which features steel imitations of such puffed and slashed sleeves, while also featuring slashing as a motif over all of its surfaces.

The Landsknechts from southern Germany and the military and social role they played in the Renaissance form the basis for understanding Rogendorf's exceptional armour – the technical and artistic virtuosity it represents, and especially its fashionable mannerisms.

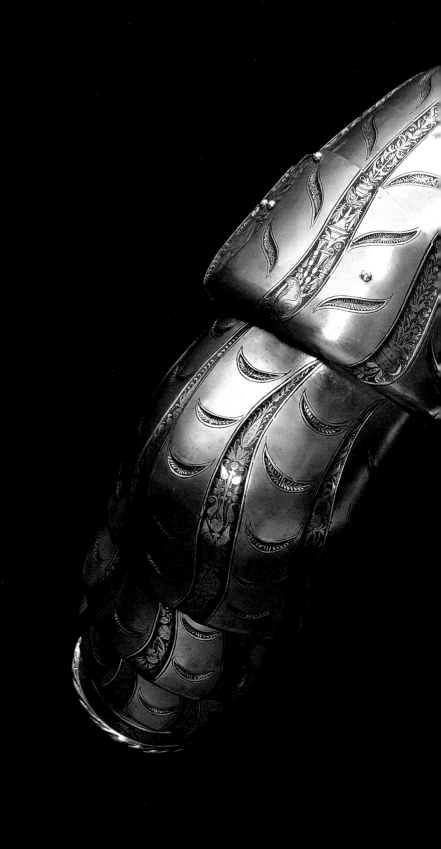

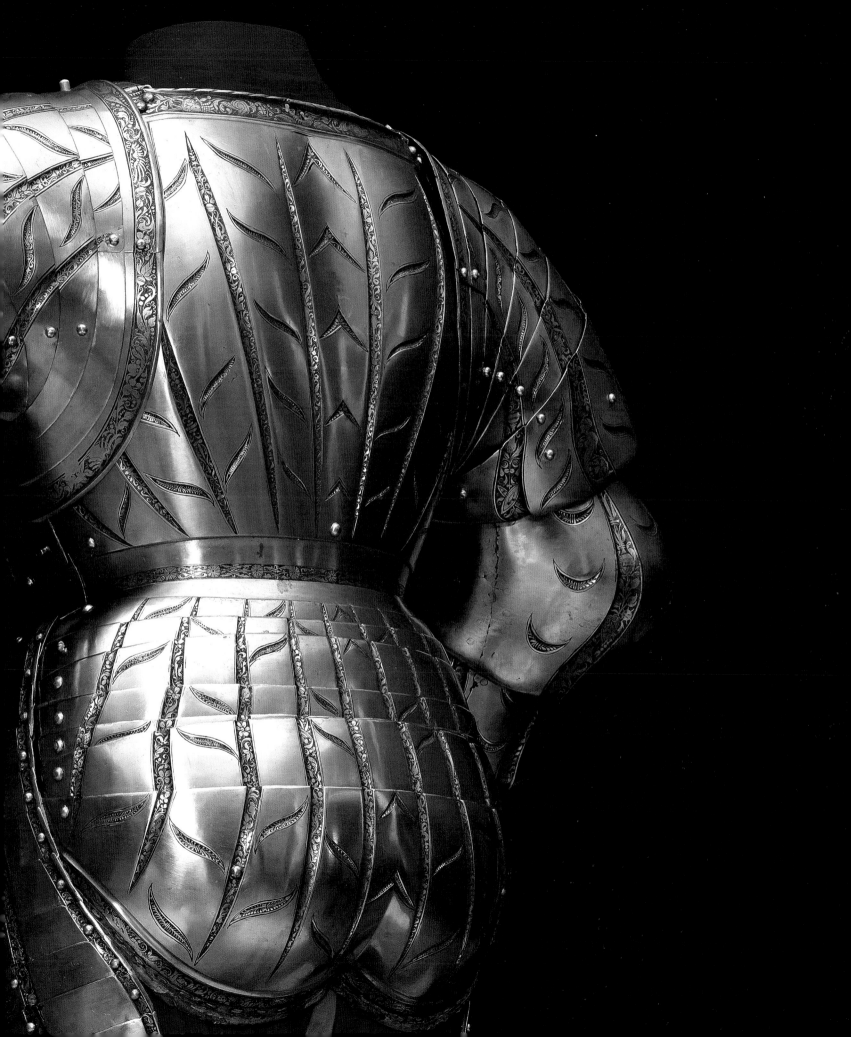

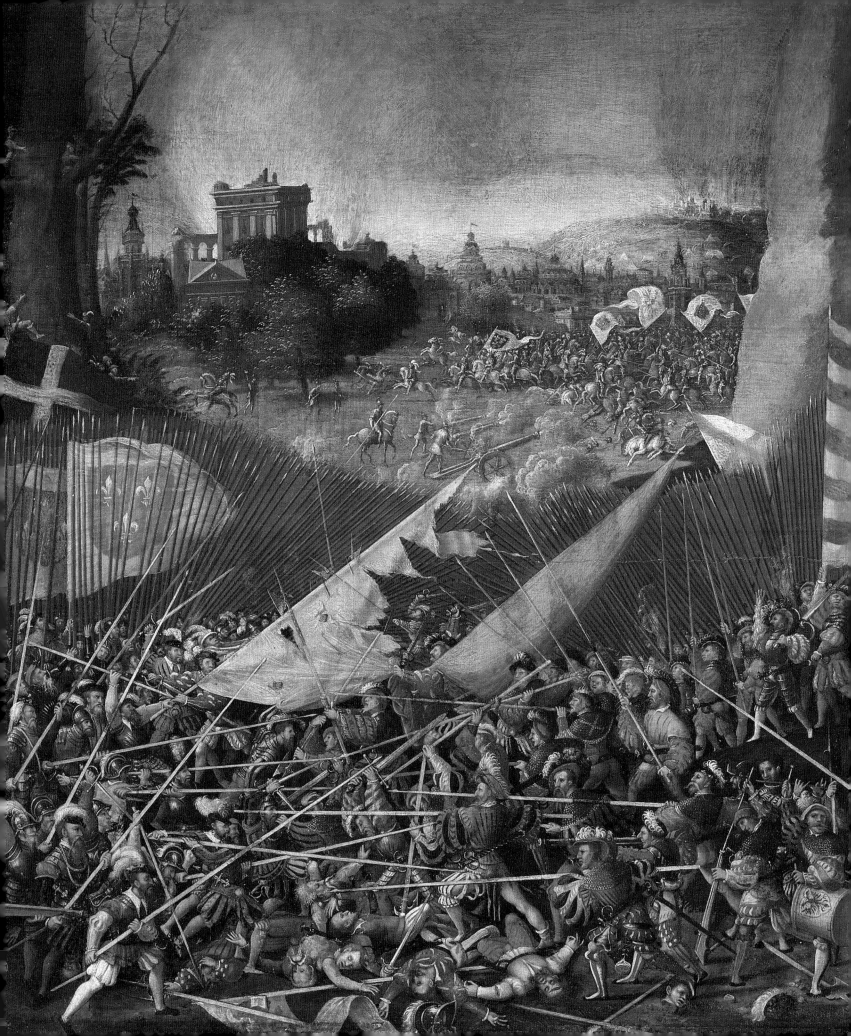

Wilhelm von Rogendorf and the Landsknechts

During one of their deployments in the Swabian War of 1499, a group of Landsknechts refused to carry out an imperial order, a manoeuvre they deemed too risky: to march from Val Müstair in Switzerland to Lombardy via the Fuorn Pass. Fearing entrapment by enemy troops, they simply refused to move. In order to placate their imperial master the unit's captain, Willibald Pirckheimer, dismounted, took off his field armour and donned the attire of the Landsknechts. Dressed in this fashion – no longer in full plate armour but instead wearing clothes like those of his foot soldiers – he set off for the mountains. He called upon his men to follow him and, as he recounts in his book *De Bello Helevetico*, with their leader dressed like them they decided to obey.[9]

This anecdote poses the question of what exactly it was that distinguished the Landsknechts from other soldiers, persuading a commander like Pirckheimer to dismount for them, and an officer like Rogendorf – as we hope to show – to commission a costly facsimile of their attire in steel. Renaissance Landsknechts were mercenary soldiers, men who fought for money. But such people have existed throughout history up to and including modern wars.[10] What made Landsknechts so important in the early modern era were their revolutionary tactics and their subsequent impact on the outcome of many battles.

Armed with pikes or halberds, Landsknechts formed tight squares on the battlefield. These highly-disciplined, dense, armed blocks were almost impossible to penetrate on horseback. But this strategy could prevail only if each soldier remained at his assigned post in this human bulwark during an enemy charge. Camaraderie and collaboration were thus essential. Consequently these infantry troops celebrated their more or less uniform appearance and this, in turn, clearly indicated that they belonged to a distinctive social group.

Long before the Landsknechts from southern Germany became a force to be reckoned with, the Swiss had employed similar battlefield tactics to great effect.[11] In the 1480s Archduke (later Emperor) Maximilian I began to raise foot troops in southern Germany, especially in Swabia, the Tyrol and around Lake Constance, i.e. in lands that had earlier supplied mercenaries to the Swiss, which meant they were familiar with these modern Swiss tactics. Under Maximilian, however, they began to form independent units – the Landsknechts, as they came to be called soon after their first appearance on the European stage.[12]

Ill. 1: The Battle of Pavia. German, circa 1530. London, Royal Collection Trust, inv. no. 405792 (© Royal Collection Trust / Her Majesty Queen Elizabeth II 2016)

23

Ill. 2: Daniel Hopfer, The Battle of Guinegate/ Thérouanne. Etching, circa 1495. Bologna, Pinacoteca Nazionale, Gabinetto dei Disegni e delle Stampe, inv. no. 8.138 (© Bologna, Pinacoteca Nazionale, photograph: Ulrich Heiß)

At the turn of the sixteenth century, the infantry dominated European battlefields *(ill. 1)*. Mounted noblemen had all but lost their military advantage over soldiers marching and fighting on foot. Many, however, refused to accept that this development was also changing Europe's centuries-old military order and hierarchy. In the Swabian War of 1499, for example, a number of mounted knights believed it was "disgraceful to leave it to foot soldiers to attack".[13] In his biography of Pierre Terrail de Bayard (c. 1476 – 1524) Jaques de Mailles tells us that at the Battle of Pavia in 1525 the French nobleman refused to dismount to fight shoulder to shoulder with foot soldiers; somewhat arrogantly Terrail describes the latter as "one a shoemaker, another a blacksmith, the third a baker" before continuing "as for myself [...] I, after all, am a nobleman".[14]

But others were quick to realise that wars could no longer be won without mercenary foot soldiers. Contemporary chroniclers record that in 1479 at the Battle of Guinegate/ Thérouanne in northern France *(ill. 2)* Archduke (later Emperor) Maximilian I fought side by side with them on the frontline, an action that both surprised and delighted his infantrymen.[15] At Basle in 1476 Duke René of Lorraine dismounted for Hans Waldmann, walking with the latter and carrying a pike to document his esteem for the celebrated captain from Zurich.[16] And like the before-mentioned Willibald Pirckheimer, Wilwolt von Schaumburg (c. 1446 – 1510), captain of a band of mercenaries, went so far as to cut up his hose to imitate his soldiers' attire.[17]

We should therefore also view the costume-like Landsknecht armour Rogendorf commissioned sometime before 1523 in the context of this important military revolution that began in the late Middle Ages. His is simultaneously the high-quality steel armour of a nobleman and the puffed and slashed attire typical of a Landsknecht. It bears witness to the nobility's growing appreciation of infantry tactics and the new, crucial roles played by foot soldiers,[18] and documents the rise of the mercenary to become one of the main protagonists on the Renaissance battlefield *(ill. 3)*.

Who were the Landsknechts, and what was their connection with Wilhelm von Rogendorf? Many of the soldiers serving in infantry regiments at the turn of the sixteenth century came from the bourgeoisie of one of the free imperial cities dotted throughout southern Germany. We know of journeymen serving in these regiments together with the sons of burghers and even patricians and gentlemen.[19] But the majority of mercenaries were recruited from the lower echelons of society, they were, for example, urban residents with only limited citizenship (or none), or men listed as "have-nots" in contemporary tax records.[20] Many of those crowding around the recruiting tables were poor city dwellers or countrymen such as landless peasants, craftsmen, and the younger sons of farmers without prospects or an inheritance.[21]

For many joining the Landsknechts meant leaving their familiar social environment behind. A love of adventure and the lure of danger attracted "many a wild child" to warfare, as Burkhard Waldis put it in 1548.[22] Adventurers hoping to get rich fast were drawn by the chance of plunder that vanquished and sacked cities offered.[23] Units composed of urban or guild-organised recruits may, however, have been motivated by more noble reasons.[24] At the Battle of Guinegate/Thérouanne in the summer of 1479 infantrymen allegedly shouted, "long live Austria and Burgundy" before charging the entrenched enemy.[25]

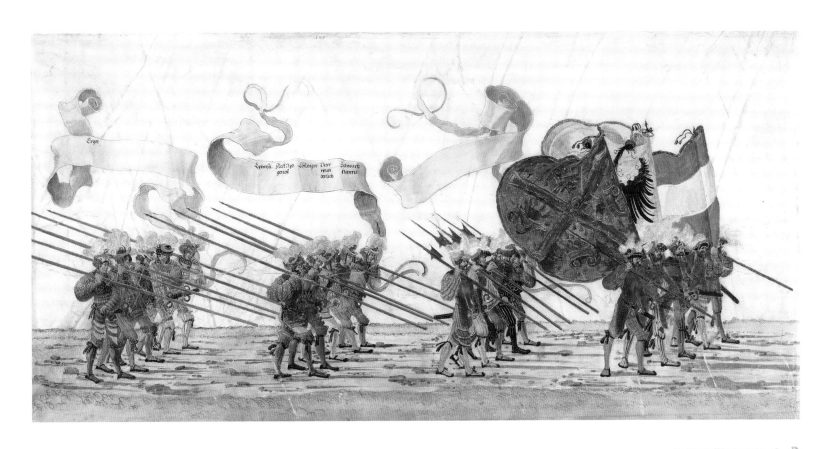

Ill. 3: Albrecht Altdorfer, Triumphs of Emperor
Maximilian I, Infantrymen. Regensburg,
circa 1512/15. Vienna, Albertina, inv. no. 25255
(© Vienna, Albertina)

Ill. 4: Letter written by Wilhelm von Rogendorf,
Bilbao, October 23, 1527. Valladolid, Archivo
General de Simancas, sign. C.j. Hac. 12-189
(© Valladolid, Archivo General de Simancas)

Ill. 4a: detail of ill. 4: Signature of Wilhelm
von Rogendorf

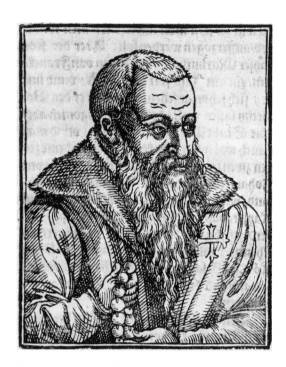

Ill. 5: Portrait of Wilhelm von Rogendorf as a Knight of the Order of Calatrava, in: Gerardus de Roo, *Annales, Oder Historische Chronick Der Durchleuchtigisten Fürsten [...]*, Augsburg 1621, p. 458 (© KHM-Museumsverband)

But most of these men were motivated neither by greed nor by some noble goal. Becoming a soldier was often simply a basic necessity, the only chance to make a living. Since the middle of the fourteenth century the population of southern Germany had increased rapidly. A bad harvest or some other economic crisis negatively affected more and more people. The change from farming to cattle breeding put many farm hands out of work as far fewer men were needed to tend cattle than to plough fields.[26] For all those who, for whatever reason, had to fend for themselves, signing up as a mercenary offered some form of security.

Wilhelm von Rogendorf, however, was not one of them. He was the scion of a recently ennobled family from Lower Austria.[27] But he was not the firstborn and was therefore confronted with decisions similar to those facing the younger sons of freeholders: he, too, could not remain at home but had to make his way abroad. Someone in his position who did not want to take holy orders and did not have a reasonable chance of assuming some respectable office generally decided to become a soldier. In the Middle Ages these young aristocratic adventurers would have joined a Crusade.[28] In the Renaissance soldiering offered them a chance to establish themselves. Some of them even became renowned and wealthy mercenary-entrepreneurs. For example, the celebrated and successful Landsknecht captains Georg von Frundsberg and Konrad von Bemelberg *(ill. 6)* were both younger sons.[29] Lazarus Schwendi, another successful Landsknecht commander, was born in 1522 as the illegitimate son of Ruland Schwendi, himself the younger brother of the firstborn son and heir.[30]

Wilhelm von Rogendorf was born in 1481, the second of Kaspar von Rogendorf's four sons to reach adulthood. In 1507, when Wilhelm was twenty-six, his elder brother Sigmund died and Wilhelm inherited the family lands. But some years earlier his father had dispatched his then thirteen-year-old second son to the court of Archduke Philip 'the Handsome' in Burgundy. By the time Wilhelm inherited his brother's title he was already well on his way to becoming a successful Habsburg courtier and diplomat – the career frequently chosen for or by a younger son. However, Wilhelm's impressive career comprised not only political and court offices but also prominent military successes. For example, he commanded an imperial unit of 4000 Landsknechts in Spain in the early 1520s (around the time his exceptional armour was produced at Augsburg); he called them "los Alemanos" (the Germans) in a letter *(ill. 4)* written at Bilbao in October 1527 shortly before he left the Iberian Peninsula for good.

Wilhelm entered the service of the young King of Spain (later Emperor Charles V) no later than 1517. His first commission was the governorship of Friesland, a restive Dutch border region. In the summer of 1522 he accompanied Charles to Spain;[31] here, too, he was put in charge of securing a fiercely contested border region, this time between Spain and France. In 1524 he was able to re-conquer the fortress of Fuenterrabía in northern Spain from the French, a military feat for which he received much praise and credit.[32] Soon afterwards Charles V made him captain of the Imperial Bodyguards and entrusted him with the governorships of Catalonia, the Cerdagne and the Roussillon. He was also awarded an honour normally reserved for Spanish noblemen: Wilhelm was the first German nobleman to be appointed to the Spanish chivalric Order of Calatrava *(ill. 5)*.[33] In 1526 the Spanish writer and historian Francés de Zúñiga described Rogendorf as "un cavallero alemán muy onrado" (a most honourable German knight).[34] He had reached the zenith of his imperial career – and it is surely no accident that this is exactly when his exquisite puffed and slashed armour was commissioned.

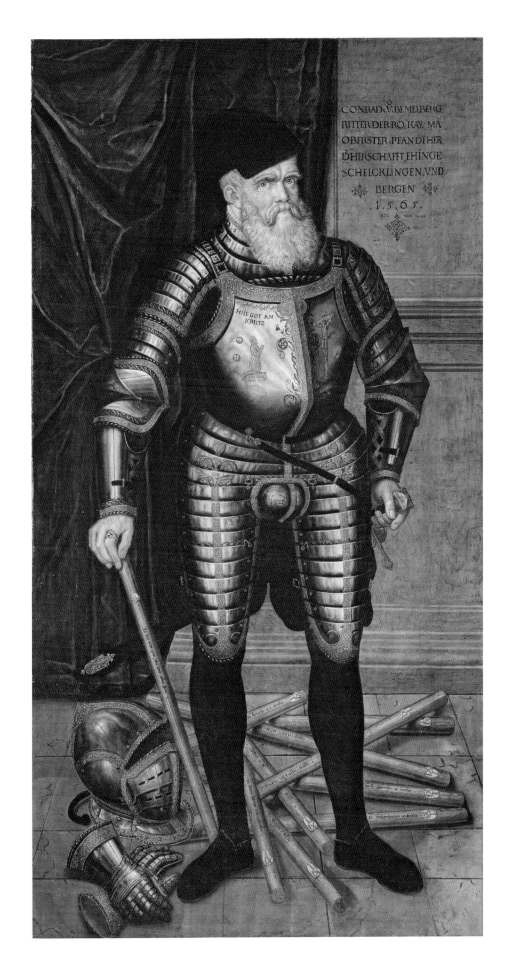

Ill. 6: Petrus Dorisy, Portrait of Konrad von Bemelberg. Dated 1582. Vienna, Kunsthistorisches Museum, Picture Gallery, inv. no. 3849 (© KHM-Museumsverband)

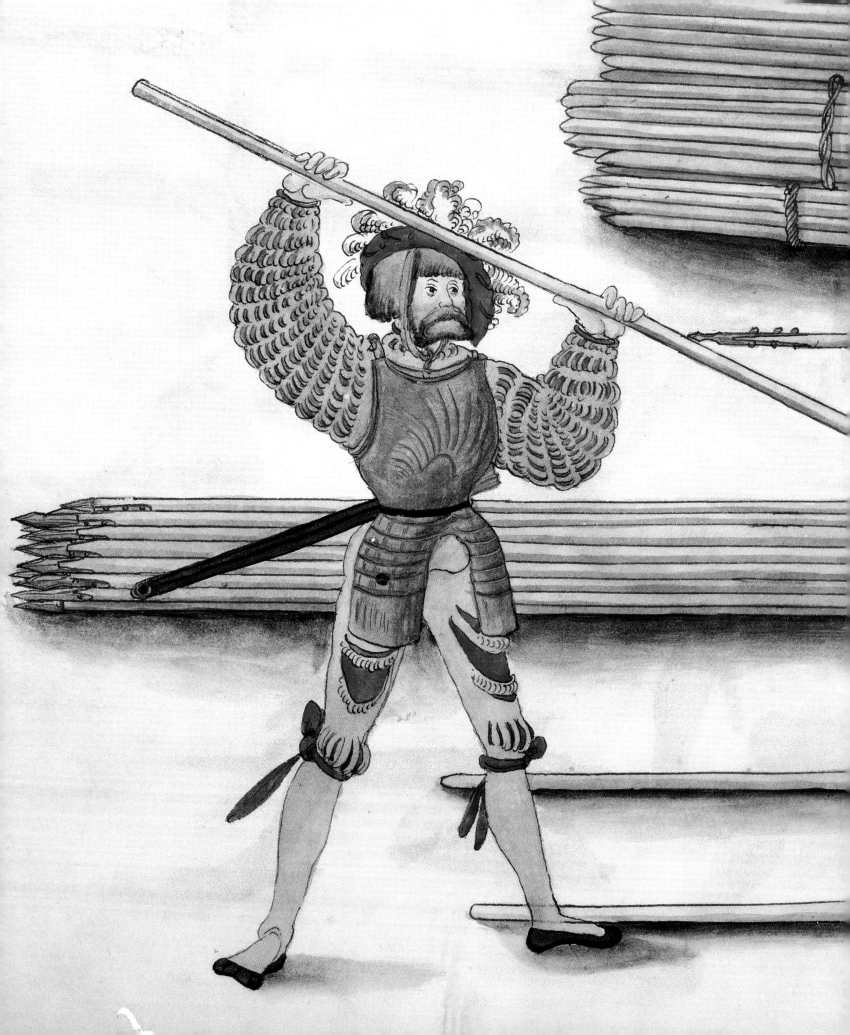

Slashing in Renaissance Fashion

We do not know who was the first to wear intentionally-slashed fabrics as a fashion statement. But long before the onset of the Renaissance people must have been fascinated by clothes comprising layers of differently coloured and/or textured cut textiles. Around 1390 Chaucer complained in the *Canterbury Tales* about the habit "to maken holes so muche daggynge of sheres".[35] However, we do not know of intentional, regular, ornamental and stylized slashings that define the fashion of a whole era prior to the Renaissance. This craze reached its apex around 1510/20, which is when Wilhelm von Rogendorf commissioned his splendid Landsknecht armour.

There is still no consensus about the origins of these modish slashings in Renaissance fashion; most scholars agree that they evolved out of the habit of cutting the tight hose and/or the sleeves of late-mediaeval clothes to increase the wearer's freedom of movement – i.e. they are generally believed to have been born of practical considerations.[36] In his *Treatise of Worship in Arms* published in 1434 Johan Hill states: "First hym nedeth to have a pair of hosen [...] And the saide hosen kutte at ye knees and lyned within with Lynnen cloth [...]."[37] For example, the protagonists in the series of tapestries celebrating *The Deeds of Julius Caesar* – produced in the Low Countries around 1450/70[38] – sport such tight, narrow and gaudily lined hose. But in the fifteenth century, contrasting linings and chemises or underwear were mostly showcased with the help of complex lacings and pierced sleeves and hose, and the former were frequently pulled out to enhance the overall effect. This shows that playing with the colours and shapes of various superimposed layers of clothes was already a fashionable trope long before it became de rigueur in the Renaissance.

The Landsknechts must have played a seminal role in establishing slashing as the epitome of Renaissance style, especially in Germany. Like the members of the period's elite, Landsknechts generally sported excessively slashed and puffed as well as brightly coloured and embroidered clothes; many of their contemporaries regarded this fashion as typical for members of these prominent military units *(ill. 7)*.[39]

The romanticising nineteenth century interpreted their slashed attire as a direct result of the eventful lives of these mercenaries. They were believed to have made a virtue of necessity by turning the tears in their ripped clothes into "squares, triangles, stars (and) crosses";[40] or to have cut up their hose and jerkins in order to have more "air,

Ill. 7: Emperor Maximilian's *Zeughausbuch* of the Tyrol (illustrated inventory of Emperor Maximilian's armoury of the Tyrol), fol. 87v. Circa 1512/17. Vienna, Kunsthistorisches Museum, Kunstkammer, inv. no. KK 5074 (© KHM-Museumsverband)

openings, and freedom of movement" during a battle.[41] Many nineteen...
torians have suggested that civilian Renaissance fashion evolved out of these practical
martial solutions associated with the Landsknechts.

The clothes worn by foot soldiers in battle really did have to be comfortable and loose,
and we can safely assume that they were slashed at, for example, the knees and the el-
bows.[42] And most of the Landsknechts' clothes were probably also torn as they wore
them day in day out, and frequently in battle too. In addition, war-torn clothes had
been regarded as the epitome of martial bravery both in the centuries preceding the
Renaissance and among the Landsknechts.[43] But practical arguments alone cannot ex-
plain the frequently elaborate, showy character of the clothes sported by these hired
soldiers, especially as a love of splendour and display in a way contradicts the need for
practicality. So we can assume that there must have been more to the fashionable slash-
ings favoured by the Landsknechts and found on Rogendorf's armour.

Popular sixteenth-century tunes celebrate clothes both "cut up, slashed, in the manner
of Landsknechts" and "cut up and slashed like a nobleman's".[44] So what was it, this
craze for slashed clothes in the early modern era – a style favoured by the nobility, or
one popular with the Landsknechts, or maybe one espoused by both at the same time?
We first encounter slashed clothes around 1480/90, when they were worn by members
of the elite. Around 1488/90, for example, Domenico Ghirlandaio painted a portrait
of Giovanna Tornabuoni, who was born into one of Florence's leading families, wear-
ing a robe made of an exquisite multi-coloured fabric elaborately and decoratively
slashed at her upper arm (ill. 8). The white lining of her sleeves has been carefully pulled
out, creating an elegant interplay of colours, shapes and textures.[45]

Soon after 1490 we already find less exalted members of society such as Hans Burgk-
mair the Elder, a painter from Augsburg,[46] but also mercenaries (ill. 9) sporting fash-
ionably slashed clothes in their portraits. However, until about 1500 slashes remained
relatively low-key: small cuts decorated puffed sleeves, hose and doublets. Hose and
sleeves were still narrow and cut close to the body. But soon after 1500 clothes became
wider and more voluminous and the craze for slashes reached its highpoint.

In the first decades of the sixteenth century decoratively slashed clothes were regarded
as the epitome of luxury. Slashing a garment was neither difficult nor expensive. It
was enough to pierce or cut a piece of cloth with a pair of scissors or a chisel; the
edges of the cuts were never hemmed.[47] But this technique meant intentionally
damaging sometimes-expensive fabrics, which is why it was generally regarded as
wasteful and a sign of vanity. Sumptuary laws therefore prevented the majority of
the population from wearing slashed clothes, regardless of whether they were made
of costly or cheap fabrics.[48] For example, in the late fifteenth century the burghers
of Nuremberg were forbidden to wear overgowns "slashed at the hem and at the
sleeves".[49] The Imperial Police Ordinance of 1530 decreed that the doublets of working
men should be "unverthelyt / unzerschnitten und unzerstückelt" (of one piece, not
cut up and not slashed).[50] It seems, however, that thanks to their seminal role in
contemporary warfare Landsknechts enjoyed a number of sartorial privileges: the
afore-mentioned Imperial Police Ordinance of 1530 tells us that a soldier – especially
a commissioned officer – was allowed to dress as he liked ("der mag sich [...] wie im
gelegen kleyden"),[51] and this seems to have applied especially to the right to wear
slashed and puffed clothes.

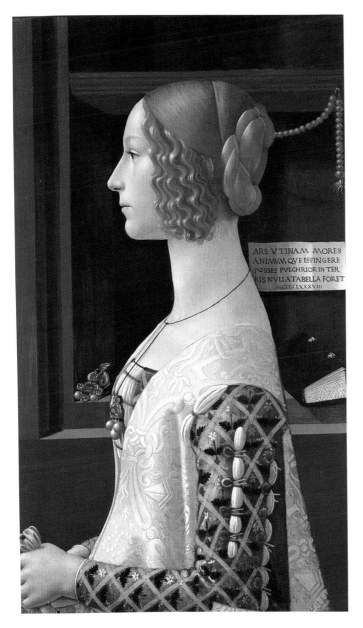

Ill. 8: Domenico Ghirlandaio, Portrait of Giovanna
Tornabuoni. Florence, 1488/90. Madrid, Museo
Thyssen-Bornemisza, inv. no. 158 (1935.6)
(© Madrid, Museo Thyssen-Bornemisza)

Ill. 9: Michel Wolgemut, Martyrdom of Saint James
and Saint John the Baptist. Coloured woodcut,
Nuremberg, 1491. London, The British Museum,
inv. no. 1860,0414.222 (© London, Trustees of
the British Museum)

Ill. 10: Landsknecht candleholder.
Southern Germany, circa 1520.
London, Victoria and Albert Museum,
inv. no. M.2-1945 (© London,
Victoria and Albert Museum)

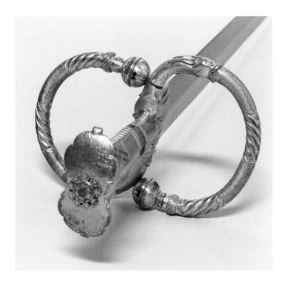

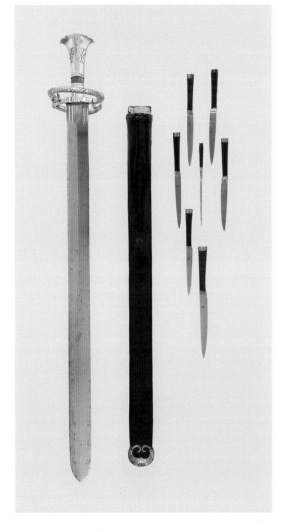

Ill. 11a: detail of ill. 11: Crossguard

Ill. 11: Katzbalger of Ulrich von Schellenberg. Southern Germany, circa 1515. Vienna, Kunsthistorisches Museum, Collection of Arms and Armour, inv. no. A 287 (© KHM-Museumsverband)

An anecdote repeatedly recounted in late Renaissance texts tells of courtiers who complained to Emperor Maximilian I about the presumptuous and costly attire sported by some Landsknechts, to which the Emperor allegedly replied: "oh what foolish solicitude"; after all, the soldiers put their life on the line fighting in the frontline while they, the noblemen, watch from a safe distance – "it [the privilege to wear elaborate clothes] is the cheese in the mousetrap to catch such mice".[52] True or false, the story clearly gets to the heart of the fashionable extravagances beloved of mercenaries at the turn of the sixteenth century.

During the late Middle Ages the different classes of society gradually began to copy the slashed garments worn by their social superiors, i.e. patricians aped noblemen, burghers imitated patricians, and eventually soldiers adopted the fashion from those higher up the social ladder.[53] It thus followed the characteristic trajectory and frequently documented social dynamics of fashion, which generally trickles down the social pyramid.[54] At the bottom end soldiers were quick to adopt the fad and make it their own. Soon artists took up the motif of a soldier in cut-up clothes *(ill. 10)*,[55] thereby playing a pivotal part in establishing the image of an elaborately dressed Landsknecht as the epitome of military prowess.[56]

But in a few individual cases the slashed fashion adopted by these mercenaries seems to have moved back up the social ladder to be taken up by members of the elite as "Landsknecht style". This manifestation of a remarkable evolution of fashion plays a seminal role in helping us to understand Wilhelm von Rogendorf's 1523 armour.

Duke Henry the Pious of Saxony (1473–1541) commissioned two portraits of himself wearing sumptuously slashed clothes from Lucas Cranach the Elder. In the earlier one, produced in 1514 *(ill. 12)*, Henry faces us in costly, fashionably cut attire but without any reference to the Landsknechts. However, when he sat to Cranach again around 1526 *(ill. 13)* he sported elaborately slashed clothes clearly designed to identify the sitter as a Landsknecht. In this second portrait the prince accessorised his voluminous and cut clothes with a "Katzbalger", the short sword with a characteristic s-shaped crossguard favoured by these hired soldiers *(ills. 11 and 11a)*; he is also fingering the steel head of a pike, the weapon wielded to such deadly effect by the Landsknechts that it became something of a trademark for them *(ills. 3, 7 and 30)*. In this portrait the future Duke of Saxony is clearly happy to be identified as a Landsknecht.

It is rare for fashion to move up the social ladder although there are a number of examples – think only of the now ubiquitous pair of (long) trousers, or of Jeans, many of which are today also intentionally cut to look "distressed". An example from the Middle Ages is the cap sported by Margrave Ekkehard in his celebrated thirteenth-century statue in the choir of Naumburg Cathedral. All of these fashions evolved out of clothes originally worn by peasants, workers, soldiers or sailors *(ill. 39)*,[57] some of which can even be traced back to antiquity and beyond.[58] But there seems to be no other example of a fashion that trickled down the social hierarchy only for a version of it to move up again. Perhaps we should emphasise once more that not every slashed garment or outfit qualifies as Landsknechts' attire. But some of the slashed clothes worn by noblemen, such as those sported by Duke Henry of Saxony c. 1526, can clearly be identified as such.

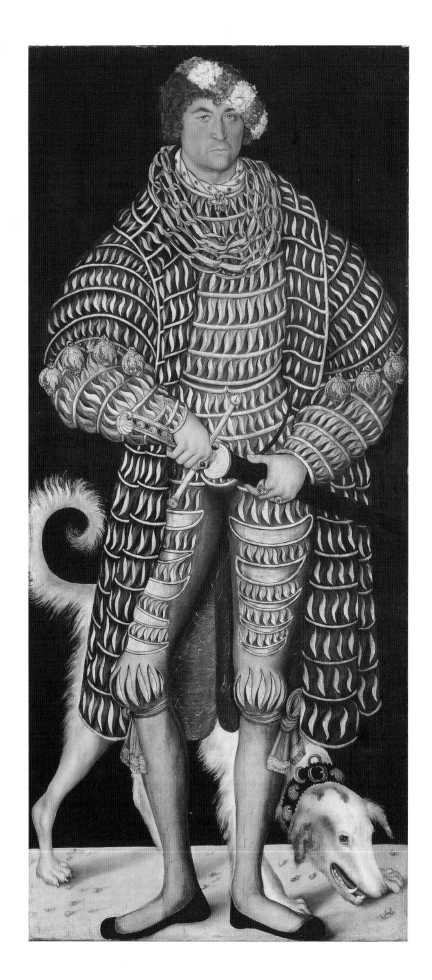

Ill. 12: Lucas Cranach the Elder, Portrait of Duke Henry of Saxony. 1514. Staatliche Kunstsammlungen Dresden, Picture Gallery, inv. no. 1906 G (© Staatliche Kunstsammlungen Dresden)

Ill. 13: Lucas Cranach the Elder, Portrait of Duke Henry of Saxony. Circa 1526. Staatliche Kunstsammlungen Dresden, Armoury, inv. no. H 75 (© Staatliche Kunstsammlungen Dresden)

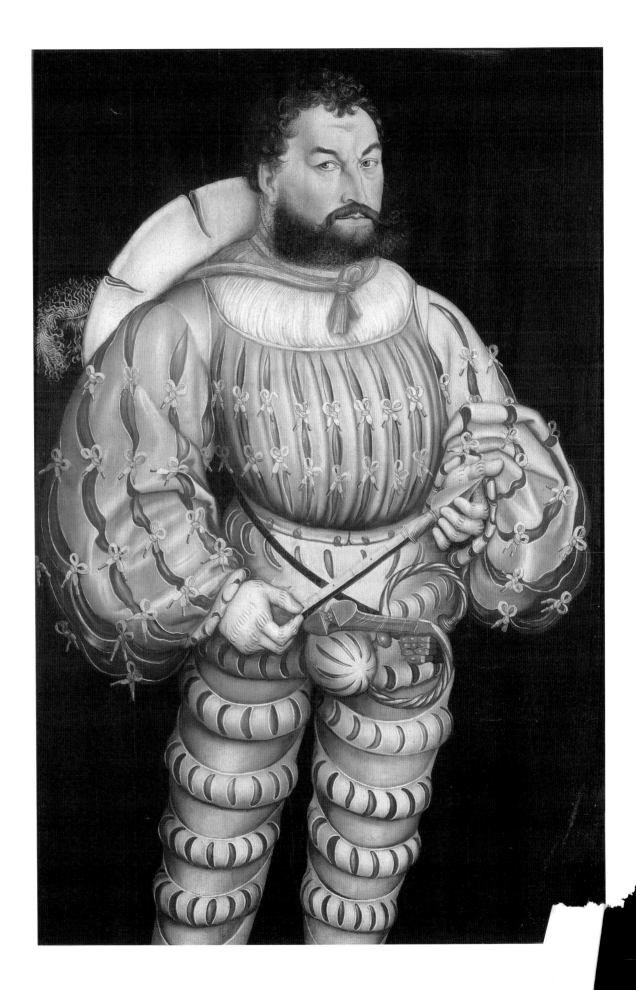

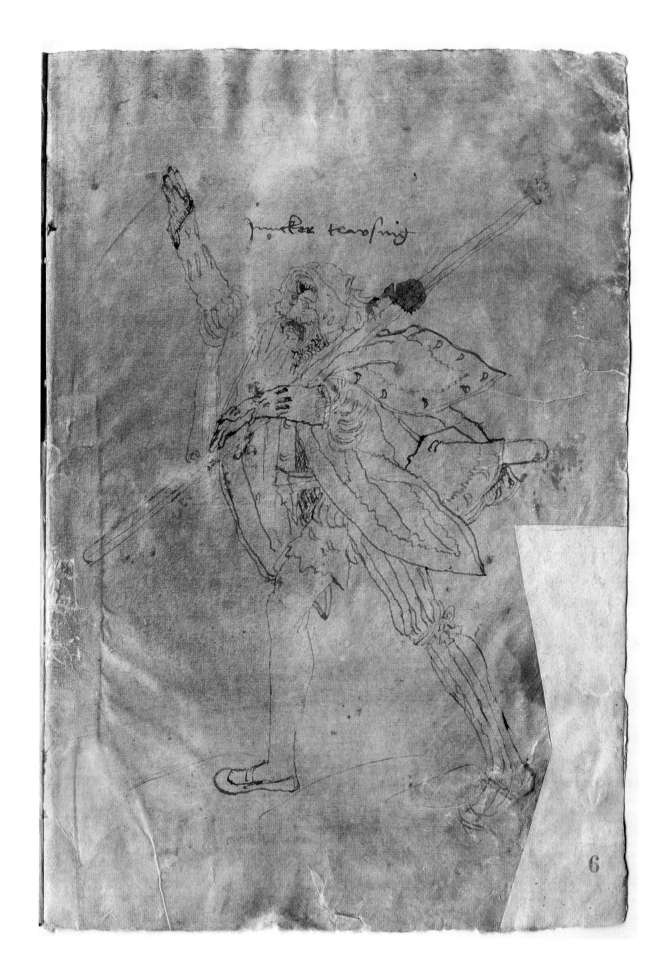

6

Ill. 15: Urs Graf, Landsknecht in the Clutches of the Devil. Paper, pen drawing, dated 1516. Basel, Kunstmuseum, Collection of Prints, Amerbach-Kabinett, inv. no. U.X.71 (© Basel, Kunstmuseum)

Ill. 14: Portrait of Junker (Master) Trausnig, in: Sketchbook of Paul Dolnstein, sketch 10. Circa 1500. Weimar, Thüringisches Hauptstaatsarchiv, Reg. S (Bau- und Artillerieangelegenheiten), fol. 460, no. 6, leave 6r (© Weimar, Thüringisches Hauptstaatsarchiv)

What is true of clothes is also true of armour: we know of numerous armours produced in the early sixteenth century and decorated with etched or embossed "slashes" that do not function as a direct and explicit reference to the Landsknechts. They include, for example, the leg armour of a boy's harness made around 1512/14 for Archduke (later Emperor) Charles V,[59] and the cuisses worn by Duke William IV of Bavaria in the tiltyard in 1513/14.[60] However, the armour of Wilhelm von Rogendorf must be seen in the context of the Landsknecht style. Like the sumptuous clothes sported by Duke Henry in his second portrait, Rogendorf's armour is also clearly informed by this extravagant fashion that had recently moved from the fringes of society to its centre. The sleeve-vambraces and the slashed details festooning this armour cannot be explained solely by the Renaissance's love of cut and puffed clothes. Like the attire worn by the fashion-conscious Duke of Saxony they function as an unambiguous reference to the Landsknechts and their world.

Looking at Landsknechts' attire, we must consider two questions: one, did Landsknechts really wear such elaborate clothes in battle; and two, if they did, how could they afford such luxuries? Today, the idea of infantrymen with a soft spot for costly fashion fads may seem somewhat surprising. But modern soldiers are of little help for anyone trying to understand the mercenaries of the early modern era. Camouflage was only introduced at the turn of the twentieth century, mainly during the First World War. Uniforms (i.e. uniform attire for all the soldiers in an army) had only been introduced during the Baroque, together with military drill, in an attempt to instil discipline and order. This became increasingly important with the proliferation of firearms, as an inexperienced comrade with a gun was almost as dangerous as the enemy.[61] For Renaissance soldiers a battle was still primarily an expression of individual bravery and frequently too an act of grandstanding or self-display,[62] all of which was also expressed (and reflected) in their colourful attire.

In his highly influential book *The Courtier*, first published in 1528, Baldassare Castiglione opines that for armed combat "there is no doubt, but upon armour it is more meete to have sightly and merrie colours, and also garments for pleasure, cut, pompous and rich".[63] A century earlier (c. 1415), Johannes Rothe had written that "a colourful garment is most appropriate on the body of a knight" and that "he who has many virtues has the right to wear brightly-coloured clothes".[64] A mercenary was surely the last person Rothe and Castiglione had in mind. But the image of a colourfully dressed – and thus brave and virtuous – soldier also informed the fashionable extravagances beloved of the Landsknechts.

Nonetheless we must preserve some critical distance when looking at Renaissance depictions of soldiers and fighting men. Unlike photographs, they are not snapshots of real events in the real world, but rather they were created for a particular purpose: for example, the painter and graphic artist Urs Graf (c. 1485 – 1527/28) was Swiss, and in his drawings he satirises rival Landsknechts from southern Germany by depicting them in ridiculous, over-the-top outfits *(ill. 15)*.[65] In contrast, the German artist Albrecht Altdorfer (c. 1480 – 1538), from Regensburg, idealises Landsknechts in his contributions to the splendid *Triumphs* of Emperor Maximilian I *(ill. 3)*. The soldiers in the prints produced by Daniel Hopfner (1471–1536) also seem idealized and are presumably products of the artist's fertile imagination *(ill. 40)*. But like modern photographic portraits which have been digitally manipulated, we may still assume that all these depictions can be traced back to a real model. And we are probably closest to this template in Paul Dolnstein's portrait of Junker (Master) Trausnig *(ill. 14)*.[66]

At the turn of the sixteenth century Paul Dolnstein worked as an engineer building bridges in Saxony but he also hired himself out as a mercenary. He packed a sketch-book when he went soldiering and produced drawings of various battles and sieges as well as portraits of some of his comrades, among them the aforementioned Master Trausnig. Trausnig seems quite old in Dolnstein's sketch but marches briskly along, raising a hand to greet someone in the distance.[67] He is carrying the typical arms of a Landsknecht, a Katzbalger *(ill. 11)* and, instead of a pike, a halberd. His sleeves are puffed and slashed, the hose of his right leg is torn, the left one flamboyantly striped. He wears a voluminous fur jacket that may be either plunder, or a reminder of the aristocratic linage implied by his title "Junker".

Landsknechts had a number of opportunities to get their hands on their often elaborate garments. Pillaging was clearly one of them. For example, in 1527, during the Sack of Rome, marauding Lutheran soldiers ran amok in the Eternal City dressed in "liturgical copes and other such pomp".[68] Foot soldiers were also paid relatively well, at least in the beginning, i.e. around 1500, receiving four guilders per month,[69] and this was often augmented by an additional guilder for clothes. This was far more than the wage of, for example, a journeyman.[70] We also know of cases where a commander paid his troops in rolls of cloth or silk – which did not always meet with their approval.[71] Flush with money, soldiers could kit themselves out at one of the traders travelling in the baggage train. Or they could hire a tailor to make them a "pair of trousers to their taste"; in Nuremberg after 1569, however, they had to promise that in their finery they would "move on and not remain here".[72]

In addition, social distinctions and constraints encountered both within a military unit and in civilian life directly impacted a soldier's appearance.[73] Many of the men fighting and marching on foot probably wore relatively simple clothes. Others, however, tried to stand out by their attire, and were able to do this thanks to the special role they played in the army. For example *doppelsöldner* (double-pay men), who for double payment volunteered to fight in the frontline, generally wore steel armour, which was not necessarily part of the attire of a common foot soldier.[74]

Jörg Breu's *Symon Clappermaul (ill. 16)* is such a *doppelsöldner* and he proudly proclaims: "I am paid double / and that's why I don't remain in the back [...] I am a free double-pay man / and I step up in my armour."[75] Particularly interesting for us is that Symon's armour, like Rogendorf's, features chased "slashes" – but, as was customary at the time, his puffed sleeves are made of fabric. These clothes set him apart from rank-and-file soldiers and imitated the attire worn by the higher ranks. Next up the chain of command was the ensign, followed by the captain, and finally the colonel[76] – the rank held by Wilhelm von Rogendorf when he received his puffed and slashed armour in 1523.

Rogendorf's armour is, of course, much finer than the harness worn by common infantrymen. It is an exquisite and unique custom creation, a testament to outstanding technical and artistic virtuosity. Its puffed sleeves were not intended for combat but rather allowed him to transform his fully functional infantry armour into a ceremonial steel costume that could be worn in a formal and elegant setting, presumably at the court of Emperor Charles V.

Ill. 16: Jörg Breu, *Symon Clappermaul*. Woodcut, circa 1525/30, in the edition of David de Negker, Vienna, c. 1580 (image taken from: Breunner-Enkevoërth [1883], unnumbered plate)

ICH hab doppel solt auff mein leib/
 Darumb ich nit dahinden bleib/
Muß vornen dran kost was es wöl/
 Drumb ich mich wider den Feind stell/

Ich bin ein Doppensöldner frey/
 In meim Harnisch trit ich herbey.
Schwing mein Spieß tapffer wie ein Mañ/
 Den Feind darmit erheben kan.

Gedruckt zu Wien in Osterreich / durch Dauid de Necker Formschneider/
Mit Röm:Kay:Mt:c.gnad vnd freyheit nit nachzudrucken.

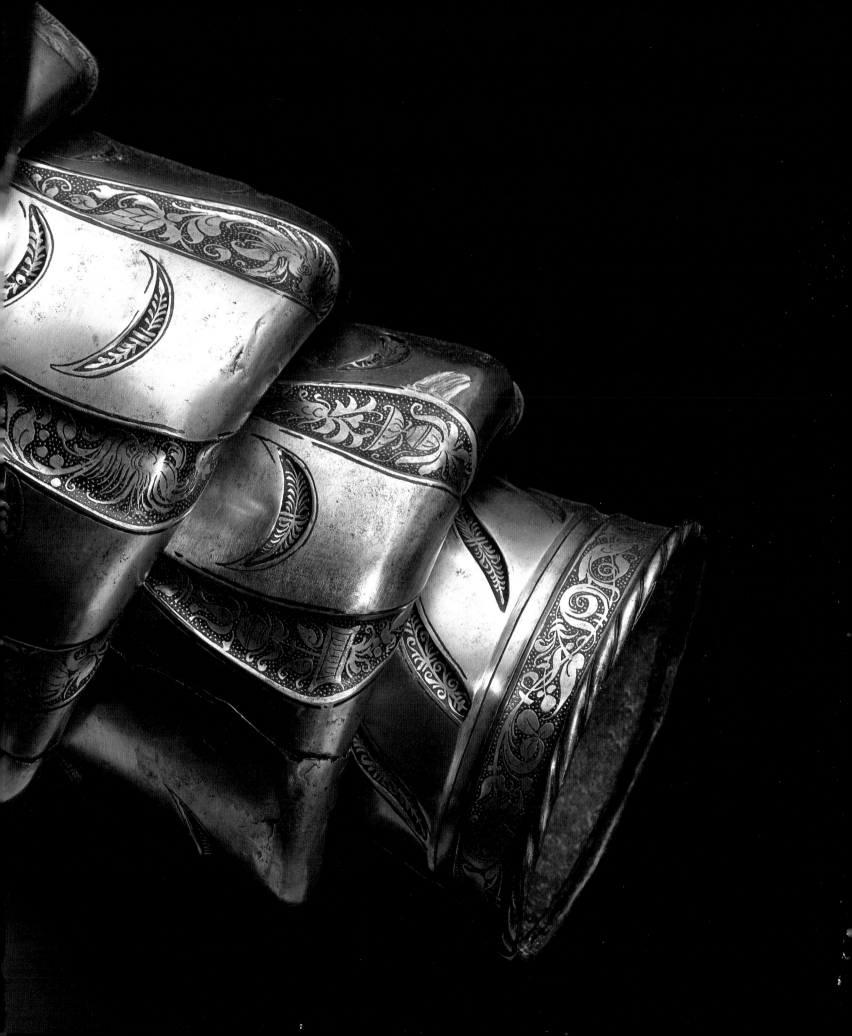

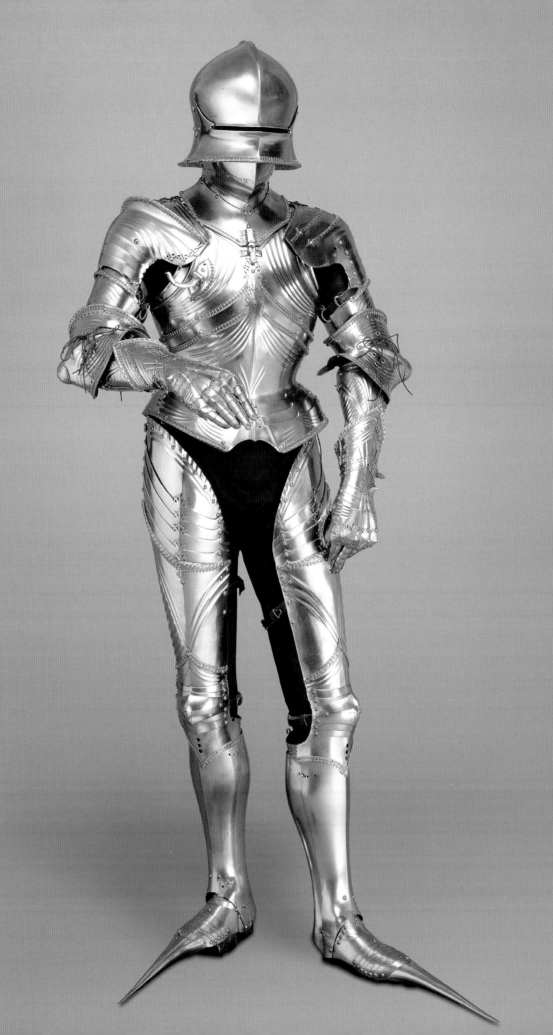

Fashion in Steel

Full plate armour evolved in the late fourteenth century, reaching its apex of technical perfection by the middle of the fifteenth century.[77] From then on almost every part of the elite warrior's body could be encased in steel, with the individual pieces of each suit of plate armour working together to form a flexible whole. The continual development throughout the sixteenth century of increasingly effective armour of hardened steel, rather than iron, reflects not only its continuing importance in warfare and tournaments; the late Middle Ages and the Renaissance also regarded armour as a nobleman's ideal attire, which meant that it remained not only militarily and socially relevant but also that it was constantly subject to the vagaries of fashion.[78] In keeping with contemporary ideals of male beauty and attire, an armour produced around 1480 was dominated by long, elegant, narrow lines, aiming for a slim, graceful silhouette *(ill. 17)*. In contrast, Rogendorf's armour, made more than a generation later, seems heavy and more muscular, reflecting the Renaissance's new aesthetic ideal *(ill. 18)*. But more than anything it is an example of an exceptional facet of the armourers' art – it is the most famous of the few extant garnitures produced in the early sixteenth century which include costume elements.

The creation of a Renaissance *costume* armour – i.e. an armour comprising elements inspired by fashionable clothes – demanded that a knight's protective equipment, made of steel, should conform to or at least evoke the forms and lines of fine textile clothing: steel is made to billow like silk. Its surface is embellished with textile patterns and sculpted to suggest the tailor's cutting techniques. In this context two shapes dominate early Renaissance armour: pleated skirts *(ill. 19)* and puffed and slashed elements. It is not surprising that armourers at the turn of the sixteenth century preferred to imitate in steel these two types of clothing – at the time both featured prominently in court fashion; they were ubiquitous in the castles and at court where such bespoke armour would also be worn. But *costume* armour reached its apogee in the steel imitations of puffed and slashed textile garments.

The puffed and cut fashion that informed Rogendorf's armour evolved – as we have discussed above – out of a style current in the early sixteenth century.[79] It has no protective function and, if anything, negatively affects any practical use. In this it differs from the pleated steel skirt, which may look impractical and extravagant but does in fact offer additional protection for the wearer's waist, pelvis, groin and upper legs. They are cut-out at front and rear so that they may be worn on horseback.

Ill. 17: Lorenz Helmschmid, Armour of Archduke Maximilian I. Augsburg, circa 1484. Vienna, Kunsthistorisches Museum, Collection of Arms and Armour, inv. no. A 62 (© KHM-Museumsverband)

Many of them are sculpted so as to appear to be vertically pleated and are engraved and embossed with small regular slashes, and their surface decoration sometimes imitates textile ornamentation.[80]

Almost all extant *costume* armours include a pleated skirt of steel, or 'base'; we have records that tell us that such armours were produced around 1510/20 at, for example, Innsbruck,[81] Greenwich[82] and probably also Brunswick,[83] for instance the harness made there around 1526, presumably for Albrecht of Brandenburg *(ill. 19)*. Most pleated-skirt armours also have slashed and slightly puffed sleeves and leg armour. But Rogendorf's voluminous pleated sleeves are exceptional and we may assume that his contemporaries also regarded them as extraordinary.

Rogendorf's garniture is the work of Kolman Helmschmid, a celebrated armourer from Augsburg and the leading master in the art of sculpting steel. In armours like the one he produced for Rogendorf, Helmschmid pushed armour-making to the very limits of what was technically possible. He continually tried to improve and perfect the illusion created by his metal attire; compare, for example, Rogendorf's Landsknecht armour with the only similar example to have survived – a fragmentary costume garniture produced by Kolman not much later (c. 1525/30), of which a number of pieces are known: backplate, hoguine (rump-defence) and a pair of puffed and slashed sleeve-vambraces are now in New York *(ill. 20)*;[84] breastplate and tassets, the left cuisse and one of the field vambraces (not puffed) are now in Paris.[85] These exchange pieces were dispersed after they were sold by European and American art dealers at the turn of the twentieth century.

Suggesting the human anatomy beneath what the viewer is asked to believe is textile, the shape of the arms beneath the sleeve-vambraces of the Rogendorf armour is clearly defined. The 'sleeves' grow narrower towards the wrist and end in straight cuffs. This is not the case in the fragmented armour now divided between New York and Paris; the latter's etched decoration suggests that Kolman produced it soon after 1525: the puffed sleeves in New York hide the arm almost completely; they are much more voluminous, more like the now-lost loose, flowing sleeves that Kolman produced around this time and that are depicted in the so-called *Thun-Sketchbook (ill. 21)*[86].

In addition, the wrist plates of the sleeve-vambraces now in New York clearly suggest or imitate heavy, billowing sleeves pulled down by gravity. This creates a feeling of elasticity and greatly enhances the illusion of "steel textile". And, last but not least, the more elaborate chased three-dimensional quality of the slashes is executed in cunning detail. Continuing the textile-steel conceit, it is embossed with decorative raised cuts of a kind shown on the doublet worn by Kunz von der Rosen in a portrait by Daniel Hopfner.[87] But unlike Rogendorf's sleeve-vambraces, the etched decoration contained within these "slashings" imitates the structure of the cloth-of-gold interlining showing through the gaps in the outer layer. The sleeve-vambraces now in New York clearly represent a step forward in the evolution of this daring concept, which, as far as we know, was first attempted in Rogendorf's armour.

We should not be surprised that in the early sixteenth century armourers enthusiastically explored the contrasts between steel and fabric. These two utterly different materials had always been intimately connected in an armour. Certain pieces of an armour – always the helmet and sometimes other parts such as the cuirass and cuisses –

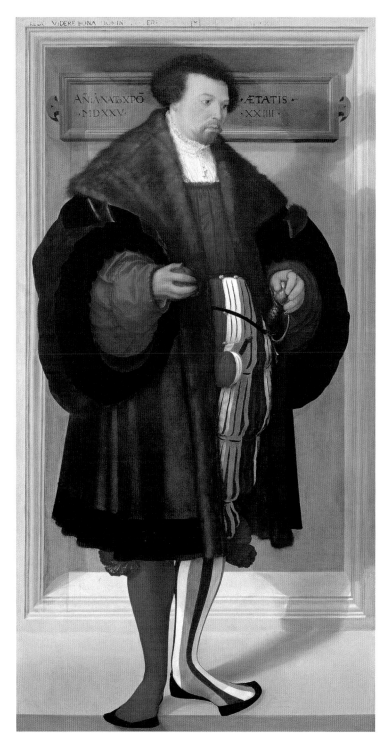

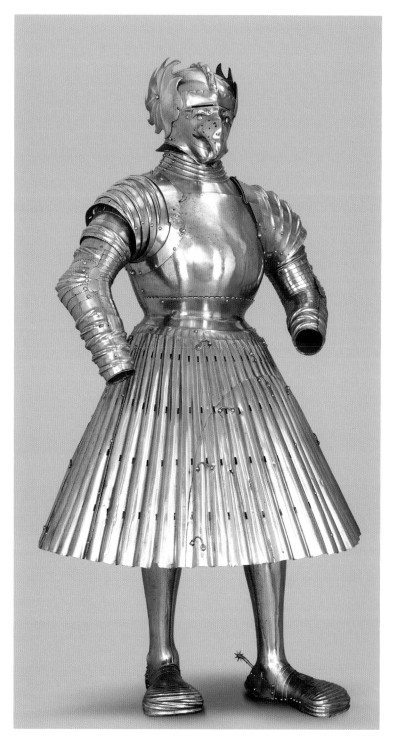

Ill. 18: Christoph Amberger, Male Portrait
(Hans Ulrich Sürg von Syrgenstein?). 1525.
Vienna, Kunsthistorisches Museum, Picture
Gallery, inv. no. 887 (© KHM-Museumsverband)

Ill. 19: Armour of Albrecht of Brandenburg.
Brunswick (?), circa 1526. Vienna, Kunsthistori-
sches Museum, Collection of Arms and Armour,
inv. no. A 78 (© KHM-Museumsverband)

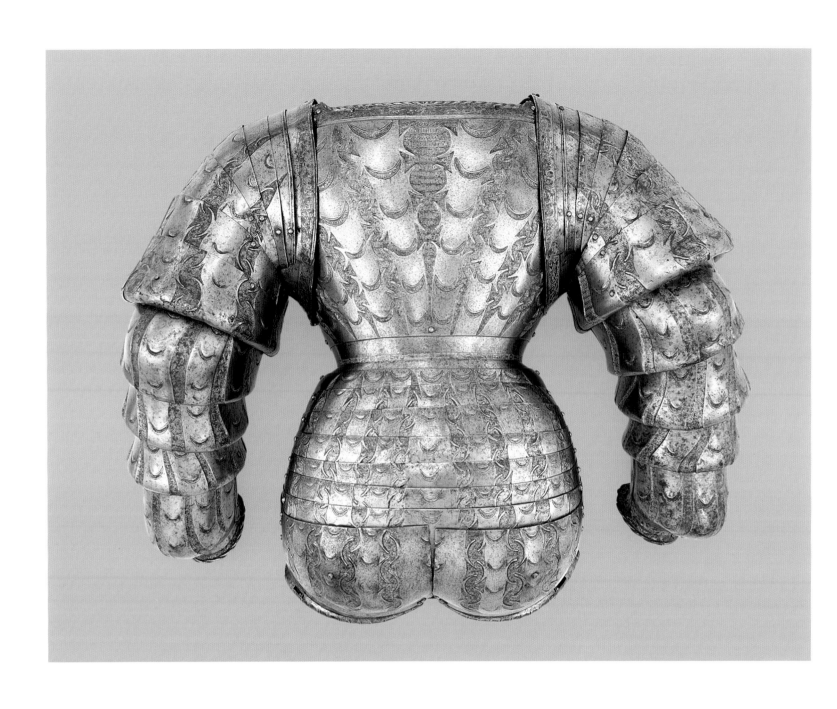

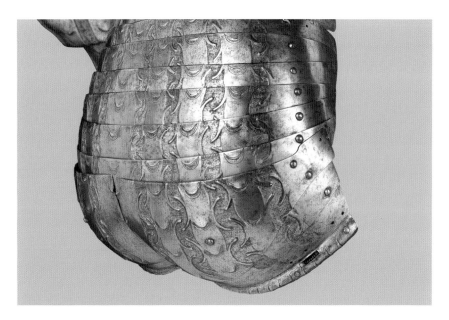

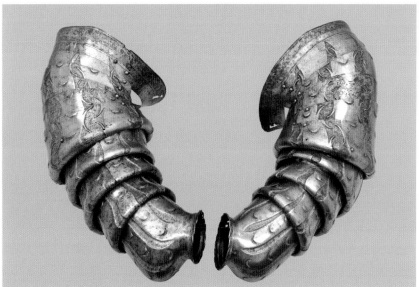

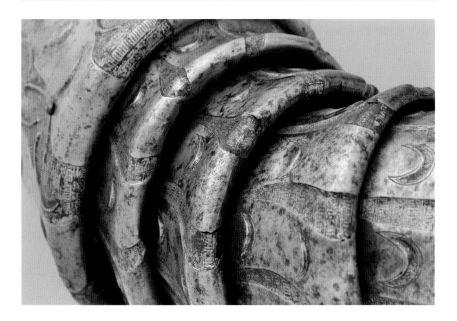

Ills. 20 and 20a–c: Kolman Helmschmid, fragments of an armour: puffed armlet, and back with hoguine. Augsburg, circa 1525/30. New York, The Metropolitan Museum of Art, inv. no. 26-1882-3 (© New York, The Metropolitan Museum of Art)

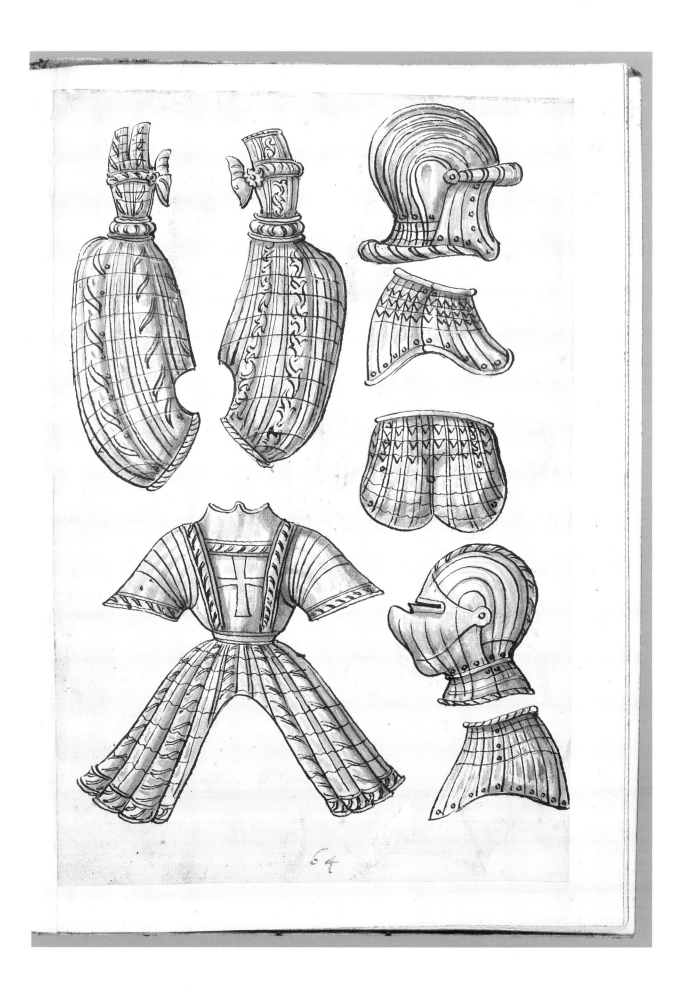

64

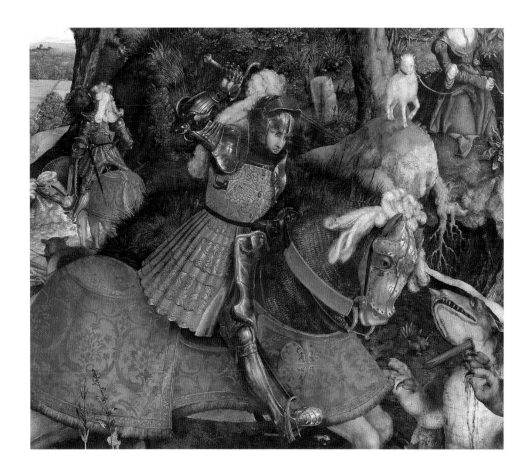

Ill. 22: Leonhard Beck, Saint George and the Dragon, detail. Augsburg, circa 1515. Vienna, Kunsthistorisches Museum, Picture Gallery, inv. no. 5669 (© KHM-Museumsverband)

Ill. 21: So-called *Thun-Sketchbook*, vol. 1, fol. n74r. Augsburg, first half of the sixteenth century. Prague, Uměleckoprůmyslové Museum v Praze, sign. GK 11.572-B (© Prague, Uměleckoprůmyslové Museum v Praze)

were lined with linen or silk stuffed with tow, wool, or other fibres, which absorbed the shock of blows and made the armour comfortable to wear.[88] Many armours were also covered with precious brightly-coloured silks – see, for example, the sumptuous sleeveless red-and-gold overgown that Saint George wears over his armour in Leonhard Beck's eponymous painting (c. 1515; *ill. 22*). Lorenzo de' Medici owned a number of jousting armours faced in rich textile, including one completely covered with azure velvet decorated with winding tendrils.[89] In 1510 Emperor Maximilian I participated in a tournament at Augsburg wearing a "red tunic embroidered with large pearls and precious stones".[90]

Almost nothing of these colourful textile embellishments of fifteenth- and sixteenth-century armour has survived, beyond a few intriguing scraps. For example, rare fragments have survived on a field armour made for Emperor Maximilian I in 1480, which is now in Vienna.[91] They comprise leather straps used to lace the leg armour onto the arming doublet that are covered with purple silk and fitted with gilt-brass flower-shaped eyelets and rivets *(ill. 23)*. These tiny but exquisite survivals help us imagine the profusion of colours that once adorned this and similar harnesses. Rogendorf's Landsknecht armour has also retained a small piece of its original leather and textile elements: at the bottom edge of the rump defence, a tiny piece of a decoratively-slashed leather edging band has survived *(ill. 36)*. On the other armour mentioned above (parts of which are now in New York) Kolman Helmschmid incorporated a representation of this slashed decorative band into the steel hoguine *(ill. 20a)*.

Ill. 23a: detail of ill. 23:
Gilt brass flower-shaped rivet

We will have to look more closely at the origins of the armourer's love of playing with the contrasts between steel and textile to thoroughly understand Rogendorf's puffed armour. Experimentation with costume styles presupposes familiarity with the breadth of – and the rapid changes in – contemporary fashion. In the later Middle Ages this was a relatively new phenomenon, but one regarded with deep and abiding interest – exemplified by the lifelong passion for clothing of the Augsburg patrician Matthäus Schwarz (1497–1574).

Schwarz was the accountant of the Fugger family, who were prominent bankers and merchants; between 1520 and 1560 he had his changing wardrobe documented in a little book comprising small pictures.[92] Over the years this grew to no less than 137 portraits of Schwarz sporting different outfits. The series of images in Matthäus Schwarz' *Book of Clothes* is a unique document of the evolution of shape, form and colour in male fashion during the first half of the sixteenth century.

Schwarz commissioned pictorial records of his clothes because, as he put it in the introduction to his book, "fashion is turned on its head every day" and he wanted to see "what would become of it".[93] He records both the material and the origins of his clothes and frequently also why he bought them and on which occasions he wore them. In March 1523 – when the craze for puffing and slashing was at its height in southern Germany – Schwarz was at Augsburg, sporting a doublet made of white fustian with puffed sleeves and decorated, as he proudly notes, with "4800 slashes" *(ill. 24)*.[94] At the same time, and presumably only a few streets away in the same city, Kolman Helmschmid was busy producing Rogendorf's armour with its puffed parade sleeve-vambraces embellished with almost as many chased and etched slashes as were actually cut into Schwarz's doublet.

However, an abiding interest in changing fashion alone cannot explain the exceptional appearance of Rogendorf's armour. At the time armourers' imagination went far beyond imitating a gentleman's fashionable attire. They frequently also imitated human or animal anatomy, even incorporating fantastical creatures into their work. Renaissance helmets have survived that feature forged steel faces and pseudo-classical curly hair,[95] the muzzle of a fox *(ill. 25)* or the grotesque visage of a bird *(ill. 19)*. On a horse armour made for Duke Frederick II of Liegnitz (c. 1515/20)[96] the wooden planks of the tilt were projected onto the steel and then etched into it, imitating the natural veining of the wood.

We can trace the tradition of figurative sculpted (embossed and chased) details on armour north of the Alps back to at least the 1470s. The oldest known classical-style parade helmet dates from 1475/80; this gilt helmet now in New York was made in Northern Italy and imitates the head of a lion.[97] At the same time, around 1477, Kolman Helmschmid's father Lorenz produced a horse armour for Emperor Frederick III that is lavishly embellished with three-dimensional embossed decoration. The peytral features an angel clutching a shield emblazoned with a coat of arms, each side of the crupper is decorated with a double-headed eagle, and a dragon has settled on the base of the horse's tail so that the tail itself cascades out of the creature's wide-open mouth.[98] Following in his father's footsteps, Kolman Helmschmid produced equally fantastic zoomorphic armour throughout his life, artefacts like the celebrated dolphin morion of Emperor Charles V *(ill. 26)*,[99] which, like Rogendorf's armour, dates from the 1520s.

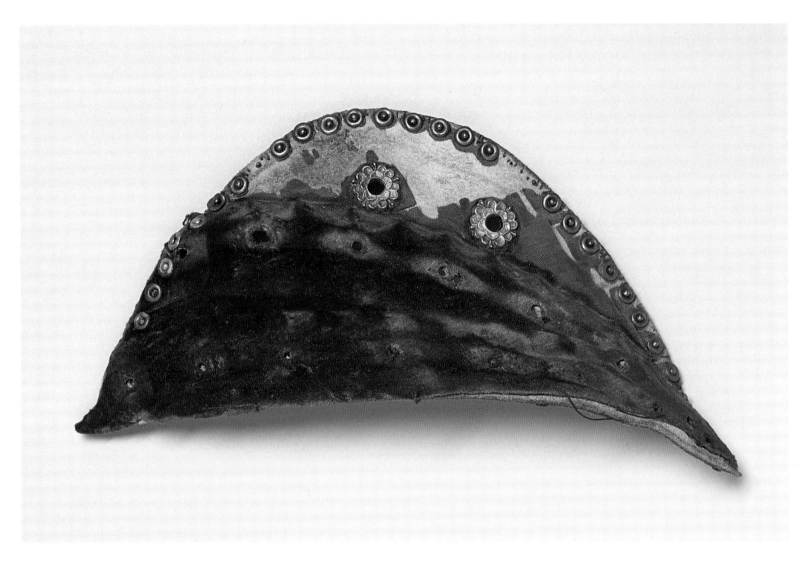

Ill. 23: Lorenz Helmschmid, leather strap with
purple silk from a leg armour of the cuirass of
Archduke Maximilian I. Augsburg, 1480. Vienna,
Kunsthistorisches Museum, Collection of Arms and
Armour, inv. no. A 60 (© KHM-Museumsverband)

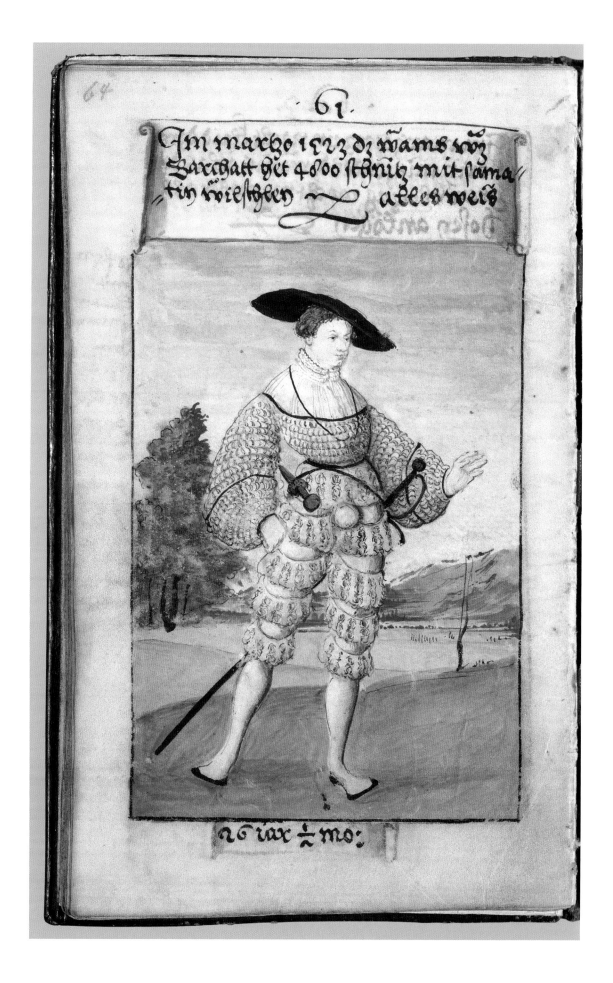

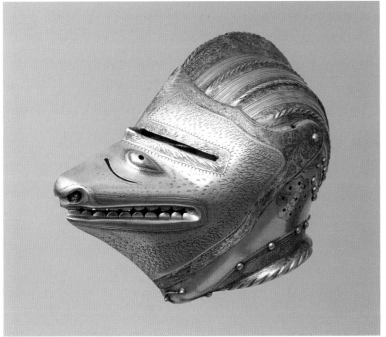

Ill. 25: Hans Seusenhofer, so-called Fox-Helmet of King Ferdinand I. Innsbruck, 1526/29. Vienna, Kunsthistorisches Museum, Collection of Arms and Armour, inv. no. A 461 (© KHM-Museumsverband)

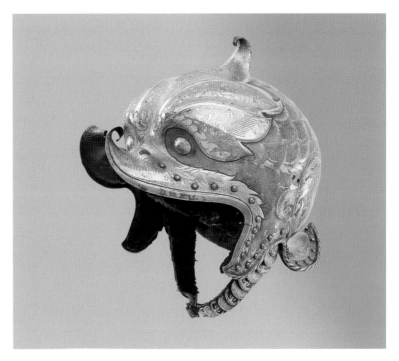

Ill. 26: Kolman Helmschmid, Dolphin Morion of Emperor Charles V. Augsburg, circa 1530. Madrid, Patrimonio Nacional, Real Armería, inv. no. A 59 (© Madrid, Patrimonio Nacional)

Ill. 24: Matthäus Schwarz' *Book of Clothes*, miniature no. 61. Augsburg, 1523. Brunswick, Herzog Anton Ulrich-Museum, Collection of Prints, inv. no. 67a (© Brunswick, Herzog Anton Ulrich-Museum)

Armour featuring chased three-dimensional figurative decoration was not usually worn in battle; instead it was designed to be worn in formal public settings such as pageants, masques or tournaments.[100] Such festive events played a seminal role in court life during the later Middle Ages and the Renaissance. References to classical or mythological themes or heroes functioned as the symbolic expression of a ruler's military power and political authority (or at least his claim to them) – see, for example, the festivities celebrated in 1549 at Binche Palace in Hainaut (in what is now Belgium) by Emperor Charles V and his son Prince Philip, the future King Philip II of Spain. The aim of this royal progress through the Holy Roman Empire and the Low Countries was to introduce Philip as his father's heir throughout the very extensive Habsburg domains. Binche Palace was the setting for one of the highly significant and extravagant festivities staged in the course of this year-long journey *(ill. 27)*.[101] Rogendorf's exquisite Landsknecht armour would have been very much at home in such a complex and refined intellectual setting.

We do not know where or on what occasion(s) Rogendorf actually wore his Helmschmid armour. We also do not have any pictorial or written sources on the practical use of such sleeve-vambraces. But a study of documented contemporary festivities and similar armour allows us to imagine the event(s) at which he may have worn it. One possibility is a formal display of Landsknecht combat staged in the course of some festivity celebrated at the Habsburg court. In the Renaissance these opulent court events featured historical and allegorical allusions but they frequently also

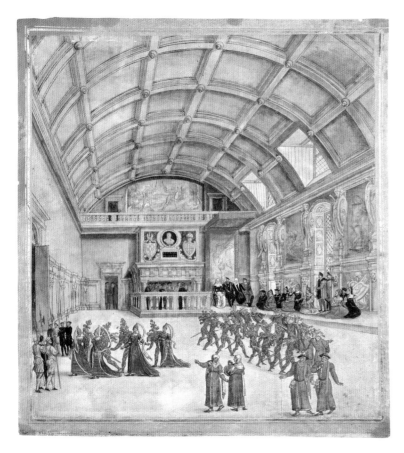

Ill. 27: Anonymous artist, Feast in the Great Hall of Binche Palace, 1549. Brussels, Bibliothèque royale Albert Ier, Collection of Prints, inv. no. F 12930, plano C (© Brussels, Bibliothèque royale Albert Ier)

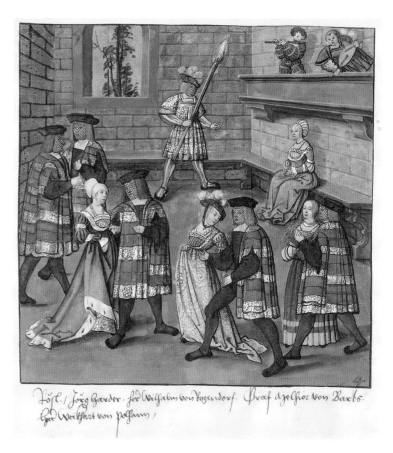

Ill. 28: Dance held at the court of Emperor Maximilian I, with Wilhelm von Rogendorf one of the dancers, in: *Freydal*, Tournament Book of Emperor Maximilian I, fol. 4. Southern Germany, 1512/15. Vienna, Kunsthistorisches Museum, Kunstkammer, inv. no. KK 5073 (© KHM-Museumsverband)

incorporated references to contemporary political and military events such as, for example, the ongoing war against the Ottoman Empire,[102] or the Landsknechts, who, as discussed above, played such a seminal role on the battlefields of the time. Produced around 1512/15, *Freydal*, the tournament book of Emperor Maximilian, includes an exhibition fight between Landsknechts wearing infantry armour complete with voluminous and very colourful textile sleeves *(ill. 29)*. The inscriptions tell us that all the protagonists in this theatrical engagement were, like Rogendorf, members of the Austrian gentry: two of them were scions of the Thurn and Embs families, respectively, who, like the Rogendorfs, supplied commanders for the bands of mercenaries then employed by the Habsburgs.[103] And a dance depicted in this tournament book documents that Rogendorf too participated in these festivities celebrated at the imperial court *(ill. 28)*.[104]

Other evidence suggests that armour with puffed and slashed sleeve-vambraces may also have been worn during combats on foot staged as part of courtly tournaments (i.e. not only for exhibition fights). Combats on foot became very popular in the late fifteenth century at the court of Emperor Maximilian I, probably a reflection or expression of the resounding success of professional infantry units in recent battles.[105]

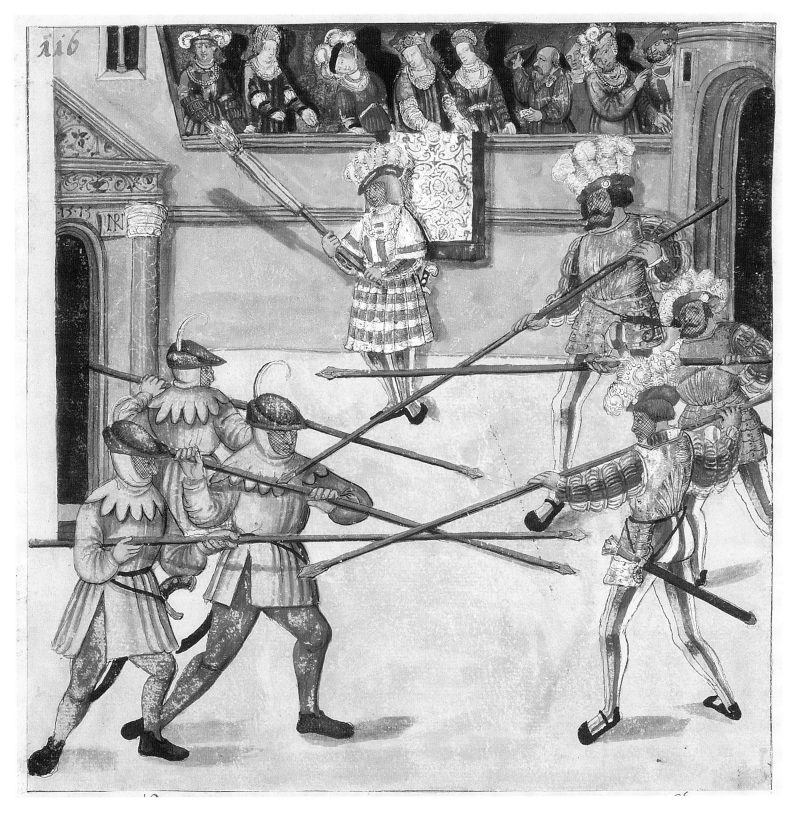

Ill. 29: Landsknecht exhibition bout staged at
the court of Emperor Maximilian I, in: *Freydal*,
Tournament Book of Emperor Maximilian I,
fol. 116. Southern Germany, 1512/15. Vienna,
Kunsthistorisches Museum, Kunstkammer,
inv. no. KK 5073 (© KHM-Museumsverband)

Ill. 30: Nicolaas Hogenberg, Formal Entry of Charles V into Bologna, plate 34. Etching. Netherlandish, 1530. London, The British Museum, inv. no. 1871,1209.2016 (© London, Trustees of the British Museum)

The aforementioned fragmented armour with puffed sleeves now in New York *(ill. 20)* and Paris[106] may have been produced for use in combats on foot. It includes rump defences that feature special closing mechanisms presumably designed to attach fully enclosed leg armour *(ill. 20a)*. The steel hoguine and closed cuisses to protect both the front and the back of the thigh are exceptional in early sixteenth-century armour and were designed exclusively for formal combat on foot. They protect parts of the body normally left uncovered by the plates of field armour of the time (including the rump and the back of the thighs), which would be highly advantageous in courtly foot combat, in which an injury could provoke a diplomatic incident or at least be highly embarrassing.[107] Rogendorf's armour does feature a hoguine *(ill. IV)* but here we have neither the closing mechanism discussed above nor a leg armour that completely encases the thighs.[108] We also do not know if puffed and slashed sleeve-vambraces were actually worn by participants in tournament combats on foot or if they were replaced for such bouts with standard field vambraces which were more flexible and practical.[109]

Rogendorf may also have worn his armour with elaborate sleeve-vambraces solely at formal public events, without any active sporting or martial aspect – such as, for example, marching into a city at the head of a Landsknecht unit. On July 7, 1485 Archduke (later Emperor) Maximilian I, clad in infantry armour and leading an army comprising 5000 soldiers, formally entered the city of Ghent, which made a considerable impression on contemporary chroniclers.[110] In his *Book of Clothes*, Matthäus Schwarz, the aforementioned accountant of the Fugger merchant-dynasty, recorded a pageant held at Augsburg in March 1527 in which he had marched with a group of sixty men all dressed in identical Landsknecht armour with puffed and slashed textile sleeves *(ill. 31)*.[111]

We also have records that show that in November 1530 infantry units were part of the retinue of Charles V that escorted him to his coronation as Emperor of the Holy Roman Empire in Bologna *(ill. 30)*.[112] Four-and-a-half years earlier, on March 10, 1526, Charles had formally entered the city of Seville in Andalusia for his marriage to Isabella of Portugal. As colonel of the imperial Landsknecht units, Baron Wilhelm von Rogendorf also participated in this pageant as it wound its way through the city's lavishly decorated streets to the cathedral.[113] We do not know what he wore on this occasion but perhaps it is not too far-fetched to assume that he was armed in a splendid Landsknecht garniture with puffed and slashed sleeve-vambraces made of steel.

Ill. 31: Matthäus Schwarz' *Book of Clothes*, miniature no. 87. Augsburg, 1527. Brunswick, Herzog Anton Ulrich-Museum, Collection of Prints, inv. no. 67a (© Brunswick, Herzog Anton Ulrich-Museum)

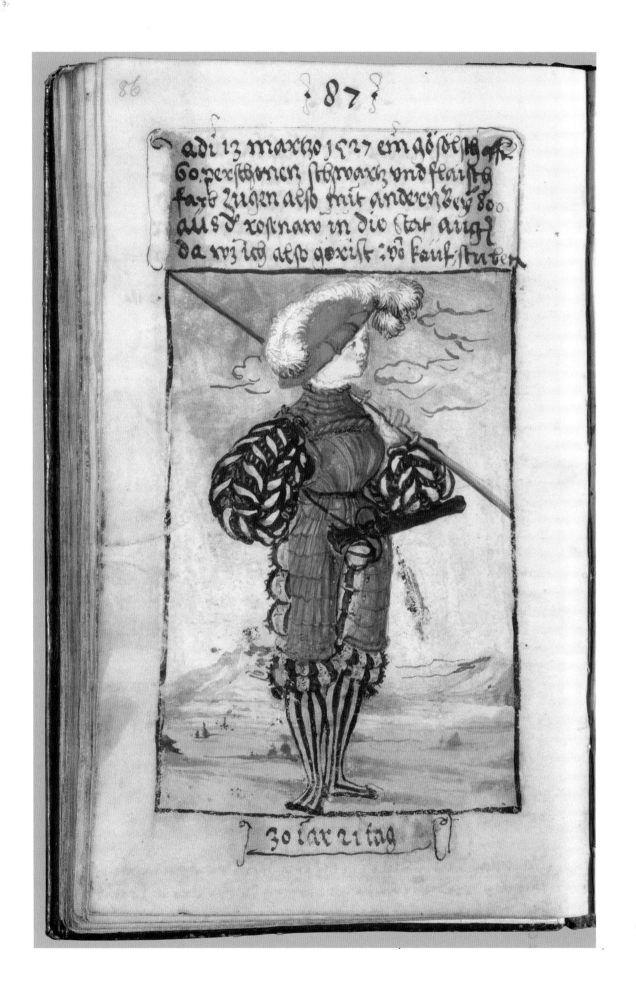

adi 13 marzo 1527 em dose ost
60 perstonen sterwarz und flaist
farb zugen aus mit anderen bey 800
aus d rossnaw in die stat augst
da wj ich also gerist: vo kauf stuben

3o iar 21 tag

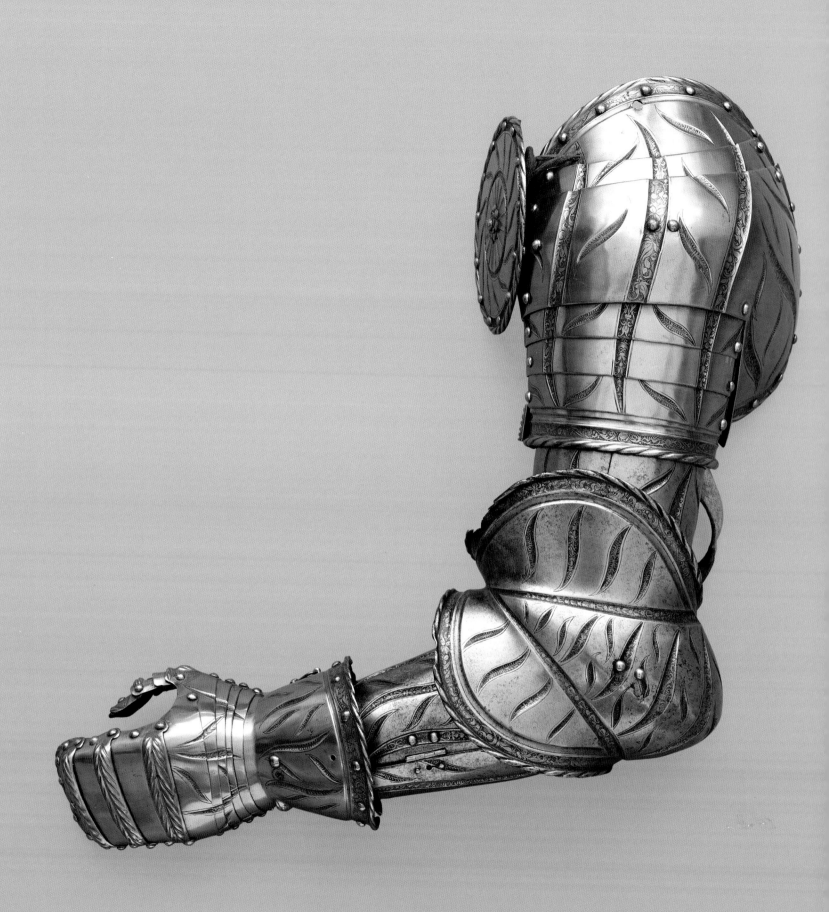

Wilhelm von Rogendorf's Garniture

Wilhelm von Rogendorf presumably received his Landsknecht armour shortly after 1523 while he was still in Spain. However, what he saw when he opened the chest or barrel which contained the harness was not only the parade armour now in Vienna – those pieces were but part of a larger garniture predominantly for field use. It included more pieces than could be worn at any one time, a number of which have not survived.

A garniture was conceived somewhat like a modular construction system. The basic war armour was provided with 'pieces of exchange' that could be used to configure and adapt the harness for different uses – on the battlefield, in the lists, or for parades and pageants. The leg armour, tassets and cuirass skirts could be changed to suit either cavalry or infantry use for example, or the hoguine and sleeve-vambraces could be traded for the more usual field pieces for an elaborate pageant, parade, or combat exhibition.[114] Sadly we cannot be sure of the original and complete inventory of pieces comprising the Rogendorf garniture when new, but we have a number of important clues. The standard pauldrons with besagews, leg armour, and gauntlets, all for the field, also survive at Vienna, as does the right lower cannon from the field vambraces. Meanwhile, the right upper cannon and left couter have been preserved at the Wallace Collection in London *(ills. 32 and 35a–c)*; these two pieces were wrongly assembled together, probably in the nineteenth century, as if they both belong to the left vambrace.[115] These pieces allow us to draw inferences on the original size of the garniture, although a number of questions remain.

Judging from the extant pieces, we may assume that Rogendorf's garniture was modest in extent, the field configurations being restricted to infantry and light- and medium cavalry roles. However, it is of course also designed to celebrate the prowess of the Landsknechts through the use of the costume pieces – the sleeve-vambraces and hoguine – which were almost certainly worn at court festivities and perhaps certain forms of combat spectacle. The garniture was cleverly designed to take account of the very specific demands of the professional military of the time, which relied heavily on infantry units. The garniture thus perfectly reflects Rogendorf's military and representational requirements as colonel of the imperial Landsknechts.

In battle Rogendorf would have replaced the puffed and slashed sleeve-vambraces with the alternative vambraces, pauldrons and gauntlets for the field of which most parts have survived; only the right couter and upper and lower cannons for the left arm have been lost *(ill. 32)*. Extant pictorial sources of the early sixteenth century document many

Ill. 32: Armour garniture of Wilhelm von Rogendorf, exchange armlet for the field (left arm), temporarily assembled from the pieces now in Vienna (pauldron, right lower cannon from the field vambraces, gauntlet) and London (couter and right upper cannon); see note 115 (© KHM-Museumsverband)

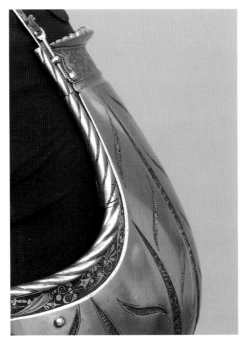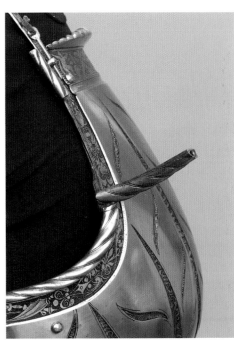

variations of arm defences for infantrymen, such as fully-enclosed vambraces; mail sleeves reinforced with shoulder and elbow plates, and perhaps also minimal split-plates for the upper and lower arms; and mail sleeves worn by themselves or combined with their textile counterparts *(ill. 16)*. Rogendorf's Landsknecht garniture is now missing its original helmet. It was almost certainly a burgonet similar to the one placed on the ground at the sitter's feet in the portrait of Konrad von Bemelberg *(ill. 6)*. It is possible that on certain occasions Rogendorf might have elected to wear instead a broad textile beret with feathers of the type often found in contemporary depictions of Landsknechts *(ills. 16 and 40)*.

But Rogendorf's garniture was also equipped for light or medium cavalry service, a sine-qua-non for a colonel commanding a Landsknecht unit. This aspect of the garniture is proven not only by the field leg armour, which would only have been worn on horseback, but also by the small lance-rest (designed to support the medium cavalry spear or 'demi-lance' against the impact of a charge) that the armourer cleverly incorporated into the roped border of the breastplate; the lance-rest can be lowered when required *(ills. 33a and b)*, or raised and locked away if not. When raised, this ingenious and apparently unique lance-rest system ensures that no bolt holes or staples (normally a practical necessity of lance-rests) mar the pristine surfaces of what now appears to be exclusively an infantry breastplate. We find a sideways-folding (i.e. foldaway) lance rest on the light half-armour that Desiderius Helmschmid produced for Emperor Charles V in 1543 *(ill. 34)*; like the lance rest on Rogendorf's harness, this lance is another refined detail typical for the Helmschmid workshop.[116] When armed to fight as a light cavalryman, Rogendorf probably would have worn the long tassets also employed for infantry service (but leaving off the codpiece and the hoguine). The lost burgonet would have also been worn open-faced, without its articulated face defence or 'falling buffe'. The medium cavalry configuration, however, required more extensive plate protection, which almost certainly involved a shorter cuirass skirt and short tassets worn with the extant leg armour *(ill. 35c)*, while the face was protected with the addition of the falling buffe, like the one shown in Bemelberg's portrait *(ill. 6)*.

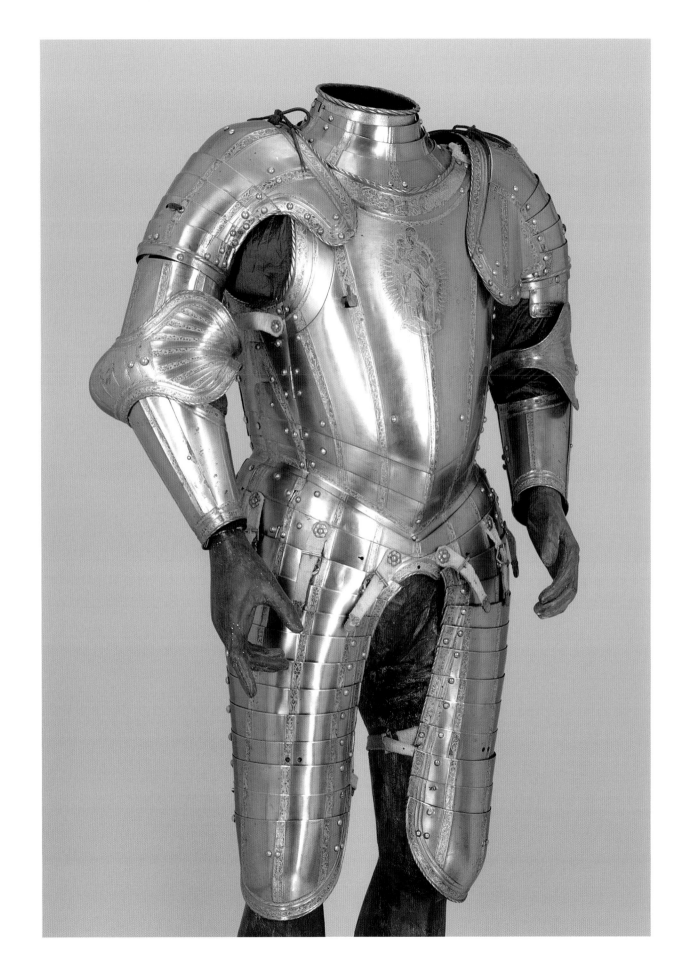

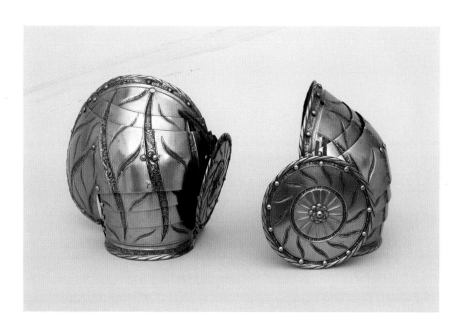

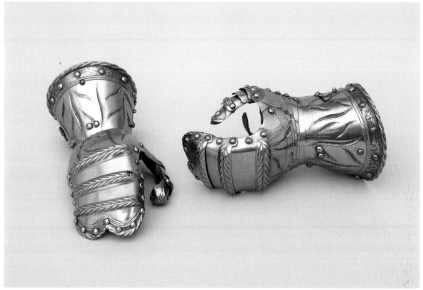

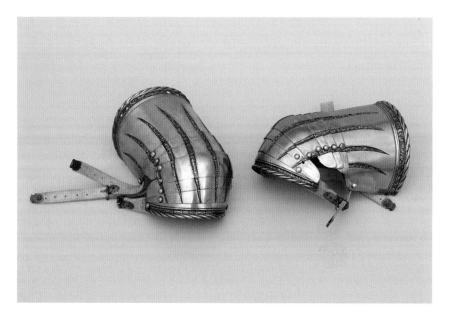

Ills. 35a–c: Exchange pieces for the armour garniture of Wilhelm von Rogendorf: a pair of pauldrons with besagews, gauntlets and poleyns each (© KHM-Museumsverband)

Ill. 36: Armour of Wilhelm von Rogendorf, remnants of the decorative leather strap for the hoguine (© KHM-Museumsverband)

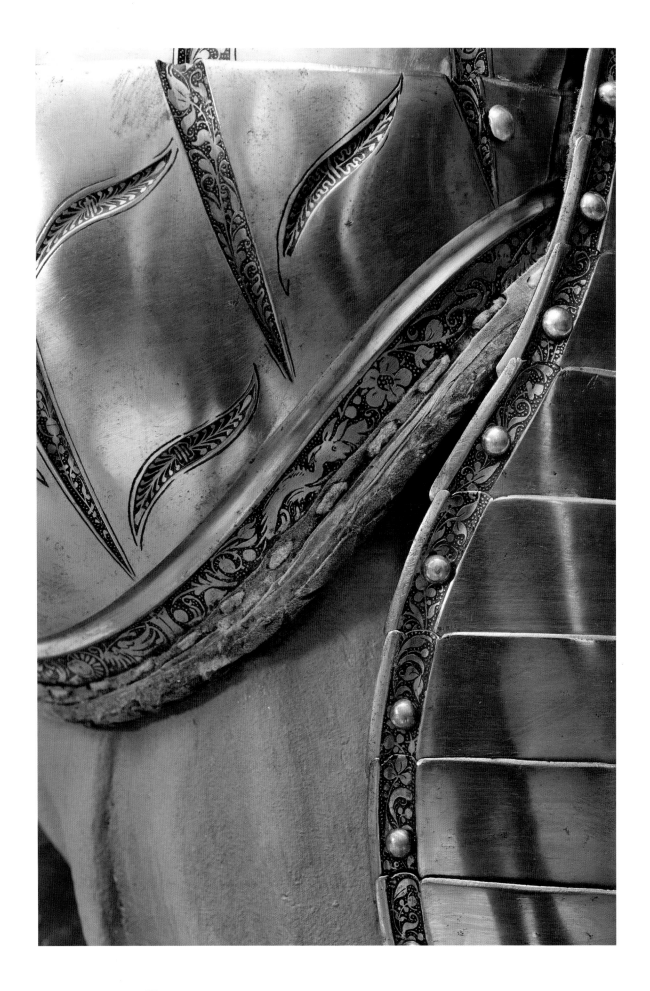

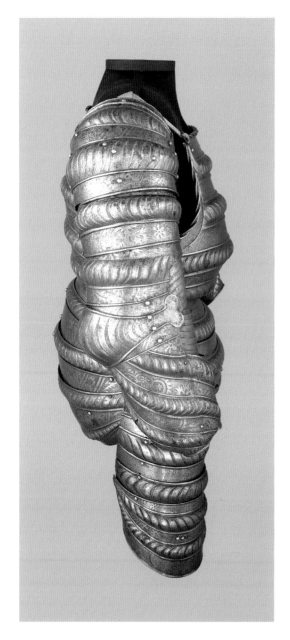
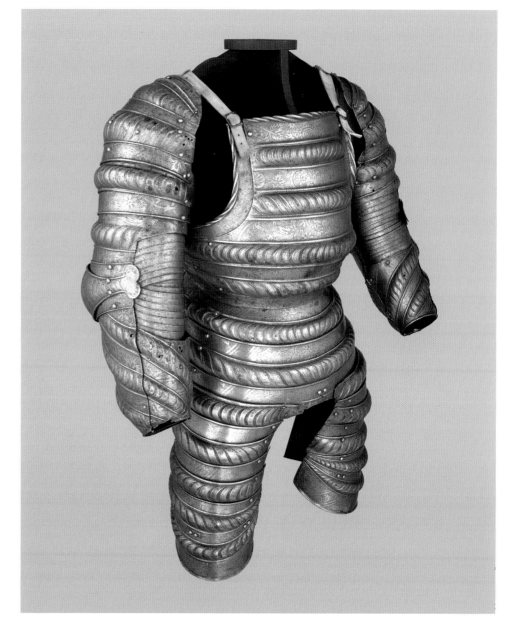

Ills. 37a and b: Infantry armour. Southern Germany, circa 1520/25. London, The Wallace Collection, inv. no. A 28 (© London, The Wallace Collection)

Ills. 38a and b: Hans Kels, portrait medallion of Kolman Helmschmid (obverse/reverse). Augsburg, 1532. Staatliche Münzsammlung München (© Staatliche Münzsammlung München)

It is impossible to know from the extant pieces for exchange if Rogendorf's garniture also included special pieces for heavy cavalry use. This most iconic form of knightly combat, distinguished by the frontal charge with the heavy cavalry lance, is vaguely suggested by the close-helmet *(ills. 63 and 70)* displayed with this harness since the sixteenth century; this helmet, however, does not belong to Rogendorf's garniture as it lacks the characteristic slashings.[117] In addition, the lightweight, concealed lance-rest incorporated into the extant breastplate is completely unsuitable for heavy lance combat; it is simply not strong enough. If Rogendorf's 1523 garniture were to provide a heavy cavalry option, it would have had to include a second breastplate with a stronger lance-rest, as well as a second helmet, heavy cavalry pauldrons, full cuisses and greaves, and sabatons, to say nothing of the required *en suite* horse armour, vamplates, saddle steels, etc. However, there is no evidence that such pieces for this garniture ever existed.

We also cannot determine with certainty the function of the hoguine in Rogendorf's garniture *(ill. IV)*. This unusual element is found on fully-enclosed armours for foot combat in the early sixteenth century.[118] However, we cannot identify any strap to connect Rogendorf's existing hoguine with a presumed full leg armour like the one we can assume to have once existed for the armour now in New York and Paris *(ill. 20b)*.[119] It ends instead in a decoratively-slashed leather hem *(ill. 36)*. A less elaborately puffed and slashed infantry armour made in southern Germany around 1520/25 and now in London *(ills. 37a und b)*[120] also features a hoguine without a strap for full leg defences. It seems probable therefore that this technically ingenious but practically unnecessary element was conceived in the same spirit as the sleeve-vambraces, and was intended to be worn with them as part of the Landsknecht parade-costume configuration of the garniture. It is an additional buttress of the cunning conceit of flamboyant textile clothes made of steel. Along with the impressive sleeves, even the seat of the Landsknecht's trousers, or hosen, has been replicated in metal.

Wilhelm von Rogendorf's Landsknecht armour is not signed and we do not have any contemporary written records that mention it. However, stylistic comparisons allow us to attribute it firmly to two outstanding master craftsmen from Augsburg – the armourer Kolman Helmschmid, and the etcher Daniel Hopfer.

Kolman Helmschmid (1471–1532) *(ills. 38a and b)* was a scion of one of the great German dynasties of armourers active during the later Middle Ages and the Renaissance. He was the son of Lorenz (c. 1445 – 1516) and the father of Desiderius Helmschmid (1513–1579). Their joint oeuvre spans almost a century and is generally regarded as one of the highpoints of the armourer's art in Europe.[121] Lorenz began making geometric late gothic armour around 1480 *(ill. 17)*, while the elegant works produced by his grandson Desiderius around 1540/50 perfectly embody late Renaissance taste *(ill. 34)*. From around 1510 until his death in 1532 Kolman designed armour modelled in fluid, rotund forms[122] – with Rogendorf's Landsknecht armour being the absolute epitome of the Renaissance ideal of the male form and masculine fashion.

The workshop of the Helmschmid dynasty comprised skilled craftsmen who served an international clientele. They received commissions from as far afield as Italy, Spain and Prussia.[123] But the most important of their many customers were members of the house of Habsburg: over five generations, from Emperor Frederick III (1415–1493) to King Philip II of Spain (1527–1598), the Habsburgs commissioned armour from the Helmschmids in Augsburg. In the 1480s Lorenz was court armourer to Emperor Maximilian I; Desiderius even signed one of his last extant works – a circular shield made for Emperor Charles V he produced in 1552 – with "CAYS. MAY. HARNASCHMACHER" (armourer to His Imperial Majesty).[124]

In the 1520s Kolman was the favourite armourer of Emperor Charles V. A long list of works produced for his imperial patron during these years bears witness to this fruitful relationship; most of these imperial armours are now preserved in the Real Armería in Madrid.[125] In 1524, the year after Kolman completed Rogendorf's harness, Charles even tried to persuade him to move to Spain to become his court armourer, an offer Kolman refused by pleading family obligations.[126] But we know for certain that he travelled to Spain in 1526 and in 1529 to personally deliver harnesses commissioned by the Emperor, but these visits were short and he soon returned to his native Augsburg. In 1529 the artist Christoph Weiditz added a comment to a miniature in his *Book of Clothes* of himself dressed as a sailor during his journey on board the ship that took him from Genoa to Barcelona: "thus Stoffel [a diminutive of Christoph] Weidlitz travelled across the sea with Kolman Holmschmidt [sic]" *(ill. 39)*.[127]

In addition to its exalted imperial patrons the Helmschmid workshop must have worked for other members of the Habsburg court too. In 1524 Kolman is said to have remarked about his overflowing order-book that he had commissions for armour from "princes, seigneurs et autres" (princes, lords and others) to keep him busy for the next two years.[128] Sadly we know next to nothing about these works. This general dearth of solid facts is also the reason why we do not have any information about who commissioned Rogendorf's garniture. We do not know if it was Rogendorf himself or – and this is an extremely tempting possibility – if it was a gift from the Emperor. But the close relationship between Charles V and his general on the one hand, and between the Habsburg ruler and his armourer on the other, suggests that the commission must have been at least approved by the Emperor.

Ill. 39: Christoph Weiditz' *Book of Clothes*, fol. 78 (1529), Christoph Weiditz in sailor's attire with the inscription: "Allso Ist der Stoffel weyditz mit dem Kolman Holmschmidt Iber Mär gevorn" (thus Stoffel [a diminutive of Christoph] Weidlitz travelled across the sea with Kolman Holmschmidt). Nuremberg, Germanisches Nationalmuseum, ms. 22474
(© Nuremberg, Germanisches Nationalmuseum)

Also Ist der Stoffell noch ditz
mit dem Koloman Kolm[?]
schmidt Ihendtin[?]
gewarn.

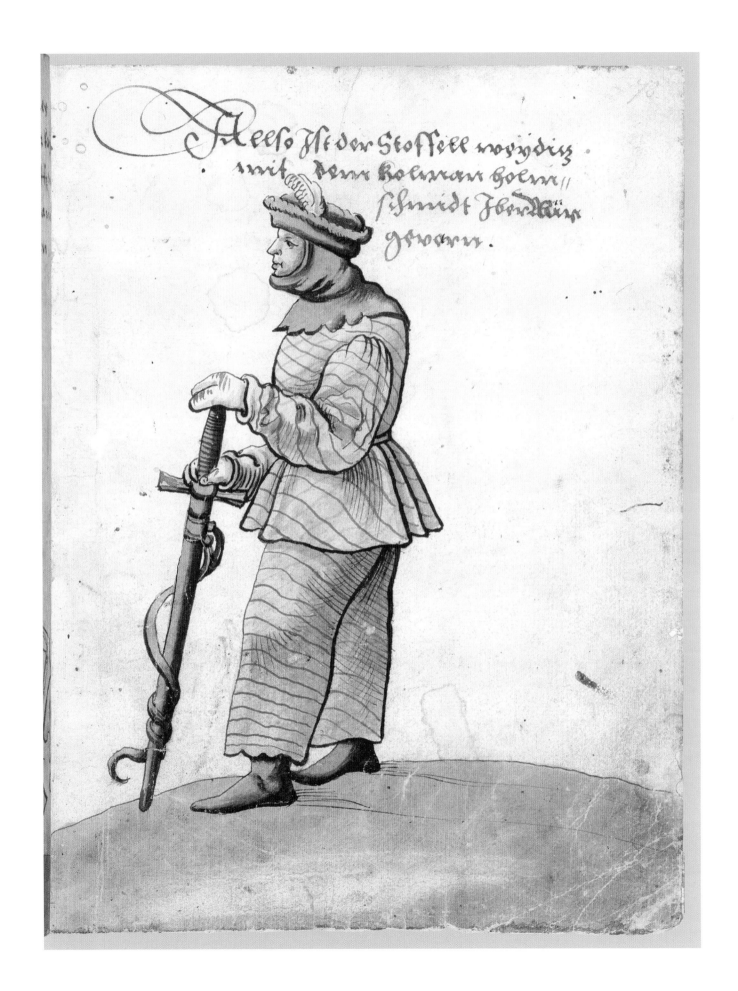

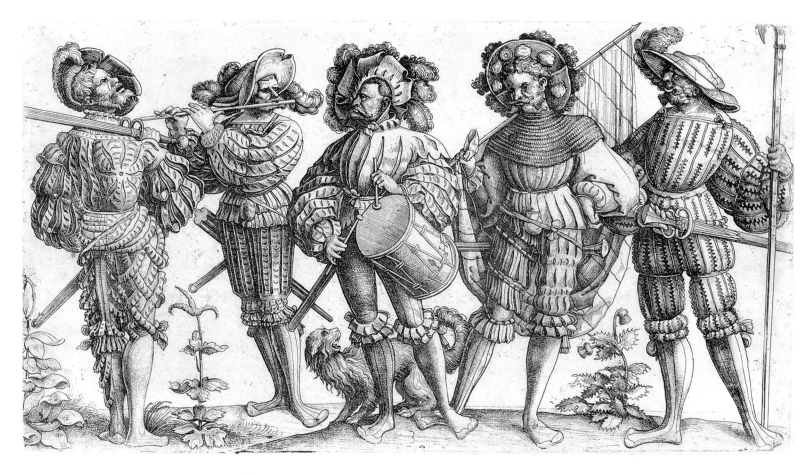

Ill. 40: Daniel Hopfer, Five Landsknechts. Etching, circa 1520/30. London, Victoria and Albert Museum, inv. no. E.6292A-1910 (© London, Victoria and Albert Museum)

The Imperial Diet held at Worms in 1521 would have offered an ideal opportunity for placing the order and for the armourer to take measurements: we know that Kolman Helmschmid came to Worms to deliver harnesses ordered by the Emperor, and that Wilhelm von Rogendorf was invested with a baronetcy while attending the Diet.[129] Kolman then returned to Augsburg. Wilhelm spent some months in the Low Countries before accompanying the Emperor to Spain in 1522, where he remained for several years. The date incorporated into the etched decoration *(ill. IX)* indicates that Rogendorf's garniture was completed in 1523, i.e. during Wilhelm's Spanish sojourn.

The etched decoration on Rogendorf's Landsknecht garniture is most probably by Daniel Hopfer (1471–1536), an artist from Augsburg. Born in Kaufbeuren, he moved to Augsburg in 1493 at the age of twenty-two;[130] Hopfer specialised in the acid-etching of iron and steel, a technique he used both to decorate armour and for printmaking. His workshop must have been extremely successful – over the years his tax records show a steady increase in taxable income; he was also repeatedly elected to public office in his adopted hometown. In 1524 Emperor Charles V bestowed on him the right to bear a coat of arms. In 1536 Hopfer died a wealthy and highly respected burgher in Augsburg.[131]

72

Ill. 41: Plate for the etching in ill. 40. London,
Victoria and Albert Museum, inv. no. E.6292-1910
(© London, Victoria and Albert Museum)

We may assume that Hopfer trained as an etcher at Augsburg, a leading centre of armour production, either in the workshop of an armourer or of an etcher of armour. Etching had been used by blade-smiths for centuries; around 1480 armourers also started to adopt this technique. In the middle of the 1490s Hopfer began to employ this technique in highly innovative ways. He is regarded as one of the pioneers of using etching in printmaking, which employs the same technique as etching on armour: in both cases the iron or steel plate (or piece of armour) is first covered in acid-resistant paint (the 'resist'); then an acidic, highly corrosive paste is used to cut into the unprotected areas to create a decorative pattern or image.[132] The earliest extant print produced using this technique, *The Battle of Guinegate/Thérouanne* (c. 1495; *ill. 2*), bears Hopfer's signature. His etched oeuvre is by far the largest by an early Renaissance artist specialising in this technique.[133]

We may also assume that initially these graphic artists obtained the plates used for their etchings from armourers. We can deduce this from the characteristic chemical composition of the steel plate used for Hans Burgkmair the Elder's etching *Venus and Mercury* (c. 1520), and the way it has been worked.[134] We may assume the same for Daniel Hopfer's plates *(ills. 40 and 41)*[135] although they have not yet been the subject of a metallurgical analysis.

Ill. 42: Daniel Hopfer, Interior of the Dominican Church of Saint Catherine at Augsburg. Etching, early 1520s. London, The British Museum, inv. no. 1845,0809.1311 (© London, Trustees of the British Museum)

Ill. 42a: detail of ill. 42: Decoration of the vault

Fortunately both a large number of prints and a relatively large number of pieces of armour decorated by Daniel Hopfer have survived. Two of the latter are signed: a jousting shield made for Emperor Charles V in 1536,[136] and a hunting sword produced around the same time.[137] These late works serve as starting points for stylistic comparisons that allow us to identify and trace Hopfer's armour decorations until at least as far back as 1505/10. His late works are marked by an elegant, nimble style while his early work features powerful and energetic scenes still partially informed by a late mediaeval idiom.[138]

Rogendorf's armour, dated 1523, is neither an early nor a late work. The style of the etched decoration is closely related to Hopfer's contemporary prints, such as, for example, his etching showing the interior of the Dominican church of Saint Catherine at Augsburg *(ill. 42)*; the handling is similar and the decoration of the vault *(ill. 42a)* comprises motifs identical to those used in the etched decoration of Rogendorf's armour.

The few extant contemporary sources suggest a loose collaboration between Renaissance armourers and etchers, as befitted independent autonomous artists. Jörg Sorg the Younger (c. 1525 – 1603) from Augsburg is one of the few documented master craftsmen who specialized in decorating armour. His armour pattern-book now at Stuttgart features works he executed between c. 1549 and 1563 for no less than nine different Augsburg armourers.[139]

Different but equally remarkable is the career of Paul Dax (1503–1561), an artist from Innsbruck *(ill. 43)*. Between c. 1530 and his death in 1561 he produced among other things paintings, glass paintings and maps as well as designs for fortifications and pageants for the Habsburg court.[140] Extant documents show that in 1540 the imperial

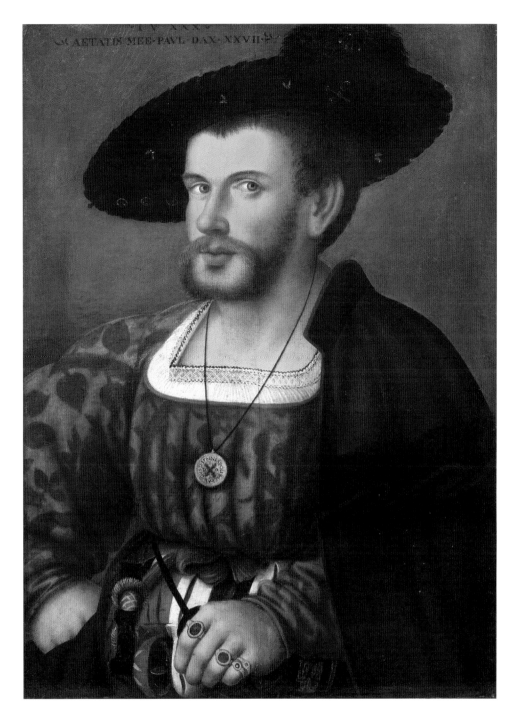

Ill. 43a: detail of ill. 43: Medal (inscription: "NEAPOLIS·LEZ·AWGVSTI·1528")

Ill. 43: Paul Dax, Self-portrait. 1530. Innsbruck, Tiroler Landesmuseum Ferdinandeum, inv. no. Gem 93 (© Innsbruck, Tiroler Landesmuseum Ferdinandeum)

armoury commissioned him to decorate an armour, and that the court armourer Jörg Seusenhofer complained that Dax's etching had "cut a little too deep", making gilding difficult.[141] This suggests that Dax was fairly inexperienced as an armour decorator. Interestingly, Paul Dax had been a Landsknecht before he became an artist. In 1528 he participated in the Siege of Naples, a fact he proudly emphasises by including a medal in his 1530 self-portrait *(ill. 43a)*. In 1529 he was among the defenders of Vienna during the Ottoman siege of the city,[142] where he must have served under Wilhelm von Rogendorf, who, together with Count Niklas II von Salm-Neuburg, had commanded the defenders *(ills. 52 and 52a)*.

Ill. 44: Kolman Helmschmid, exchange pauldron for an amour, detail. Augsburg, circa 1525. New York, The Metropolitan Museum of Art, inv. no. 14.25.828 (© New York, The Metropolitan Museum of Art)

Daniel Hopfer, however, seems to have spent his entire career as a decorator of armour working primarily – or perhaps even almost exclusively – in the Helmschmid workshop; we can identify his idiom from c. 1505/10 until 1536 mainly on armour produced by Lorenz, Kolman or Desiderius Helmschmid. On an armour designed by Kolman Helmschmid around 1525 and decorated with chased and etched tritons *(ill. 44)*[143] Hopfer was presumably responsible not just for the etched decoration – i.e. the outermost decorative layer – but also for the templates on which these chased scenes were based. The three-dimensional tritons on this harness cannot hide their kinship with the characteristic, faintly humorous mythical creatures found in many of Hopfer's prints.[144]

For Rogendorf's garniture, too, we may assume a close collaboration between armourer and etcher. Here the etched ornament is more than merely a decorative skin. Imitating a textile interlining, the etched decoration peeks out from the chased "slashes", creating the illusion of being beneath – rather than incised into – the steel surface. Such a perfect illusion of a puffed and slashed garment embellished with a lavishly-decorated inner layer of rich material presupposes the close collaboration of armourer and etcher.

Ill. 45: Hans Kels the Elder, Game board for the "Lange Puff", detail. Kaufbeuren, dated 1537. Vienna, Kunsthistorisches Museum, Kunstkammer, inv. no. KK 3419 (© KHM-Museumsverband)

The members of the Helmschmid family were friends with (and sometimes even related to) many artists besides Daniel Hopfer; for example, the maiden name of Kolman's first wife Agnes (who died before 1508) was Breu, one of the leading Augsburg dynasties of painters; in 1500/05 Kolman commissioned a portrait of himself and Agnes that is now in Madrid.[145] The aforementioned armour-etcher Jörg Sorg the Younger (c. 1525 – 1603) was a grandson of Kolman Helmschmid; his mother Catherine was the elder sister of Desiderius Helmschmid.[146] The Helmschmids also cultivated contacts with the Burgkmair family of painters and printmakers,[147] and the master-woodcarvers Hans Kels the Elder and Hans Kels the Younger.

In his magnificent 1537 game-board for the "Lange Puff" (a form of backgammon; the game-board is now in Vienna), Hans Kels the Elder included a medallion that references his friendship with Helmschmid in a remarkable and ultimately mysterious way *(ill. 45)*:[148] a scene depicting Venus and Mars sharing a bed; on a wall hang weapons and pieces of armour, among them an infantry harness. In front of the bed is carved a strutting rooster and a mace, which must be read as the arms of the Helmschmid family. We find an identical rooster in Kolman Helmschmid's portrait medal that Hans Kels produced in 1532 *(ill. 38b)*.

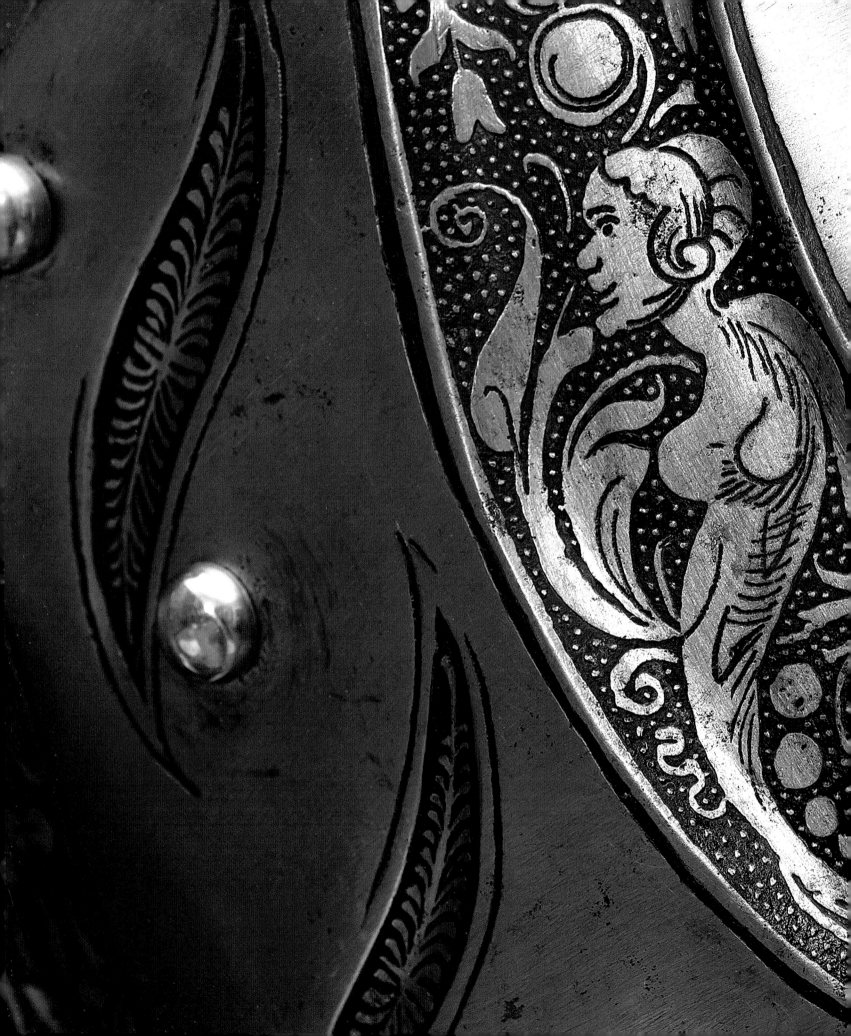

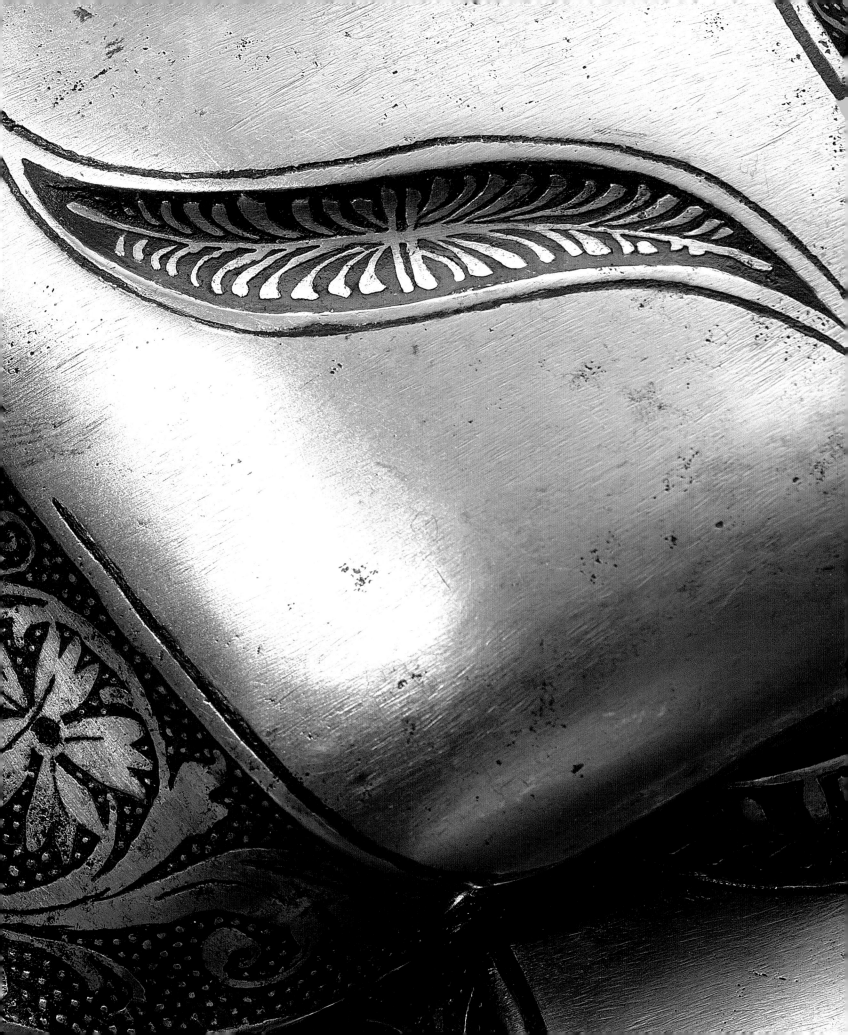

Andreas Zajic

The Rogendorf Family

It may sound surprising at first that an artwork as spectacular as the 1523 Landsknecht garniture was made for a member of a family that is but little-known even to historians. At the turn of the sixteenth century, however, the Rogendorfs were very much at the centre of things, both artistically and politically. Their family history combines a rapid rise and a steep fall. The main protagonists are Wilhelm's father Kaspar, Wilhelm himself, and his brothers Wolfgang and Georg together with Wilhelm's son Christoph.[149]

In 1480 Kaspar von Rogendorf was invested with an Austrian baronetcy. At the time the oldest known record of one of his ancestors dated back less than a century. In the middle of the fifteenth century Kaspar's father Sigmund had served as leading financial officer (*Landschreiber*) and administrator of the governance of Styria (*Hauptmannschaft*). But there are no extant records that throw light on the family's origins – in the sixteenth century many of the families successfully moving up the social ladder did not want to, or could not, recall their precedents.

Even as a young man Kaspar von Rogendorf was adept at using his father's contacts to advance his own career. In addition, his brother Balthasar (who died young in 1483) had been brought up with Archduke Maximilian at the Habsburg court in Wiener Neustadt. This greatly facilitated Kaspar's endeavours to position himself for a successful career in the service of the Habsburgs. Emperor Frederick III initially employed him as the captain of a unit of mercenaries – in a way anticipating the subsequent career of his son, Wilhelm. In the 1470s Kaspar moved his main place of residence from Styria to Lower Austria. He lent the Emperor a substantial sum of money, receiving profitable manors and offices in return, among them the burgraviate or captaincy (*Burggrafschaft*) of Steyr. This income enabled him to acquire additional lands and new privileges. Kaspar's influence grew apace.

Kaspar now held lands in Carinthia and Styria as well as in Lower Austria. Initially he operated a foundry near the Erzberg in Styria. Like many other entrepreneurs of the early modern era, he presumably saw this estate as a venture to maximise his profits. Kaspar also consolidated his possessions in the Weinviertel (the area north-east of Vienna) and the southern Waldviertel (west of Vienna) around Pöggstall Castle. Acquired in 1478, Pöggstall evolved into the centre of his holdings, and continued to serve as the family's main residence until 1601.

Ill. 46: Kaspar von Rogendorf with his five Sons, detail of an epitaph. Southern Germany, 1493. Rosenburg/Lower Austria, chapel (© Krems, Institut für Realienkunde des Mittelalters und der frühen Neuzeit, photograph: Peter Böttcher)

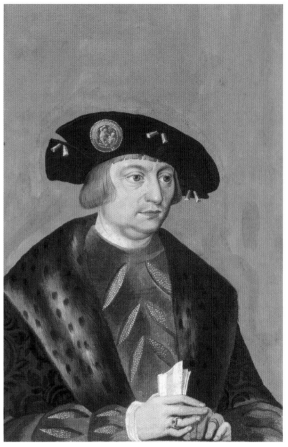
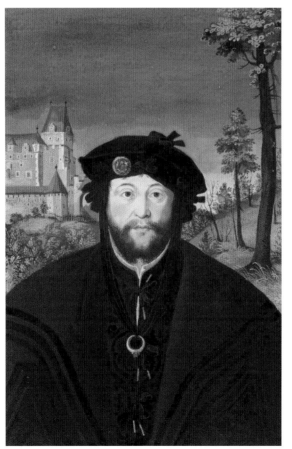

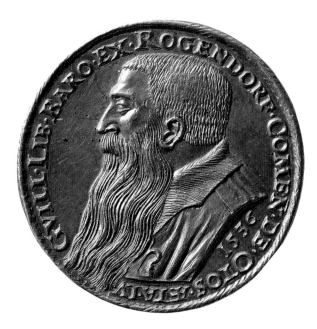
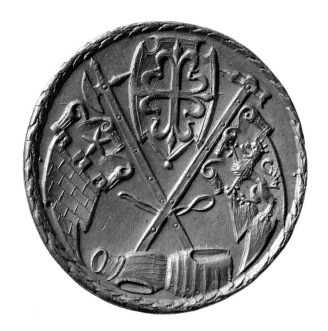

Kaspar's career at the Habsburg court followed the customary trajectory: by 1475 he was a steward, ascending the first rung on the ladder of court offices. By 1478 he was already a chamberlain, and in 1493 the Emperor made him his master of the kitchen (*Küchenmeister*), a prestigious office that brought Kaspar into direct contact with the monarch. Frederick III died only a month later on August 19, 1493 but shortly afterwards his son and heir Maximilian made Kaspar a member of the *Regiment*, a governing board residing in Vienna. He had quickly risen to one of the key positions at court and in local government. He subsequently joined Maximilian's chamber of finance (*Rechenkammer*), an office surely much to the liking of this clever courtier with a head for figures. Between 1501 and his death in 1506 Kaspar served as councillor to the Lower Austrian *Regiment*, the most important central authority in the Habsburgs' hereditary lands in the eastern part of their domains, which was responsible for all the Habsburg territories between Vienna and Linz as far south as modern Slovenia.

Four of Kaspar's five sons reached adulthood: Sigmund, Wilhelm, Wolfgang and Georg *(ill. 46)*. The early death of Sigmund, who passed away in 1507, allowed Wilhelm to have two simultaneous careers: on the one hand, he continued his service at the Habsburg court, begun in 1494 in Burgundy, which would eventually take him to many of their European territories. On the other hand, he inherited the family lands centred on the ancestral seat at Pöggstall. In order to combine the two Wilhelm shared responsibilities with his brothers.

His youngest brother, Georg *(ills. 49, 58, 60 and 61)*, coordinated the seigniorial agendas at home. We only have a later copy of a portrait of Georg; it was painted in 1518 and includes a view of Mollenburg Castle, one of the family's baronies. Wolfgang *(ill. 48)* held important offices at court and in the country, serving, for example, as the Constable (*Landmarschall*) of Lower Austria. Wilhelm *(ills. 47, 51a and b)* enjoyed the most

Ill. 52: View of Vienna during the First Siege of
Vienna 1529 (so-called "Meldemann-Plan").
Coloured woodcut, printed in Nuremberg 1530.
Wien Museum, inv. no. 48.068 (© Wien Museum)

glittering political and military career of the four brothers, and he was also a skilled diplomat on his own account. He served a total of five Habsburg rulers, from Frederick III to Ferdinand I. His career oscillated between battlefield and court, taking him all over Europe but only rarely back home to Pöggstall. Considering his exhausting peripatetic life we should not be surprised that contemporary sources report that he appeared prematurely aged by the 1530s.[150] At the same time, however, people who knew him praised his courtly-aristocratic demeanour, emphasising both how well he was generally liked and his unwavering Catholic faith.[151]

Wilhelm spent his youth as a page at the courts of Frederick III and Maximilian I, and at the court of Philip I at Ghent. In 1504 Philip made him his councillor and chamberlain, and in 1506 Rogendorf accompanied the Archduke to Spain. Shortly after Philip's untimely death, Wilhelm began his diplomatic career under Maximilian, which took him, for example, to England and the court of King Henry VII in late 1506. Not long afterwards Wilhelm also began his second career – in the army. In 1508 and again in 1513 he commanded the imperial infantry against the Venetians; in May 1513 he was severely wounded in his right thigh.

Historically, however, the most important project in which Wilhelm was involved was the First Congress of Vienna in 1515; he was a member of the imperial party attending the preparatory negotiations for this double wedding, which were held at Bratislava. In 1520 he represented Archduke Ferdinand (who was still in Brussels) at the latter's marriage *per procurationem* to Princess Anne of Hungary. Contemporary sources note that Wilhelm appeared wearing a complete harness ("in ainem ganzen khyraß"). Only a few years later, in 1526, the Habsburg-Jagellion mutual succession treaty signed in 1515 was activated, greatly increasing the Habsburg's sway over Central Europe and making them the region's dominant power for centuries to come.

By 1517 at the latest Wilhelm had entered the service of Charles V, who entrusted him with the strategically important governorship of Friesland. In 1521 Charles elevated the manor of Pöggstall to a free imperial barony. Another exceptional sign of imperial favour is the fact that the Emperor changed the castle's name from Pöggstall to Rogendorf. After several years of military service in Spain *(ills. 51a and b)*[152] Wilhelm finally returned home in 1529, serving as commander of the imperial army in Hungary, defending the Empire's borders against the advancing Ottomans. In the same year Wilhelm, together with his brother-in-law Count Niklas II von Salm-Neuburg, was in charge of the defence of Vienna during the first Ottoman siege of the city *(ills. 52 and 52a)*.[153] Serving as Lord Chamberlain *(Obersthofmeister)* to Ferdinand I, Rogendorf spent the next few years playing a key role in ensuring unimpeded communications between the Habsburg siblings and was thus closely involved in the political decision-making process.

Ill. 52a: detail of ill. 52 (left of Saint Stephen's Cathedral, turned by 90°): Wilhelm von Rogendorf on his charger, with the inscription: "her wilhelm freiher zu rosendorff [sic]"

In 1539, at the age of fifty-eight, Wilhelm retired from court. But he was not to enjoy a peaceful old age. Contrary to his express wishes, Ferdinand I recalled him to court in 1541 and made him once more commander of the imperial troops in Hungary, charged in August of that year with holding the city of Buda *(ills. 53 and 53a)*. But the campaign failed, primarily because of Wilhelm's procrastinations and the disastrous deployment of his son Christoph.[154] Soon afterwards, Buda fell to the Ottomans. The Kingdom of Hungary remained occupied and divided into three parts for a century and a half.

Ill. 53: Erhard Schön, The Siege of Buda 1541.
Coloured woodcut. Vienna, Albertina,
inv. no. DG1950_401 (© Vienna, Albertina)

Ill. 53a: detail of ill. 53: Tent of Wilhelm von
Rogendorf with the family's arms and the
inscription: "der von Rogen=/dorff Hauptman"

While reclining in an armchair during the siege, Wilhelm was severely wounded by a stray cannonball, dying from his injuries shortly afterwards at Šamorín (Sommerein) on the Danube, east of Bratislava, during the retreat of the imperial army from this military fiasco.

Wilhelm's brilliant career marked the highpoint of the family's fortunes. With his son Christoph events took a serious turn for the worse. Christoph was born in 1510; he was Wilhelm's only son from his marriage to Countess Elisabeth von Öttingen *(ill. 50)*[155] and was raised by his grandmother Isabelle de la Hamaide at Ghent and Condé. The powerful position of his famous father was clearly an asset when he set out on his own, initially successful career in the army. During the 1532 Siege of Kőszeg (in western Hungary) Christoph allegedly commanded 400 heavy cavalrymen. In 1535, possibly already a colonel in the Imperial Bodyguards, he fought in the naval Battle of Tunis.[156] In 1537 the Emperor invested Christoph with the title Count of Guntersdorf – with an explicit reference to the achievements and merits of his father Wilhelm.

But Christoph was cut from a very different cloth. Contemporaries describe him as arrogant and decadent. At the Siege of Buda his hubris seriously undermined his father's authority and standing in the eyes of the assembled Hungarian nobles – with the above-mentioned catastrophic results for the campaign and for Wilhelm himself. In the middle of the 1540s Christoph's marriage to Elisabeth von Mansfeld-Vorderort began to unravel, and this seems to have resulted in the rupture of his relationship with his imperial patrons, Emperor Charles and King Ferdinand. Christoph separated from his wife and began to pile up huge debts to pay for his extravagant lifestyle.

Among the nobility of Lower Austria the count's passion for grandeur and luxury was legendary, as a number of anecdotes recorded by Reichard Streun von Schwarzenau, an aristocratic lawyer, genealogist and politician, document:[157] the count, for example,

Ills. 54a and b: Medal minted under the name of Christoph von Rogendorf as Marquis des Îles d'Or (obverse/reverse). Silver. Paris, circa 1547/52. Private collection (© iNumis.com)

commissioned for himself a mobile bathtub, built on a sleigh, so that he could ride through the snow-covered valley from Pöggstall to Ottenschlag in his bath attended by his barber. For a spring ball held at the family's palace in Vienna in 1546 he is said to have planted cherry trees bearing ripe fruits on the palace's roof terrace to surprise and delight his guests. And the hem of his velvet-lined state robe was at all times carried by two pages walking beside him – even when passing through a narrow doorway. In the summer of 1546, however, Christoph caused a major scandal by absconding to Constantinople with a large sum of money. There he tried to offer his services as an informant or spy to the Sultan. Christoph had become a traitor – and one deep in debt to boot. However, he soon lost the Sultan's favour too. His money problems returned and as the intelligence he was hawking proved less useful than expected he decided to flee again, this time to France.

In the summer of 1548 at the latest he arrived at the French court; in 1549 he acquired the title of Marquis des Îles d'Or *(ills. 54a and b).*[158] In 1562 he liaised between the French court and the Protestant princes of the Empire. But it seems that Christoph managed to make enemies in France too, as he fled for some time to England where he asked for political asylum. Thanks to his prodigality he ended his profligate life in poverty. In 1585 he was said to inhabit a small house in Normandy, where he died in 1588.

What were the consequences of Christoph's treason in Austria? Naturally he forfeited all his privileges and titles. In 1547 the aulic chamber (*Hofkammer*) seized his indebted estates and opened bankruptcy proceedings against him. It took Christoph's heirs years to recover most of their hereditary estates. But they never managed to reconnect with the family's former glory during Wilhelm's lifetime. In the seventeenth century the Rogendorfs settled in Moravia. All records end in the nineteenth century.

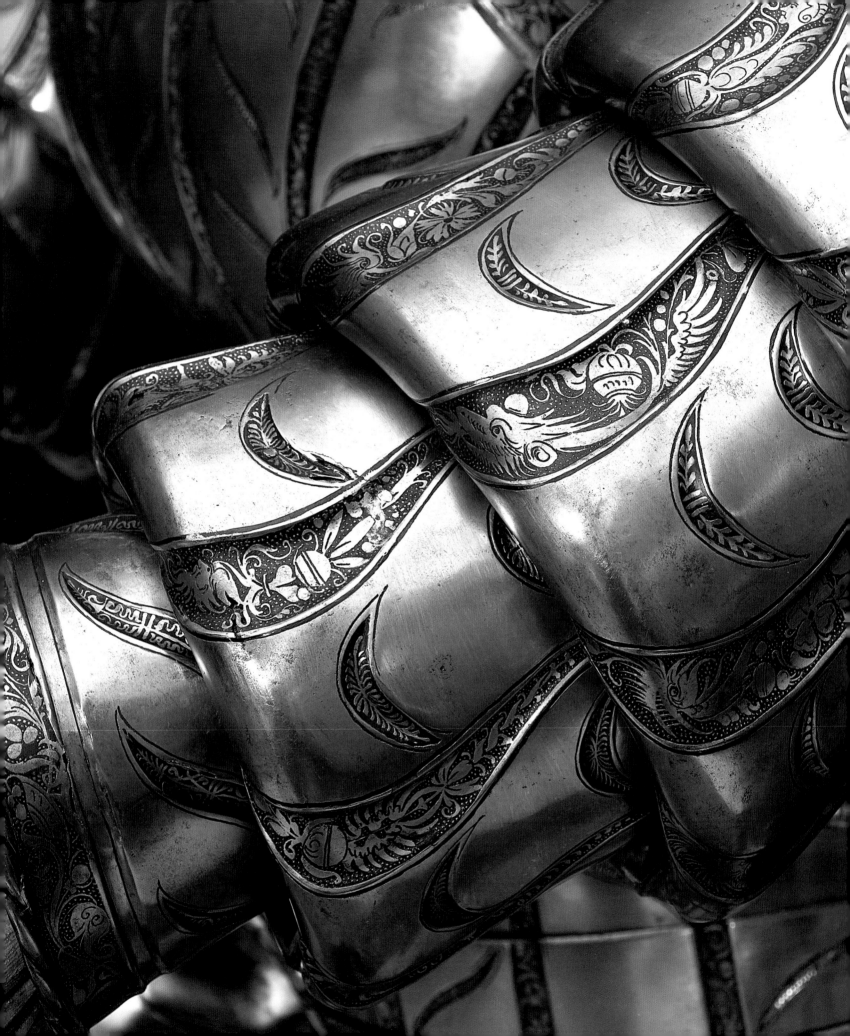

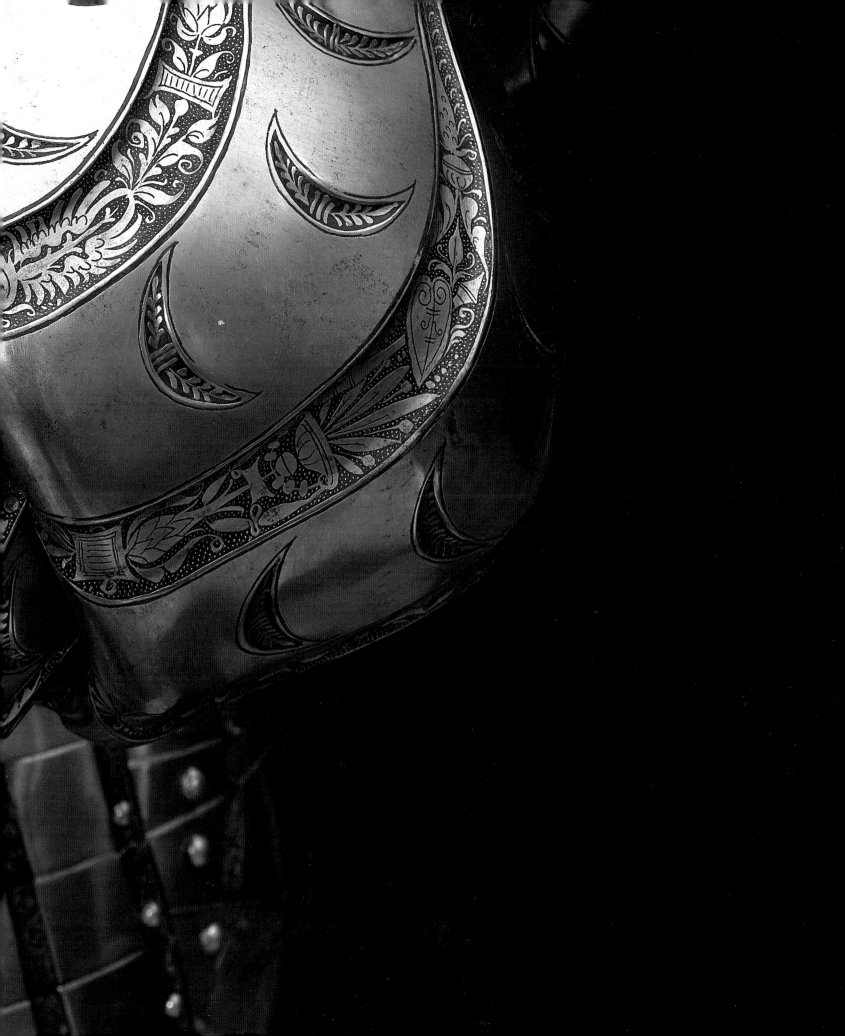

Andreas Zajic

The Rogendorfs as Patrons of the Arts

Today few people have heard of the Rogendorfs but at the turn of the sixteenth century they were among Austria's leading families – and some of the most ambitious patrons of the arts. They spent lavishly on enlarging and embellishing their castle at Pöggstall, commissioned portraits from well-known and highly-regarded artists, collected first-class artworks and were interested in artefacts from distant civilizations. Judging by its inventory, their collection may almost be described as avant-garde.

We have records detailing extensive building works at Pöggstall between the 1480s and the 1540s. Kaspar von Rogendorf's interest in architecture may have been informed by a childhood spent in Styria where Emperor Frederick III had put his father Sigmund in charge of building work at Graz Castle. With its choir with straight termination the excessively large chapel at Pöggstall has (presumably intentionally) much in common with the Saint George's Chapel at Frederick's residence at Wiener Neustadt. Of the church's rich contents only some gravestones with epitaphs and some altars *(ill. 46)* have survived.

During this period Pöggstall Castle was also repeatedly enlarged and altered. Wilhelm added a splendid frescoed Great Hall in the south wing *(ill. 55)*. The artists working at Pöggstall in the 1540s would go on to build and decorate Stallburg Palace in Vienna for Archduke (later Emperor) Maximilian II; they included the court architect Bernhardin Comata/de Camatha and the court painter and builder Pietro Ferrabosco. The most remarkable feature at Pöggstall is the Kanonenrondell (canon round tower) erected in front of the castle's façade. This almost circular edifice is less a part of the fortifications than an innovative piece of architecture that projects authority and power. From the beginning it housed stables and a granary. The round tower recalls designs in Albrecht Dürer's treatise on fortifications published in 1527. It is, however, remarkable that the round tower at Pöggstall was essentially completed that very year, which might be explained by the fact that two of the Rogendorf brothers were personally acquainted with Dürer.

During the autumn of 1520 and the first few months of 1521 Wilhelm and Wolfgang von Rogendorf became acquainted with Dürer at Antwerp. The two brothers together, or Wolfgang alone, repeatedly invited the famous artist to dine with them. Dürer recorded these encounters in the diary he kept during his journey to the Low Countries,[159] which is why we know he also produced a now-lost silverpoint drawing of Wolfgang,

Ill. 55: Pöggstall Castle/Lower Austria, fragments of the fresco in the Great Hall in the south wing. Circa 1520/30 (© Andreas Zajic)

Ill. 56: Albrecht Dürer, The Rogendorf coat of arms. Coloured woodcut, 1520. Nuremberg, Germanisches Nationalmuseum, inv. no. H 349 (© Nuremberg, Germanisches Nationalmuseum)

and that the latter bought two "Passions", one engraved and one comprising woodcuts, from the artist. Dürer also sketched a woodcut showing the Rogendorf arms. It is the largest of all his woodcuts of an escutcheon *(ill. 56)*.[160]

No one has previously noticed that one of the greatest manuscripts produced in the Netherlands shortly after 1500 once belonged to the Rogendorfs. The so-called *Croy Book of Prayers* now in Vienna *(ill. 57)* is inscribed with the words "1543 / forte fortune force / rogendorff",[161] which clearly connects it with Wilhelm's son Christoph who had this very motto inscribed beneath a sundial on the south façade of Pöggstall Castle in 1542 or 1545. Christoph may have acquired the codex in Flanders in 1543; or its anonymous first owner may have been his father Wilhelm – which would turn the *Croy Book of Prayers* into the *Rogendorf Book of Prayers*. This suggestion is supported by the family tree-like entries in the codex. It contains autograph inscriptions by Archduke (later Emperor) Charles V as well as by Antoine de Lalaing and Philippe de Croy, after whom the codex is now named. Wilhelm was not only close to the Emperor but also friends with the other two.

We know of a number of excellent portraits of Wilhelm and his brothers, at least through extant copies in the book of portraits by Hieronymus Beck von Leopoldsdorf from the third quarter of the sixteenth century: a portrait of Georg von Rogendorf produced in 1518 *(ill. 49)* must have been painted by a talented artist from the so-called Danube School, now tentatively identified as Wolf Huber. The likeness of Wolfgang von Rogendorf executed before 1520 *(ill. 48)* is presumably by a Netherlandish master, probably from Brussels. And an early portrait of Wilhelm von Rogendorf dated 1508 *(ill. 47)* is also attributed to a Netherlandish painter, possibly the Master of the Legend of the Magdalen.[162]

An excellent portrait of Georg von Rogendorf (though he has not previously been identified as the sitter) has survived in the Hermitage in Saint Petersburg *(ill. 58)*. Thanks to his full beard and impressive bearing the sitter was long identified as Otto Henry, Elector Palatine. However, the painting is no longer attributed to the Nuremberg artist Georg Pencz.[163] The inscription on the frame visible on a slightly later copy of this portrait now at Eferding *(ill. 60)*[164] clearly identifies the sitter as Wilhelm's brother Georg. A copy at Eferding of its companion piece, a portrait of Wolfgang *(ill. 59)*, suggests that this likeness must have been one of a pair of portraits.[165] We may assume that a now-lost portrait of Wilhelm completed this sibling "triptych". We also know of a now-lost monumental portrait bust of Georg produced in 1536 *(ill. 61)*[166] but we do not know where it was originally intended to be displayed. Was it part of a funerary monument or did it function as an autonomous artwork?

Even stranger artefacts were housed at Pöggstall Castle in the 1540s: some were "very old and with strange names [...] so that no one knew what to call them which is also why they were not described".[167] The Rogendorfs owned exotic and rare objects, works given pride of place in contemporary Kunst- and Wunderkammer collections, among them "ain turckischer Huet" (a Turkish hat), perhaps a trophy from the First Siege of Vienna in 1529, "ain spanisch rundell" (a Spanish round shield; possibly an *adarga*) that Wilhelm may have brought back from Spain, "ein muster von ainer alten galeen" (a model of an old galley), presumably a souvenir from the Battle of Tunis, the 1535 naval encounter in which Christoph had fought. Most intriguingly of all, the inventory of Pöggstall Castle compiled in 1547/48 (i.e. following Christoph's flight) lists "indianischen vederzeug uund russtung" (Indian feather attire and armour).[168]

Ill. 57: So-called *Croy Book of Prayers*, fol. 9v/10r.
Ghent/Bruges, probably 1510s. Vienna,
Österreichische Nationalbibliothek, codex 1858
(© Vienna, Österreichische Nationalbibliothek)

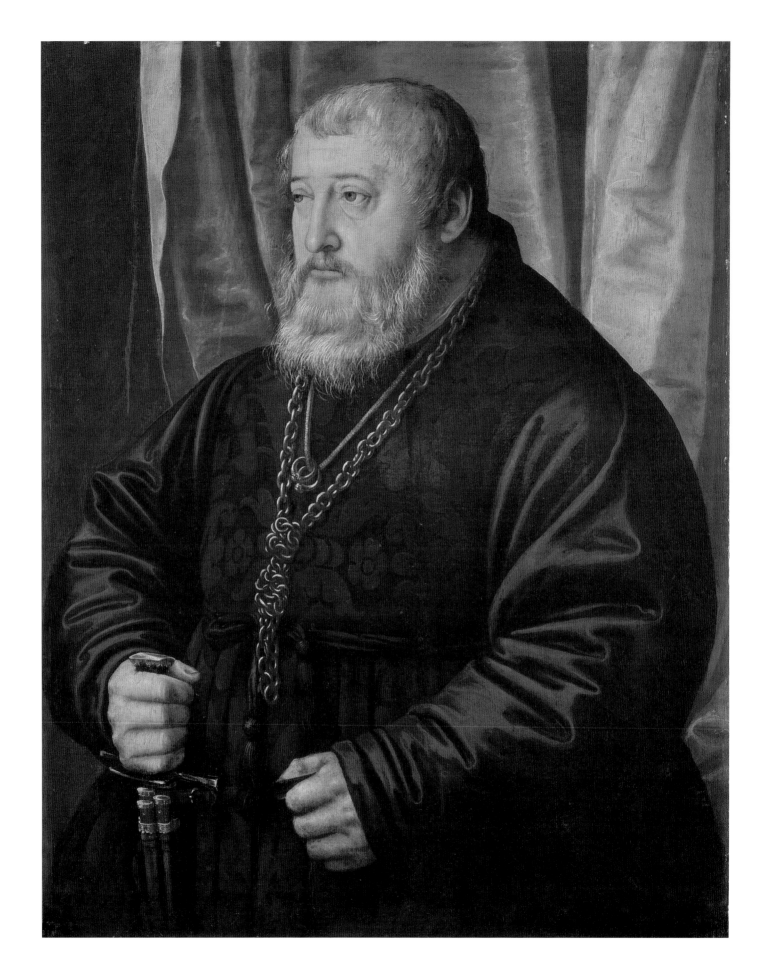

Ill. 59: Copy of a portrait of Wolfgang von
Rogendorf. second half of the sixteenth century.
Inscription on the frame:
"SOL SEIN SCHICKT SICH WOLFF FREIHER
ZCV ROGEN/DORFF VND MOLLENBVRG ·
ERBHOFMEISTER YN OHSTER/REICH ·
R(ÖMISCHER) K(AISERLICHER) M(AIESTÄ)T ·
RATH VN(D) KAMERER · SEINS / ALTERS YM
LVII · ANNO DOMINI · M · 5 · VND VIERZCIG"
Eferding, private collection
(© KHM-Museumsverband)

Ill. 60: Copy of a portrait of Georg von Rogendorf
(see ill. 58). second half of the sixteenth century.
Inscription on the frame:
"GOT ALLEIN DIE EHRE · GEORG FREIHER /
ZCV ROGENDORFF VND MOLLENBVRG
SEINS AL/TERS IM NEVNVNDVIERZIGSTEN
IAR / IM IAR NACH CHRISTI VNSERS HERRN
GEBVRT 1541"
Eferding, private collection
(© KHM-Museumsverband)

Ill. 58: Portrait of Georg von Rogendorf. 1541 (?).
Saint Petersburg, The State Hermitage Museum,
inv. no. GE-4766 (© The State Hermitage Museum,
photograph: Vladimir Terebenin)

Ill. 61: Bust of Georg von Rogendorf. Stone, dated 1536. Damaged inscription on the tablet bottom left (see note 166):
"[GEORG FREIHERR VON / RO]GEN[DORFF VND AVF] / MOLLEN[BVR]G · SEI[NS] / ALTERS · IM · 49 · IAR · 153[6]"
Formerly Brno, zemská galerie (image taken from: Ivo Hlobil – Eduard Petrů, *Humanism and the Early Renaissance in Moravia*, Prague 1999, ill. 73)

"Zeug" (attire) and "russtung" (armour) probably refer to objects identified as pieces of armour, "veder" (feather) and "Indianisch" (Indian) clearly refer to (Central) American feather artefacts. We would like to suggest the possibility that (like Wilhelm's Landsknecht armour) these objects ended up in the collection long housed at Ambras Castle near Innsbruck. May we assume that Rogendorf's "vederzeug" has survived – as the celebrated Mexican feather headdress now in Vienna *(ill. 62)*?[169] Tracing the provenance of this artefact back to Pöggstall – rather than the collection of the Counts of Montfort[170] – seems at least plausible.

As well as the extant feather headdress, the Ambras inventory compiled in 1596 lists a "mörischer rockh" (Moorish garment), lost after 1788, with sleeves set with "gulden schiepen" (gold scales).[171] This may conform to the (admittedly somewhat general) description of an artefact at Pöggstall as a "russtung" (armour).[172] In the 1540s the Rogendorfs' "vederzeug" (feather attire) is identified as "Indian". Around 1577 the feather artefacts in the collection of the Counts of Montfort are more vaguely described as "mörisch" (Moorish),[173] a term later also used in the Ambras inventory. The correct description in the Pöggstall inventory suggests that Wilhelm may have acquired the artefacts soon after their arrival in Europe. At the time large numbers of Pre-Columbian artworks were shipped from Mexico to Europe. The Rogendorfs could have acquired such artefacts in the Low Countries or in Spain. However, if they were among Moctezuma's "gifts" sent by Hérnan Cortés to Emperor Charles V in 1519[174] they cannot be identified as the objects now at Ambras as these are not listed in the consignment dispatched by the conquistador.

But Wilhelm would have been able to acquire artefacts first-hand from Cortés' treasure in at least two places: in 1520 at Brussels or Antwerp, three years before Emperor Charles V presented a part of this exotic treasure to his aunt Archduchess Margaret, the governor of the Netherlands, which he did on August 20, 1523.[175] In his diary Dürer records seeing some of these "gifts" sent by Cortés in late summer/early autumn of 1520, and it was during these very weeks that he also frequently dined with the Rogendorfs.[176] Beginning in the autumn of 1518 Wilhelm spent almost three years in the Low Countries, at the precise time when Cortés' treasure was dispersed among the collections being assembled by European noblemen. But from 1522 onwards Wilhelm would also have had opportunities to acquire such exotic artefacts in Spain. Or may we assume that it was Charles V himself who presented his successful commander with this "Indian feather attire and armour"?

But let us return to European armour. We hope to show that Wilhelm's 1523 Landsknecht armour is not a singular exceptional artwork made for a member of the Rogendorf family but rather one of many masterpieces commissioned by these dedicated patrons of the arts. It was also probably not the only harness of such outstanding quality produced for a Rogendorf. In the 1480s Wilhelm's father Kaspar sat for a portrait wearing an exquisite armour *(ill. 46)* that is very similar to the one that the young Archduke (later Emperor) Maximilian commissioned from Lorenz Helmschmid around 1484. Was Wilhelm merely following a family tradition when he commissioned his famous garniture from Kolman Helmschmid?

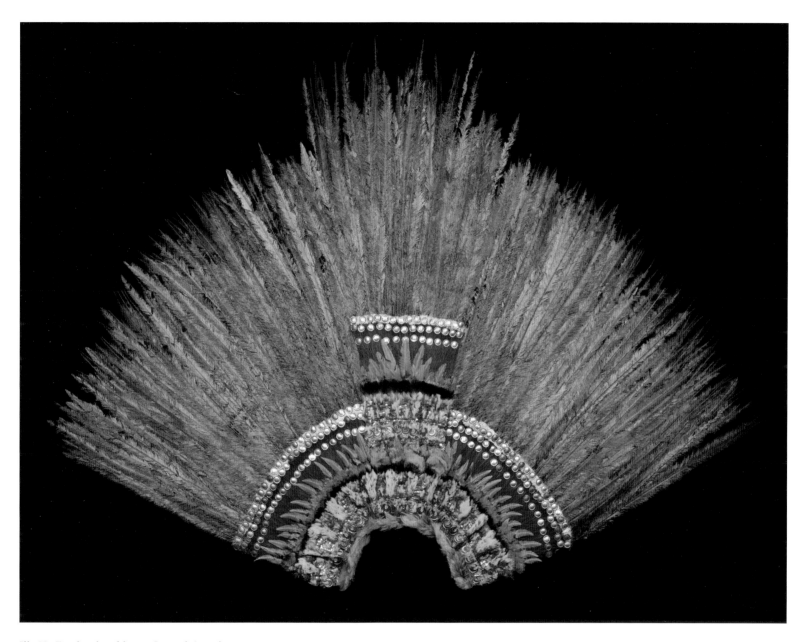

Ill. 62: Feather headdress. Central American, circa 1520. Vienna, Weltmuseum Wien, inv. no. VO 10402 (© KHM-Museumsverband)

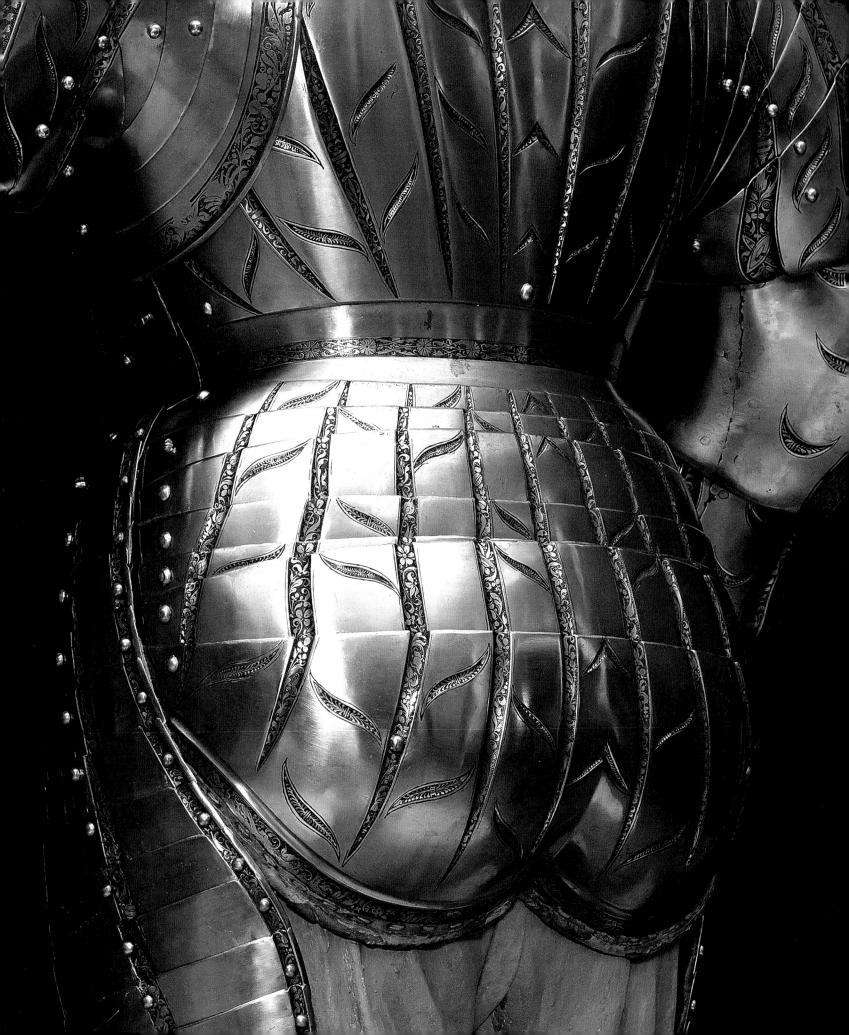

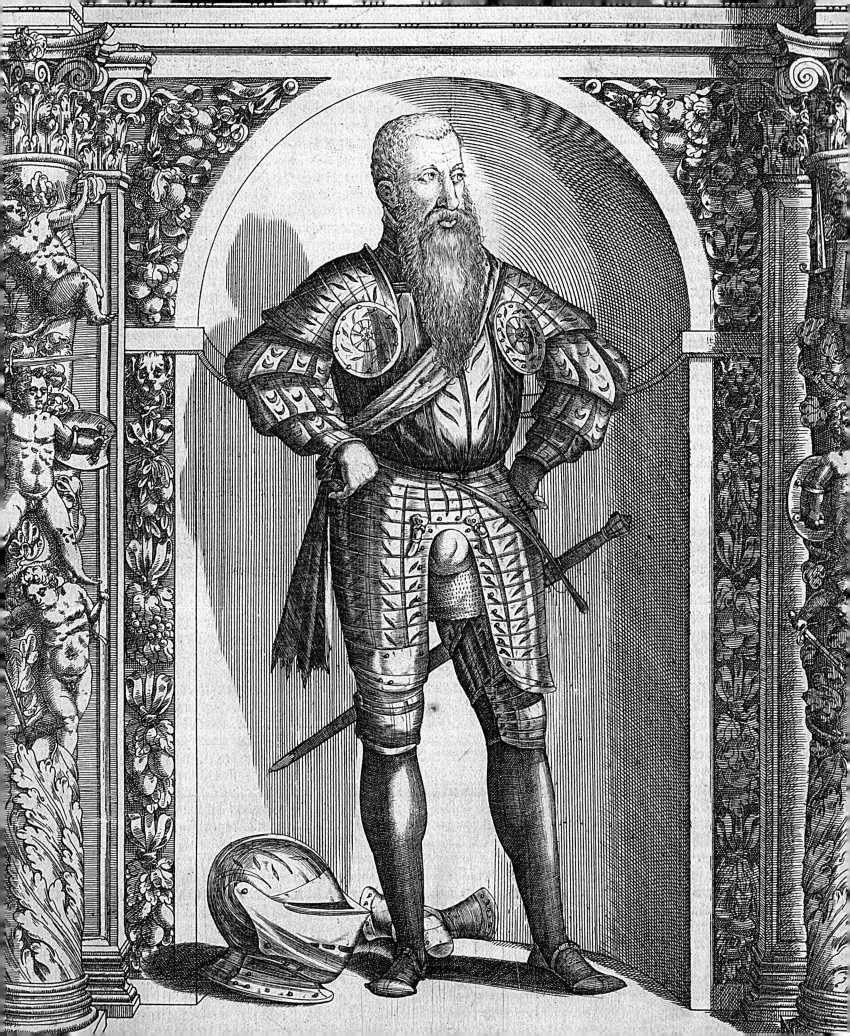

Provenance: Ambras – Vienna

We know nothing about the early provenance of Wilhelm von Rogendorf's Landsknecht garniture. After its completion in 1523 we have no records telling us what happened to it during the subsequent six decades – there are no extant receipts, descriptions or depictions.[177] The harness is only documented from the 1580s onwards, in the so-called "Heldenrüstkammer" (Armoury of Heroes) at Ambras Castle near Innsbruck, one of the great Renaissance armouries: as noted above in the present work, the inventory of this collection compiled in 1583 mentions "Lord Roggendorff [sic] / a white etched armour with sleeves with lames [...]".[178]

Ambras Castle was the main residence of Archduke Ferdinand II, who collected the armour of celebrated rulers and generals. His Armoury of Heroes contained, for example, arms and armour that had belonged to Emperor Charles V, Elector Johann Frederick of Saxony or Doge Sebastiano Venier as well as Wilhelm von Rogendorf.[179] The earliest pictorial record of Rogendorf's armour is in the *Armamentarium heroicum*, the illustrated catalogue of Ferdinand's Armoury of Heroes that was published after his death in 1601/03 *(ill. 63)*.

Many European courts sent Ferdinand historical armours for his collection; he received these armours from "well-known princes and heroes and heirs and descendants", as the introduction to the *Armamentarium heroicum* put it.[180] We can assume that this is also what happened in the case of Rogendorf's armour as his decedents continued to be in contact with the Habsburgs despite the scandal surrounding Wilhelm's son Christoph.[181] For example, Hans Wilhelm von Rogendorf, the grandson of Wilhelm's brother Wolfgang, served as councillor and *Erbland Hofmeister* (Master of the Household of the Austrian Hereditary Lands) to Emperor Maximilian II.[182] Ferdinand II may even have met Wilhelm as a child at the court of his father, King Ferdinand I. In the 1530s, during the first decade of Ferdinand's life, Wilhelm von Rogendorf was one of the King's closest advisors.

The gallery in which the Armoury of Heroes was housed at Ambras no longer exists. Originally the Armoury was displayed in a single large hall located above the entrance to the castle.[183] But the extant detailed inventories of the Ambras collection take us on a virtual tour of this gallery, inviting us to imagine Rogendorf's harness *in situ*. Next to the entrance, along the east wall, stood a row of vitrines that showcased the armour of kings and emperors. Six rows of additional showcases were set up in the gallery to

Ill. 63: Portrait of Wilhelm von Rogendorf, in: Jakob Schrenck von Notzing, *Armamentarium Heroicum*, Innsbruck 1602/03 (© KHM-Museumsverband)

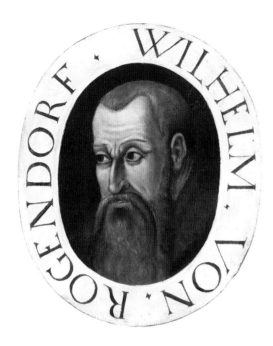

Ill. 64: Portrait of Wilhelm von Rogendorf from the Armoury of Heroes at Ambras Castle. Circa 1580. Vienna, Kunsthistorisches Museum, Picture Gallery, inv. no. 6863 (© KHM-Museumsverband)

house all the other objects.[184] In one of them in the second row on the south wall "obenauf dem casten" (on top of the cupboard), as the 1596 inventory put it, was Rogendorf's armour.[185] Like many of the other armours it was accompanied by a small portrait *(ill. 64)* that may have been a copy after a now-lost portrait of Rogendorf executed in the 1530s *(ill. 5)*.[186]

Archduke Ferdinand died in 1596, and during the following centuries the Armoury of Heroes at Ambras Castle was more or less forgotten – until 1805, when this peaceful, out-of-the-way palace was suddenly touched by history. Napoleon had declared war on Austria, and had awarded the Tyrol to his ally Bavaria. Both the French and the Bavarians removed objects from the collection at Ambras, threatening to disperse and destroy a collection that was the Emperor's private property. In order to save it, Emperor Francis I decided in 1806 to evacuate all the remaining holdings from Ambras to Vienna – including Rogendorf's armour.[187]

In 1809, soon after it had arrived in Vienna, the entire Ambras collection had to be moved again so as not to fall into the hands of the advancing French army – downriver to Petrovardin/Peterwardein in what is now Serbia. In the autumn of 1813, shortly before the Battle of Leipzig, the artefacts were removed once more, but this time only to the environs of Vienna, to Hainburg, a few kilometres downstream from the capital. Only after the French were defeated at Leipzig was it possible to install the Armoury of Heroes again[188] – but this time in Vienna, at Lower Belvedere Palace, the former summer palace of Prince Eugene of Savoy *(ill. 65)*[189].

In Vienna Rogendorf's armour was on public display for the first time. In 1815 Joseph von Hormayr was the first to point out that "there (i.e. at Belvedere Palace) one can see the armour of Wilhelm von Roggendorf [sic]".[190] During a visit to Vienna in 1823 the English collector and arms scholar Samuel Rush Meyrick (1783–1848) and his son Llewellyn included sketches of Rogendorf's armour in their travel diaries *(ill. 67)*.[191] The earliest photographs of the armour date from before 1857, a time when this new medium was still in its infancy; they were taken by Andreas Groll, an Austrian pioneer of photography, for a coffee-table book showcasing the Ambras Armoury installed at the Belvedere *(ills. 66a and b)*.[192] In the 1870s a life-size marble statue of Rogendorf was set up in the Feldherrnhalle (Generals' Hall) of the Heeresgeschichtliches Museum (Museum of Military History) in Vienna – thus the textile rendered in steel was transposed yet again, this time into white Carrara marble.[193]

1889 marks a caesura in the history of Rogendorf's armour; in this year the Ambras Armoury was incorporated into the newly-founded k.k. Kunsthistorisches Hofmuseum (Imperial Museum of Fine Arts) on Vienna's grand new boulevard, the Ringstrasse. In the years before it was finally closed, the Ambras collection installed at Belvedere Palace must have been something of a curiosity. The installation of 1814 had survived the intervening decades practically unaltered. During the winter months the museum remained closed because there was no heating.[194] The majority of visitors were, as the satirical journal *Hans-Jörgel von Gumpoldskirchen* put it, "strangers clutching a Baedeker and schoolboys carrying their satchel".[195] In 1889 the Collection of Arms and Armour was the first collection in the almost-completed new museum on the Ringstrasse to be inaugurated. Rogendorf's armour was displayed in the large central gallery on the ground floor in the Ringstrasse-wing (Gallery XXVII, today Gallery VII), which showcased Emperor Charles V and his time.[196] On November 3, 1889 Emperor Franz Joseph

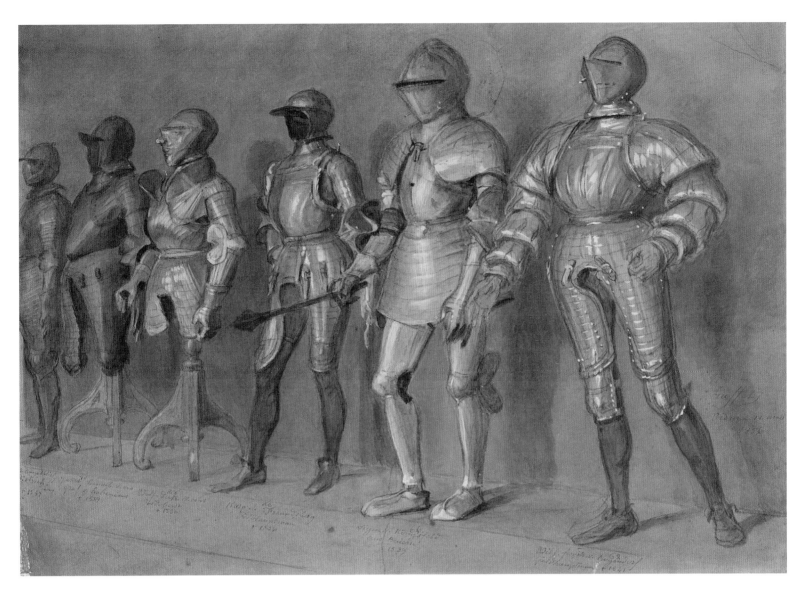

Ill. 65: August Denis Raffet, The Armoury at
Vienna. Watercolour and pencil with white
highlights, 1856. Private collection
(© Kunstauktionshaus Neumeister Munich)

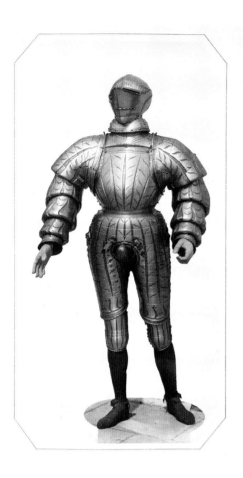

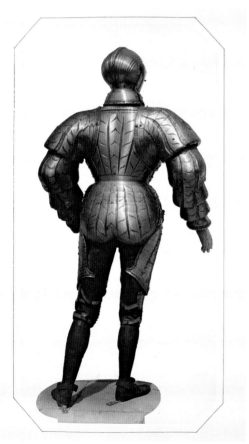

visited the galleries of the new collection and stayed – according to a report in the newspaper *Die Presse* – for an hour-and-a-half, repeatedly expressing "die Allerhöchste Befriedigung" (His Imperial pleasure).[197]

Together with the rest of the Collection of Arms and Armour Rogendorf's garniture moved in 1936 from the armoury galleries in the main building of the Kunsthistorisches Museum to a new home in one of the wings of the adjacent Neue Burg (the former imperial palace) on Heldenplatz. The official reason for this move was lack of exhibition space in the main building.[198] Unofficially, however, the installation of this collection at a prominent location as intimately connected with the house of Habsburg as the Neue Burg also sent a clear political message. The Austrian government under Karl Schuschnigg wanted to emphasise Austria's historical independence from Germany.[199] Two years later, in 1938, Adolf Hitler proclaimed Nazi Germany's annexation of Austria from the central balcony of the Neue Burg – not far from where the Collection of Arms and Armour was, and still is, housed. The Rogendorf armour spent the Second World War in an underground shelter, in the safe of the Vienna Postal Savings Bank. A map of this safety storage installation[200] was drawn up to aid rescuers charged with excavating the shelter "in case this should be necessary after a hit", as the salvage and rescue guidelines published in 1942 succinctly put it.[201]

In the years immediately after the end of the Second World War the Rogendorf armour was included in the selection of exquisite artworks from the holdings of various Viennese museums sent on an international goodwill tour to, among other places, Zurich, London, New York and Philadelphia[202] *(ills. 68 and 69)*. Between 1946 and 1953 the exhibition was shown in a total of seventeen cities in Europe and North America.[203] Its aim was to raise both support and hard currency for the resurrected but bankrupt Republic of Austria. In 1947 the Rijksmuseum in Amsterdam expressed its gratitude for the loans by presenting the Collection of Arms and Armour with a gift comprising "332 kilograms of apples and [...] 76 kilograms of cauliflower".[204]

But, like the collection's move to the Neue Burg in 1936, this exhibition tour was also informed by a shrewd political calculation: it placed some of Austria's foremost treasures at a safe distance should the Soviet Union make any attempt to seize artworks in Vienna. It is surely no accident that these masterpieces only returned in 1953. Stalin had died in March of that year, and under his successor Nikita Khrushchev the first "hot" phase of the Cold War was giving way to an uneasy detente.[205] The museums in Vienna were thus able once more to showcase their treasures safely at home in the Austrian capital – and one of them was the 1523 Landsknecht armour of Wilhelm von Rogendorf.[206]

Ills. 66a and b: Armour of Wilhelm von Rogendorf, front and back. Photographs by Andreas Groll, 1854/57, in: Eduard von Sacken – Andreas Groll, *Die vorzüglichsten Rüstungen und Waffen der k.k. Ambraser Sammlung*, Vienna 1859–1862 (© KHM-Museumsverband)

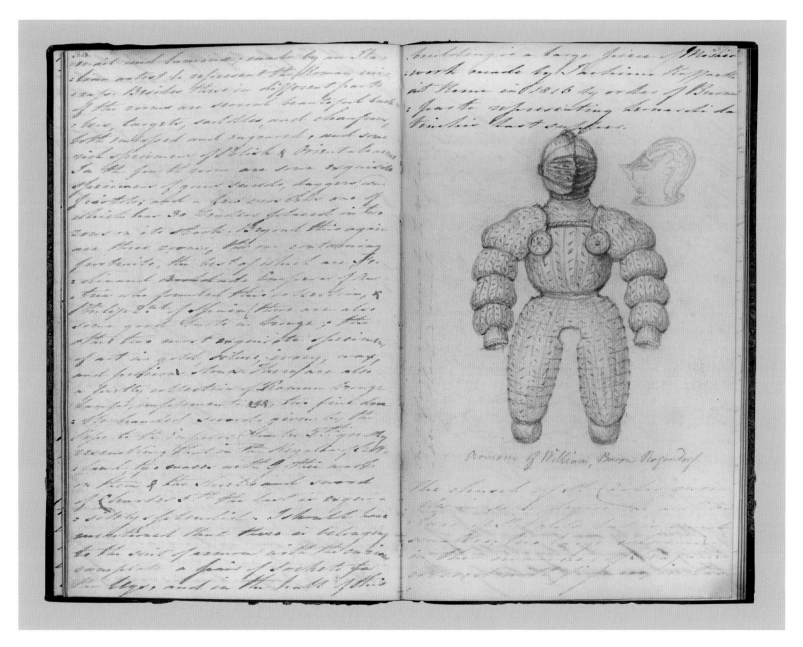

Ill. 68: Exhibition *Art Treasures from Vienna*,
New York, The Metropolitan Museum of Art, 1950
(© bpk / The Metropolitan Museum of Art, pict.
no. 70136214)

Ill. 69: Exhibition *Art Treasures from Vienna*,
Philadelphia Museum of Art, 1952
(© Philadelphia Museum of Art)

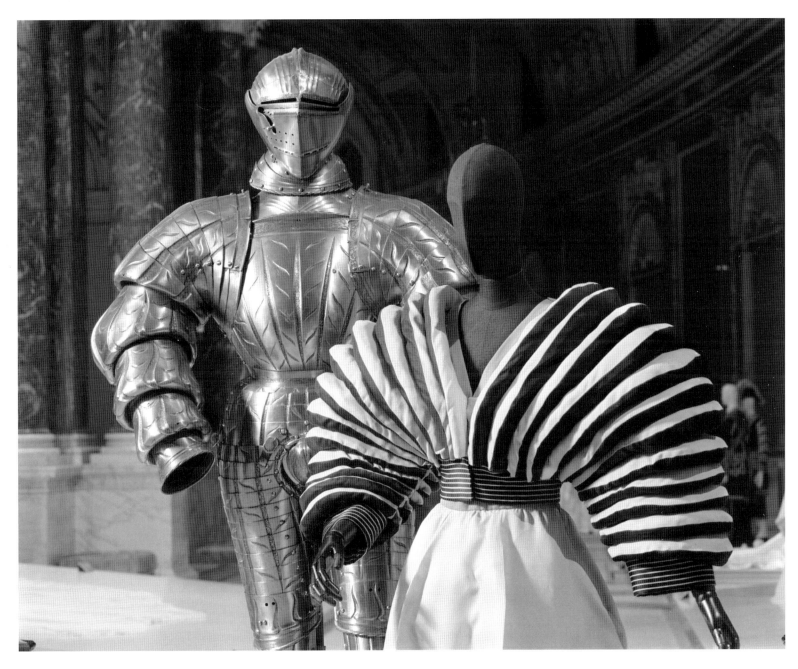

Ill. 70: Exhibition *Roberto Capucci. Roben wie Rüstungen. Mode in Stahl und Seide einst und heute*, Vienna, Kunsthistorisches Museum, Neue Burg, 1990/91 (© KHM-Museumsverband)

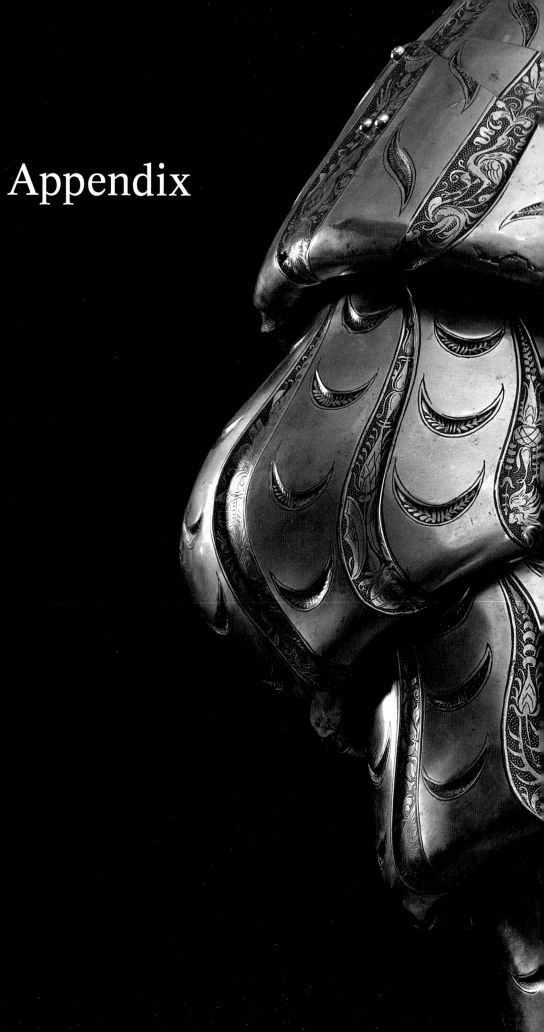

Appendix

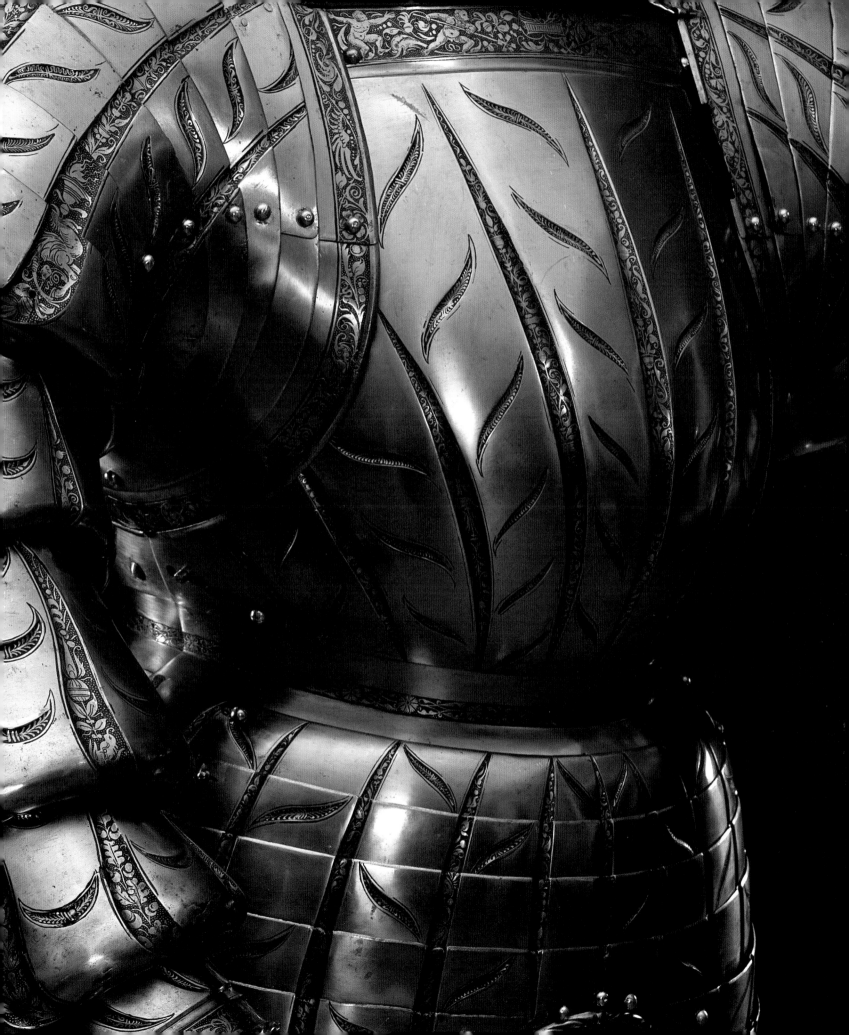

Notes

1 Dean 1926, p. 262 [Dean discusses the Rogendorf armour and an armour in New York and Paris; see notes 84 and 85].

2 See note 1 and Boeheim 1890, p. 155: "Zierharnisch" and Thomas 1938, p. 182: "Travestieharnisch".

3 See Angermann 2005.

4 Cit. after Boeheim 1888, pp. CLXXXIX et seq., reg. 5440 (p. 30); Luchner 1958, p. 79.

5 The spelling of his family name customary today (with a double "g" – "Roggendorf") does not conform to the one used in the early sixteenth century; we have therefore decided to revert to the old spelling (with a single "g" – "Rogendorf") used during Wilhelm's lifetime. See also, for example, Wilhelm's letter written in 1527 *(ill. 4a)*.

6 For more on the extant exchange pieces of Rogendorf's garniture see note 115.

7 We compared the body height of Rogendorf's Landsknecht armour with that of the half-armour of Emperor Charles V commissioned in 1543 (Vienna, Kunsthistorisches Museum, Collection of Arms and Armour, inv. no. A 546; see Gamber – Beaufort 1990, pp. 52–53 and here *ill. 34*).

8 See the essay *The Rogendorfs as Patrons of the Arts* by Andreas Zajic in this publication.

9 *De Bello Helvetico* (1517/26, printed 1610); see Pirckheimer 1998, pp. 92–93.

10 See Keegan 2004, pp. 231–232.

11 See Franz 1953, pp. 80–81; Baumann 1994, pp. 20–23.

12 See Nell 1914, pp. 268–283; Franz 1953, pp. 83–84, pp. 87–88; Baumann 1994, pp. 32–33.

13 Cit. after Pirckheimer 1998, p. 119.

14 The German translation cit. after Blau 1985, p. 84. For the French original see Mailles [1527], no page (chapter XXXVII); Romean 1878, p. 182.

15 See Wiesflecker 1971, pp. 147–148. See also Nell 1914, pp. 115–128; Wiesflecker 1971, pp. 146–149.

16 See Baumann 1994, p. 4.

17 See Keller 1859, p. 114, see also pp. 177–178.

18 Because of their at times erratic ways and their frequent debauchery the Landsknechts were not universally popular. In his *Institutio Principis Christiani* (1515, chapter 11) Erasmus of Rotterdam described this ambivalence thus: "you have to flatter and defer to these mercenaries, even after paying them, although there is no class of men more abject and indeed more damnable." Cit. after Erasmus 1997, p. 102.

19 See Dobras 1990, pp. 241–251; Baumann 1994, pp. 62–65.

20 See Dobras 1990, pp. 244–245; Baumann 1994, p. 63–64.

21 See Baumann 1994, p. 64.

22 Cit. after Waldis 2011, vol. 1, p. 368, no. IV 6, line 7.

23 See Wiesflecker 1971, pp. 292–293. On the *Sacco di Roma* 1527 see Chastel 1983.

24 See Baumann 1994, p. 65.

25 Cit. after Wiesflecker 1971, p. 147.

26 See Sabean 1972, pp. 37–48; Baumann 1994, pp. 68–69.

27 See the essay *The Rogendorf Family* by Andreas Zajic in this publication.

28 See Runciman 1951, p. 92.

29 See Baumann 1994, pp. 22 and 368–369; Schwennicke 1995, plate 13. On Frundsberg see Baumann 1984.

30 See Schwennicke 1992, plate 154. A portrait of Lazarus Schwendi (southern Germany, c. 1560/70) is in Vienna, Kunsthistorisches Museum, Picture Gallery, inv. no. 7967.

31 See Foronda y Aguilera 1914, pp. 201–205; Mur i Raurell 1998, p. 369.

32 See Mur i Raurell 1998, p. 370.

33 See Mur i Raurell 1998, pp. 370–371; Izquierdo 1992, p. 416; for the portrait see Roo 1621, p. 458.

34 Francés de Zúñiga, *Chrónica burlesca del Emperador Carlos V.* (1525–1529); cit. after Zúñiga 1989, p. 128.

35 Chaucer 1989, vol. 2, p. 1237 (X,417); see also Denny-Brown 2004.

36 See Bleckwenn 1974, p. 107; Bönsch 2011, p. 126.

37 I.e. that the hose should be slashed at the knee and lined with linen; cit. after Ffoulkes 1912, p. 173.

38 Four-part tapestry series *The Deeds of Julius Caesar*, Burgundian Netherlands, c. 1450/70, 1st tapestry on the right: *Vanquishing the Sequani*; Bern, Historisches Museum, inv. no. 6-7. See exh. cat. Bern – Bruges – Vienna 2008–2010, pp. 311–314, cat. no. 129a; Rapp Buri – Stucky-Schürer 2011, plate 68.

39 See Bleckwenn 1974, pp. 107–111.

40 Cit. after Blau 1985, p. 159. On the symbolism of war-torn clothes see Denny-Brown 2004, pp. 230–233.

41 Cit. after Breunner-Enkevoërth [1883], p. 9.

42 In the English treatise on *How a Man Shall be Armed at his Ease when He Shall Fight on Foot* (c. 1450) we read: "he schal have noo schirte up on him but a dowbelet of lynyd with satene cutte full of hoolis"; cit. after Dillon 1900, p. 43.

43 See Denny-Brown 2004, pp. 230–231; for the anecdote from the life of Wilwolt von Schaumburg see Keller 1859, p. 114, see also pp. 177–178. Landsknechts in torn hose still caused a stir at the Late-Renaissance court of Catherine de' Medici ("il avoit une jambe chaussée & l'autre nuë"); cit. after Brantôme 1665–1666, vol. 4 (1666), p. 45; see Franz 1953, p. 91.

44 "Zerhackt, zeerschnitten, durchaus nach lansknechtischen Sitten" and "zerhawen und zerschnitten nach ade-
ligen Sitten"; cit. after Krünitz 1773–1858, vol. 64 (1794), p. 286, and Meinhardt – Kröher 1976, pp. 12–13.

45 See Loschek 2005, p. 33; see exh. cat. Berlin – New York 2011, pp. 68–69, ills. 33 and 34.

46 Hans Burgkmair the Elder, *Self-Portrait as a Bridegroom*, Augsburg 1497; Vienna, Albertina, inv. no. 31327.

47 See exh. cat. Nuremberg 2015–2016, pp. 217–218, cat. nos. 137 (Jutta Zander-Seidel) and 138 (Ralf Schürer).

48 See Bulst 1988, pp. 31–33; Hampel-Kallbrunner 1962, p. 9.

49 "Der unten und an den ermeln zerschnitzelt ist"; cit. after Baader 1861, pp. 65–66.

50 Imperial Police Ordinance 1530, cit. after Weber 2002, p. 141 [10/1]. See also *Reichs-Abschiede* 1747, vol. 2,
pp. 31, 47 etc.

51 Imperial Police Ordinance 1530, cit. after Weber 202, p. 149 [19/1].

52 "Ach was närrischer bekümmernüß" and "es ist der Speck auff der fallen damit man solche Mäuß fängt";
cit. after Zincgref 1626, pp. 86–87; see Zincgref 2011, vol. 1, p. 74, no. 252.

53 See Bleckwenn 1974, pp. 107–108.

54 See Simmel 1895; Veblen 1899, pp. 111–124 [chapter 7]; most recently: Breward 1998; Wilson 2003, pp. 16–
46, 248–277.

55 For more on this candlestick in the shape of a Landsknecht see Davey – Patterson 2012.

56 See Rogg 2002.

57 See Kästner 2004; Loschek 2005, pp. 268, 280; Skjelver 2010, pp. 68–78; Bönsch 2011, pp. 195–196. On
Naumburg see Merkel 2012, pp. 198–202. For the illustration see note 127.

58 See Groemer 2010, pp. 214–215, 315–320.

59 Konrad Seusenhofer, Innsbruck, 1512/14; Vienna, Kunsthistorisches Museum, Collection of Arms and Ar-
mour, inv. no. A 186. See Thomas – Gamber 1976, pp. 215–216.

60 See Hans Ostendorfer, Tournament Book of Duke Wilhelm IV of Bavaria, Munich, dated 1541, pp. 39/40;
Munich, Bayerische Staatsbibliothek, Cgm 2800. See Leidinger 1912, plates 36 and 37.

61 See Keegan 2004, pp. 342–347.

62 See ibid, pp. 342–343.

63 Castiglione, *The Book of the Courtier*, 2nd book; cit. after Castiglione 1966, p. 116.

64 Cit. after Rothe 2009, pp. 126–127, lines 1765–1766 and pp. 130–131, lines 1807–1808. Translation by
Agnes Stillfried.

65 See Müller 2002, p. 137, no. 052; pp. 167–168, no. 075; p. 183, no. 088; pp. 217–218, no. 113; pp. 223–224, no. 117.

66 Sketchbook of Paul Dolnstein, Thüringisches Hauptstaatsarchiv Weimar, Reg. S (Bau- und Artillerieange-
legenheiten), fol. 460, no. 6, leave 6r; see Skjelver 2010, pp. 126–129; Dihle – Closs 1929.

67 For a similar depiction of Hans Schäufelin see Zijlma 1996, p. 144, no. 63.

68 "Chormanteln und ander gleycher pompa"; cit. after *Warhafftige berichtung* 1527, [pp. 13–14].

69 See *Reichs-Abschiede* 1747, vol. 2, p. 112 (Reichstagsabschied, Konstanz 1507).

70 On mercenaries' pay see Baumann 1994, pp. 86–91.

71 See ibid, pp. 89–90.

72 "Hosen Zu irem gefallen" and "allein durchziehen und hie nit pleiben"; cit. after Zander-Seidel 1990, p. 188.

73 See Simmel 1895, pp. 49–55.

74 See Baumann 1994, p. 98.

75 "Ich hab doppelt solt auff mein leib / Darumb ich nit dahinden bleib [...] Ich bin ein Doppensöldner frey /
In meim Harnisch trit ich herbey"; cit. after Messling 2008, p. 14, no. 16 (ill.).

76 On the different ranks in mercenary armies see Baumann 1994, pp. 92–103.

77 See Blair 1958, pp. 53–55, 77–80.

78 See Patterson 2009, pp. 6–7; see also Grancsay 1950.

79 On intentionally slashed clothes see the chapter *Slashing in Renaissance Fashion* in this publication.

80 See, for example, the etched decoration on the steel pleated skirt (attributed to Konrad Seusenhofer,
Innsbruck, c. 1510/15) in New York, The Metropolitan Museum of Art, inv. no. 14.25.790a, b. The steel
skirt of the armour presumably produced for Albrecht of Brandenburg (probably Brunswick, c. 1526, Vienna,
Kunsthistorisches Museum, Collection of Arms and Armour, inv. no. 118; see Thomas – Gamber 1976,
pp. 218–219) was originally embellished with decorative horizontal (textile, metal?) bands; we can deduce
this from the four rows of slashes.

81 See note 59.

82 London/Leeds, Royal Armouries, inv. no. II.5; see exh. cat. London 2009, pp. 170–175.

83 See note 80.

84 New York, The Metropolitan Museum of Art, inv. nos. 26.188.1/2, 24.179, 29.158.363a/b; see Dean 1926,
pp. 263–264.

85 Paris, Musée de l'Armée, inv. no. G 45; see Reverseau 1982, p. 132.

86 See Terjanian 2012, pp. 378–379, no. 97 (fol. n74r).

87 See exh. cat. Munich 2009, pp. 429–433, cat. no. 103 (Christof Metzger).

88 See the lining of the sallet in Vienna, Kunsthistorisches Museum, Collection of Arms and Armour, inv.
no. A 3 (Nuremberg-Landshut, c. 1480); see Thomas – Gamber 1976, pp. 97–98; and the red lining of the
half-armour of Nikolas IV Radziwill (Nuremberg, c. 1555), Vienna, Kunsthistorisches Museum, Collection
of Arms and Armour, inv. no. A 1412; see Gamber – Beaufort 1990, pp. 86–87.

89 See Spallanzani – Bertelà 1992, p. 88; Stapleford 2013, p. 151.

90 Cit. after Fugger – Birken 1668, p. 1274. Translation by Agnes Stillfried.

91 Armour of Archduke (later Emperor) Maximilian I, Lorenz Helmschmid, Augsburg, 1480, Vienna, Kunst-
historisches Museum, Collection of Arms and Armour, inv. no. A 60; see Thomas – Gamber 1976, p. 106.

I would like to thank Christa Angermann and Katja Schmitz von Ledebur for examining these old, possibly original fragments.

92 Matthäus Schwarz' *Book of Clothes*, Augsburg, 1520–1560, Brunswick, Herzog Anton Ulrich-Museum, Kupferstichkabinett, inv. no. 67a; see Fink 1963; Rublack – Hayward 2015.

93 "Sy sich also teglich verkertete" and "was daraus werden wölle"; cit. after Fink 1963, p. 98, title page and introduction; see also Rublack – Hayward 2015, p. 53.

94 "4800 schnitz"; cit. after ibid, p. 135, I 61; see also Rublack – Hayward 2015, p. 112.

95 Filippo Negroli, morion of Francesco Maria della Rovere, Milan, dated 1532, Vienna, Kunsthistorisches Museum, Collection of Arms and Armour, inv. no. A 498; see Gamber – Beaufort 1990, p. 37.

96 Horse armour of Duke Frederick II of Liegnitz, southern Germany, c. 1512/15, Berlin, Deutsches Historisches Museum, inv. no. W 81/5; see Post 1928; Krause 2011/2012, pp. 63–65.

97 See exh. cat. New York 1998, pp. 92–94, cat. no. 8.

98 Vienna, Kunsthistorisches Museum, Collection of Arms and Armour, inv. no. A 69; see Thomas – Gamber 1976, pp. 104–105. For more on three-dimensional chased decoration on armour produced north and south of the Alps in the fifteenth and sixteenth century see, for example, LaRocca 2004.

99 Madrid, Patrimonio Nacional, Real Armería, inv. no. A 59; see Conde de Valencia 1898, p. 30. See also exh. cat. Washington 2010, pp. 116–117, cat. no. 25; and Capwell – Edge – Warren 2011, pp. 92–93; Terjanian 2012, pp. 370–371 (fol. n68r) and pp. 384–385 (fol. n80r, n80v).

100 See Barber – Barker 2001, pp. 127–179; exh. cat. Bern – Bruges – Vienna 2008–2010, pp. 296–297 (Birgit Franke). On the wearing of disguises at tournaments see Schnitzer 1999, pp. 112–144.

101 See exh. cat. Vienna 2000, pp. 332–335, cat. nos. 374 and 375 (Arnout Balis). For more on this tournament see Frieder 2008, pp. 198–204.

102 See *Freydal*, the tournament book of Emperor Maximilian I (southern Germany, 1512–1515), Vienna, Kunsthistorisches Museum, Kunstkammer, inv. no. KK 5078, fol. 172. For more on the so-called Hussars' tournaments held at the court of Archduke Ferdinand II see exh. cat. Innsbruck 2005, pp. 66–74.

103 See Leitner 1880–1882, pp. LXXI and LXXVI.

104 Maximilian's Tournament book *Freydal* (see note 102), fol. 4, also fol. 61 and 250; see also Leitner 1880–1882, p. XCIV.

105 See Breiding 2012, p. 67.

106 See notes 84 and 85. I would like to thank Pierre Terjanian and Donald LaRocca for our discussions of these questions.

107 See the armour for combat on foot that completely encloses the wearer in London/Leeds, Royal Armouries, inv. nos. II.6 and II.8/VI.13 (exh. cat. London 2009, pp. 114–118, 212–217) and Paris, Musée de l'Armée, inv. no. G 179 (Reverseau 1982, p. 73).

108 On the question of lost exchange pieces for Rogendorf's armour see the chapter *The Garniture of Wilhelm von Rogendorf* in this publication.

109 See the discussion of Rogendorf's garniture in the chapter *The Garniture of Wilhelm von Rogendorf*.

110 See Wiesflecker 1971, p. 176.

111 Cit. after Fink 1963, pp. 148–149, no. I 87; see also Rublack – Hayward 2015, p. 134.

112 See Terlinden 1960.

113 On the entry into Seville see Philipp 2011, pp. 171–201. On Rogendorf in Seville see Mur i Raurell 1998, p. 373.

114 See Pfaffenbichler 2014.

115 A pair of standard pauldrons with besagews, a pair of gauntlets, a pair of poleyns and the lower right cannon from the field vambrace are now in Vienna, Kunsthistorisches Museum, Collection of Arms and Armour, inv. no. A 374; see Thomas – Gamber 1976, pp. 227–228. The right upper cannon and left couter are in London, The Wallace Collection, inv. no. A 245; see Mann 1962, pp. 174–175; these two pieces were wrongly assembled, probably in the nineteenth century. On the pieces of the garniture inventoried in 1583 see note 5.

116 See note 107.

117 In the illustration depicting Rogendorf's harness in the *Armamentarium heroicum* published in 1601/03 *(ill. 63)* slashings were added to the helmet. The suggestion that a chamfron now in Rome (Museo Nazionale del Palazzo di Venezia, inv. no. PV 11492) may once have been part of Rogendorf's garniture must be rejected after a comparison of the etched decorations. On this chamfron see exh. cat. Rome 1969, p. 28, cat. no. 145.

118 See note 107.

119 See notes 84 and 85.

120 London, The Wallace Collection, inv. no. A 28; see Mann 1962, pp. 26–27.

121 On the Helmschmid dynasty of armourers see Reitzenstein 1951. On this portrait medal see Habich 1929–1934, vol. 1, part 1, p. 112, no. 767 (with plate XCIV, no. 4). On Kolman's 1518 portrait medal by Hans Schwarz see also ibid, p. 26, no. 125 (with plate XIX, no. 3) and no. 129 (with plate XIX, no. 6). On Schwarz' preparatory portrait drawings in Berlin and Bamberg see Bernhart 1934, plate I, no. 6 (17) and no. 1 (16).

122 See, for example, the cuirass of Count Andreas Sonnenberg, Kolman Helmschmid, Augsburg, 1505/10, Vienna, Kunsthistorisches Museum, Collection of Arms and Armour, inv. no. A 310; see Thomas – Gamber 1976, pp. 220–221.

123 See Reitzenstein 1951; on the works of Desiderius Helmschmid see also Becher – Gamber – Irtenkauf 1980, p. 34.

124 See Reitzenstein 1951, pp. 182, 192. The shield of Emperor Charles V made in 1552 is now in Madrid, Patrimonio Nacional, Real Armeria, inv. no. A 241; see Conde de Valencia 1898, p. 82. On the family name Helmschmid see Reitzenstein 1951, pp. 185–186.

125 See Conde de Valencia 1898, pp. 15–40; exh. cat. Barcelona – Madrid 1992, pp. 134–151.

126 See Lanz 1844–1846, vol. 1 (1844), p. 115; Reitzenstein 1951, pp. 187–188.

127 "Allso Ist der Stoffel weyditz mit dem Kolman Holmschmidt Iber Mär gevorn". Christoph Weiditz' *Book of Clothes*, Nuremberg, Germanisches Nationalmuseum, inv. no. HS 22474; cit. after Hampe 1927, plate I (fol. 78). See also Reitzenstein 1951, p. 188.

128 Cit. after Lanz 1844–1846, vol. 1 (1844), p. 115.

129 On Rogendorf attending the Imperial Diet see *Reichstagsakten* 1896, p. 149; Frank 1967–1974, vol. 4 (1973), p. 183. On Helmschmid see Boeheim 1891, p. 189.

130 On the biography of Daniel Hopfer see ibid, pp. 9–17.

131 On Hopfer's biography see ibid, pp. 12–17; see also ibid, pp. 544–546, Q1. On Hopfer's coat of arms see ibid, p. 549, Q15, and p. 17.

132 See Krause 2011/2012, pp. 59–61.

133 On Hopfer's graphic work see Christof Metzger's catalogue raisonné (exh. cat. Munich 2009); on *The Battle of Thérouanne* see ibid, pp. 393–395, no. 72.

134 London, The British Museum, inv. no. 1862,1011.184; see Williams 1974.

135 See exh. cat. Munich 2009, p. 541.

136 Madrid, Patrimonio Nacional, Real Armería, inv. no. A 57; see Krause 2011/2012, pp. 55–56.

137 Nuremberg, Germanisches Nationalmuseum, inv. no. W 2833; see ibid, pp. 73–74.

138 See ibid, pp. 56 –57 and 60–61.

139 Stuttgart, Württembergische Landesbibliothek, Cod. Milit. 2° 24; see Becher – Gamber – Irtenkauf 1980.

140 See Egg 2000, pp. 568–569; see also Schönherr 1884, p. CXLV, reg. 1934 etc.

141 "Etwas tief eingegriffen"; cit. after Schönherr 1884, pp. CLXVIII–CLXIX, reg. 2183 and 2214.

142 See Egg 2000, p. 569.

143 Kolman Helmschmid, Augsburg, c. 1525, Turin, Armeria Reale, inv. no. B 2. One left exchange pauldron is now in Paris, Musée de l'Armée, inv. no. G 381; the right exchange pauldron is in New York, The Metropolitan Museum of Art, inv. no. 14.25.828; see Thomas 1977.

144 See exh. cat. Munich 2009, nos. 81, 91, 126, 127.

145 See Becher – Gamber – Irtenkauf 1980, p. 35. The portrait (Jörg the Elder and anonymous artist) is now in Madrid, Museo Thyssen-Bornemisza, inv. no. 244 (1930.63); see Lübbeke 1991, pp. 156–161, no. 35.

146 See ibid, p. 28 and p. 35.

147 See Reitzenstein 1951, p. 185; Terjanian 2012, pp. 306–307, 310–311, 322–327, 334–337.

148 See Reitzenstein 1951, pp. 184–185; see also Hampe 1918, p. 46.

149 This overview of the history of the Rogendorf family is based on numerous previously unpublished sources. To list them all would go beyond the scope of this publication. The author is currently preparing a monograph on the Rogendorf family for publication in 2017; see also Zajic 2012.

150 On the diary entries of the Apostolic Nuncio (February 16–18,1539, Vienna) see Friedensburg 1893, p. 308.

151 See the assessment by the Apostolic Nuncio Morone (June 13, 1537, Prague); Friedensburg 1892, pp. 181–183, here p. 182.

152 See the chapter *Wilhelm von Rogendorf and the Landsknechts* in this publication.

153 A portrait of Wilhelm von Rogendorf in profile is probably included among the portrait medals depicted on the tomb of Count Niklas von Salm (1459?–1530), Thomas Hering (?), probably 1530/35, Vienna, Votivkirche (bottom right end of the narrow side). On the tomb see Rosenauer 2003, pp. 375–376, no. 165 (Karin Gludowatz).

154 See below.

155 See Heinz 1975, p. 274.

156 Christoph von Rogendorf must be a member of the retinue of the mounted Emperor Charles V in the tapestry *Calling the Roll at Barcelona* (cartoon designed by Jan Cornelisz Vemeyen); see the cartoon for this tapestry (Netherlandish, 1546/50), Vienna, Kunsthistorisches Museum, Picture Gallery, inv. no. 2038; see exh. cat. Vienna 2013, p. 24, ill. 13, and p. 70, ill. 54.

157 St. Pölten, Niederösterreichisches Landesarchiv, Ständisches Archiv, MS 5/8, fol. 106r–107r.

158 Medal showing Christoph von Rogendorf styled Marquis des Îles d'Or, silver, Paris, c. 1547/52, private collection, inscription (obverse): "XPOFLE [CHRISTOFLE] · DE. ROGENDORFF · MARQVIS · DES · ISLES · DOR."; reverse: "Xe [CHRISTOFLE] · CO(N)TE · DE · ROGE(N)DORFF · GRA(N)D · M(AITR) E · HEREDITAIRE. DOSTRICHE ·" respectively "TANT / · A · SOVFFERT / ROGE(N)DORFF".

159 See Rupprich 1956, pp. 156–157, 164.

160 See Schoch – Mende – Scherbaum 2002, pp. 460–462, no. 253 (Rainer Schoch).

161 See Mazal 1993, p. 142; however, the owner's mark has been misinterpreted.

162 Hieronymus Beck von Leopoldsdorf's *Book of Portraits*, Austrian (Vienna?), c. 1550/70, Vienna, Kunsthistorisches Museum, Picture Gallery, inv. no. 9691, fol. 357, 359, 361; see Heinz 1975, pp. 284–285, no. 181, and p. 286, nos. 182 and 183. On the portrait of Wilhelm's wife, Elisabeth von Öttingen, see ibid, fol. 609 (Heinz 1975, p. 274, no. 154).

163 See Liebmann 1965. I would like to thank Katrin Dyballa, the author of the most recent catalogue raisonné of the oeuvre of Georg Pencz, who convincingly rejecting the earlier attribution of the portrait in the Hermitage to the master from Nuremberg.

164 Eferding, private collection. The inscription on the frame reads: "Honour to God alone – Georg Baron / von Rogendorff (sic) and Mollenburg in his forty-ninth year / A.D. 1541".

165 Eferding, private collection. The inscription on the frame reads: "May be befits Baron Wolff von Rogen/ dorff (sic) and Mollenburg – hereditary chamberlain of Austria –councillor and chamberlain (of the) Emperor of the Holy Roman Empire – at the age of 57 – A.D. 1540".

166 See Hlobil – Petrů 1999, pp. 203 and 267, note 6 and ill. 73. According to Procházka 1902, p. 19, the

now-lost sculpture, formerly in Brno, zemská galerie, was inscribed: "Baron Georg von / Rogendorff (sic) and von / Mollenburg – in his / forty-ninth year – 1536".

167 "Gar allt unnd seltzamer namen [...], das man die nit gewisst hat zu nennen, [und] derselben ursach wegen gar nicht beschriben", Vienna, Österreichisches Staatsarchiv, Hofkammerarchiv, Niederösterreichische Herrschaftsakten R 44, fol. 450s: statement by Anna von Rogendorf, submitted on January 17, 1550.

168 Ibid, fol. 139, submitted on February 7, 1548. Edlasberg notes that the clothes suffered from long storage and damage seemed unavoidable: "Item, was ich auch verrer mit dem indianischen vederzeug unnd russtung thuen, oder wohin ich die verrer uberantwurten soll, hab ich dannacht auf mein vorig derhalben etlich beschehen ermonungen nochmalß euer gnaden hiemit zu erinndern nit underlassen und mich daneben entschuldigen wollen" (Moreover, I ask Your Grace again to let me know what to do with the feather attire and armour or where to send them, or to whom I should entrust the feathers, despite my numerous admonitions I would like to remind Your Grace not to forget this, and to apologize for it).

169 Vienna, Weltmuseum Wien, inv. no. VO 10402; see Feest 2012. I would like to thank Christian Feest for his constructive criticism regarding this newly discovered source.

170 See Feest 2012, p. 24.

171 "Item ain mörischer rockh, die federn davon seer abgeschlissen, ist von plaw, rot und gelben federn, die erml und der leib sein von gulden schiepen, aufm ruggen sein 2 cristallene augen, das ain zerbrochen" (a Moorish skirt, its feathers in bad condition, is made of blue, red and yellow feathers, the sleeves and body are made of gold scales, on the back are 2 crystal eyes, one of them broken); cit. after Hochstetter 1885, p. 87.

172 "Allerlei mörsche rüstung von federwerk" (various Moorish armour made of feathers) is also mentioned in the inventory of the collection assembled by Count Ulrich VI von Montfort at Tettnang. Until now, this constituted the sole potential source for the ancient Mexican feather artefacts in the collection at Ambras; see Feest 2012, p. 24.

173 See note 172.

174 See Feest 2012, pp. 21–23.

175 See ibid, p. 23.

176 See note 159.

177 See also the two armouries listed in the inventory of Rogendorf Castle at Pöggstall, 1548, Vienna, Österreichisches Staatsarchiv, Haus-, Hof- und Staatsarchiv, MS Blau 361, fol. 4r and 8r.

178 See note 5.

179 See Schrenck von Notzing 1981, no page, no. 81.

180 Cit. after Schrenck von Notzing 1603, title page. Translation by Agnes Stillfried.

181 On the biography of Christoph see Andreas Zajic's essay on the Rogendorfs in this publication.

182 See Neidhart 1993, pp. 235–236.

183 On the reconstruction of the Armoury of Heroes at Ambras see Luchner 1958.

184 On this gallery see ibid, pp. 52–55, and appendix ills. 42–44, 47–53.

185 Cit. after Boeheim 1888, pp. CCXXVI, reg. 5556 (p. 324); see Luchner 1958, p. 79. On changes in the installation around 1590 see Boeheim 1888, pp. CLXXIX, reg. 5440 (fol. 29'–30), and Bergmann 1836, p. 19.

186 See Luchner 1958, appendix ills. 51, 52. On the portrait see Roo 1621, p. 458.

187 See Boeheim 1898, pp. 217–224.

188 See Lhotsky 1941–1945, part II, 2nd half, pp. 512–514.

189 August Denis Raffet, *The Armoury in Vienna*, pencil and watercolour with white highlights, 1856, signed and dated, private collection (Kunstauktionshaus Neumeister Munich, Old Masters auction 340, July 2, 2008, lot no. 516).

190 "Eben dort man auch den Harnisch Wilhelm von Roggendorfs..."; cit. after Hormayr 1815 (nos. 126, 127, 128), p. 529. Bornschein 1812, pp. 218–222, and Reilly 1813, pp. 39–40 do not mention the armour.

191 Diary of Samuel Rush Meyrick, p. 40, and diary of Llewellyn Meyrick, p. 33 (both July 26, 1823), London, The Wallace Collection, inv. no. Meyr 2-1-2 and 2-1-3.

192 See Sacken – Groll 1859–1862, vol. 1 (1859), plates LIII and LIV. See also Weber-Unger 2011, pp. 101–103.

193 See Strobl 1961, p. 125, no. 14.

194 See *Wiener Abendpost*, November 2, 1871, title page, "Kleine Chronik". (http://anno.onb.ac.at/anno-suche/, April 16, 2014).

195 Cit. after *Hans-Jörgel von Gumpoldskirchen* 43, 1874, issue 32, August 1, 1874, p. 2. Translation by Agnes Stillfried.

196 See [Boeheim] 1889, p. 49, no. 206; Bischoff 2008, pp. 208, 217.

197 Cit. after *Die Presse*, November 4, 1889, title page, "Kleine Chronik". Translation by Agnes Stillfried.

198 See Haupt 1991, p. 99.

199 See Staudinger 1984, esp. pp. 292–294, 301–302; Portisch – Riff 1989, pp. 487–488.

200 Vienna, Kunsthistorisches Museum, Collection of Arms and Armour, Archive, AZ 6/44, Bergungsakten 1942.

201 "Infolge einer Verschüttung des Raumes Freilegearbeiten notwendig sein"; cit. from the *Richtlinien für die Bergung (guidelines for salvage operations)*, Vienna, July 13, 1942, typescript, copy, Vienna, Kunsthistorisches Museum, Collection of Arms and Armour, Archive, Z/GK. 5416-b/42.

202 See Philadelphia 1951, p. 24.

203 See Haupt 1991, pp. 198–199.

204 Typescript, Rijksmuseum Hoofddirectie, Amsterdam, December 29,1947, signed "Th. H. Lunsingh Scheurleer, Conservator", Vienna, Kunsthistorisches Museum, Collection of Arms and Armour, Archive, 8/1947/WS.

205 See Portisch – Riff 1986, pp. 303–307.

206 See exh. cat. Vienna 1990, pp. 132–133, cat. no. 55; see also exh. cat. Basel 2009, pp. 18 and 20.

Bibliography

Angermann 2005
Christa Angermann, *Restaurierungen: Harnisch des Wilhelm Freiherr von Roggendorf*, in: *Jahresbericht 2005. Kunsthistorisches Museum Wien*, Vienna 2006, p. 96–97

Baader 1861
Joseph Baader, *Nuremberger Polizeiordnungen aus dem XIII. bis XV. Jahrhundert* (Bibliothek des Litterarischen Vereins in Stuttgart, vol. LXIII, edited by Joseph Baader), Stuttgart 1861

Barber – Barker 2001
Richard Barber – Juliet Barker, *Die Geschichte des Turniers*, translated by Harald Ehrhardt, Düsseldorf – Zurich 2001

Baumann 1984
Reinhard Baumann, *Georg von Frundsberg. Der Vater der Landsknechte*, Munich 1984

Baumann 1994
Reinhard Baumann, *Landsknechte. Ihre Geschichte und Kultur vom späten Mittelalter bis zum Dreißigjährigen Krieg*, Munich 1994

Becher – Gamber – Irtenkauf 1980
Charlotte Becher – Ortwin Gamber – Walter Irtenkauf, *Das Stuttgarter Harnisch-Musterbuch 1548–1563*, in: Jahrbuch der kunsthistorischen Sammlungen in Wien 76 (Neue Folge vol. XL), 1980, pp. 1–96

Bergmann 1836
[Joseph] Bergmann, *Der älteste gedruckte Katalog der Rüstungen in der k.k. Ambraser-Sammlung vom 1593*, in: Jahrbücher der Literatur 74, 1836, Anzeige-Blatt für Wissenschaft und Kunst, no. LXXIV, pp. 14–24

Bernhart 1934
Max Bernhart, *Die Porträtzeichnungen des Hans Schwarz*, in: Münchner Jahrbuch der bildenden Kunst 11, 1934, pp. 65–95

Bischoff 2008
Cäcilia Bischoff, *Das Kunsthistorische Museum. Baugeschichte, Architektur, Dekoration*, edited by Wilfried Seipel, Vienna 2008

Blair 1958
Claude Blair, *European Armour. Circa 1066 to circa 1700*, London 1958

Blau 1985
Friedrich Blau, *Die deutschen Landsknechte. Ein Kulturbild*, 2nd edition Görlitz 1882, reprinted Essen 1985

Bleckwenn 1974
Ruth Bleckwenn, *Beziehungen zwischen Soldatentracht und ziviler modischer Kleidung zwischen 1500 und 1650*, in: Waffen- und Kostümkunde. Zeitschrift der Gesellschaft für historische Waffen- und Kostümkunde 33 (3rd series vol. 16), 1974, pp. 107–118

Boeheim 1888
Wendelin Boeheim (ed.), *Urkunden und Regesten aus der K.K. Hofbibliothek*, in: Jahrbuch der kunsthistorischen Sammlungen des Allerhöchsten Kaiserhauses 7, 1888, pp. XCI–CCCXIII

[Boeheim] 1889
[Wendelin Boeheim], *Kunsthistorische Sammlungen des Allerhöchsten Kaiserhauses. Führer durch die Waffen-Sammlung*, Vienna 1889

Boeheim 1890
Wendelin Boeheim, *Handbuch der Waffenkunde. Das Waffenwesen in seiner historischen Entwicklung vom Beginn des Mittelalters bis zum Ende des 18. Jahrhunderts* (Seemanns kunstgewerbliche Handbücher, vol. VII), Leipzig 1890

Boeheim 1891
Wendelin Boeheim, *Augsburger Waffenschmiede, ihre Werke und ihre Beziehungen zum kaiserlichen und zu anderen Höfen*, in: Jahrbuch der kunsthistorischen Sammlungen des Allerhöchsten Kaiserhauses 12, 1891, pp. 165–227

Boeheim 1898
Wendelin Boeheim, *Die aus dem kaiserlichen Schlosse Ambras stammenden Harnische und Waffen im Musée d'Artillerie zu Paris*, in: Jahrbuch der kunsthistorischen Sammlungen des Allerhöchsten Kaiserhauses 19, 1898, pp. 217–239

Bönsch 2011
Annemarie Bönsch, *Formengeschichte europäischer Kleidung* (Konservierungswissenschaft. Restaurierung. Technologie, edited by Gabriela Krist, vol. 1), 2nd edition Vienna [et al.] 2011

Bornschein 1812
Adolph Bornschein, *Oesterreichischer Cornelius Nepos, oder: Leben, Thaten und Charakterzüge Oesterreichischer Feldherren; die sich von der ältesten Zeit bis zur Schlacht von Deutsch Wagram durch ihre Thaten besonders ausgezeichnet haben*, annotated and edited by Adolph Bornschein, Vienna 1812

Brantôme 1665–1666
Pierre de Bourdeille de Brantôme, *Mémoires de Messire Pierre de Bourdeille, Seigneur de Brantôme. Contenant Les Vies des Hommes illustres et grands Capitaines François de son temps*, 8 vols., Leiden 1665–1666

Breiding 2012
Dirk Breiding, *Rennen, Stechen und Turnier zur Zeit Maximilians I.*, in: *"Vor halbtausend Jahren…". Festschrift zur Erinnerung an den Besuch des Kaisers Maximilian I. in St. Wendel*, St. Wendel 2012, pp. 51–82

Breunner-Enkevoërth [1883]
August Johann Graf Breunner-Enkevoërth (ed.), *Römisch kaiserlicher Majestät Kriegsvölker im Zeitalter der Landsknechte*, Vienna [1883]

Breward 1998
Christopher Breward, *Cultures, Identities, Histories: Fashioning a Cultural Approach to Dress*, in: Fashion Theory 2, no. 4, pp. 301–314

Bulst 1988
Neithard Bulst, *Zum Problem städtischer und territorialer Kleider-, Aufwands- und Luxusgesetzgebung in Deutschland (13.–Mitte 16. Jahrhundert)*, in: André Gouron – Albert Rigaudiére (eds.), *Renaissance du pouvoir législatif et genèse de l'État* (Publications de la société d'historie du droit et des institutions des anciens pays de droit écrit, vol. 3), Montpellier 1988, pp. 29–57

Capwell – Edge – Warren 2011
Tobias Capwell – David Edge – Jeremy Warren, *Masterpieces of European Arms and Armour in the Wallace Collection*, London 2011

Castiglione 1966
Baldassare Castiglione, *The Book of the Courtier*, translated by Sir Thomas Hoby, introduction by W. H. D. Rouse, London – New York 1966

Chastel 1983
André Chastel, *The Sack of Rome 1527*, translated by Beth Archer (The A. W. Mellon Lectures in the Fine Arts, 1977. The National Gallery of Art, Washington D.C. / Bollingen Series XXXV, 26), Princeton N.J. 1983

Chaucer 1989
Geoffrey Chaucer, *Die Canterbury-Erzählungen*, Middle English and modern German prose, translated by Fritz Kemmler, with notes by Jörg O. Fichte (Goldmann-Klassiker mit Erläuterungen), 3 vols., Munich 1989

Conde de Valencia 1898
El Conde V.do de Valencia de Don Juan, *Catálogo histórico-descriptivo de la Real Armería de Madrid*, Madrid 1898 [reprinted Valladolid 2008]

Davey – Patterson 2012
Jemma Davey – Angus Patterson, *Fashionably dated: A 'Landsknecht' Candlestick at the Victoria and Albert Museum*, in: Journal of the Antique Metalware Society 20, June 2012, pp. 34–41

Dean 1926
Bashford Dean, *Puffed and Slashed Armor of 1525*, in: The Metropolitan Museum of Art Bulletin 21, no. 11, Nov. 1926, pp. 260–264

Denny-Brown 2004
Andrea Denny-Brown, *Rips and Slits: The Torn Garment and the Medieval Self*, in: Catherine Richardson (ed.), *Clothing Culture, 1350–1650*, Hampshire/England – Burlington/USA, pp. 223–237

Dihle – Closs 1929
Helene Dihle – Adolf Closs, *Das Kriegstagebuch eines deutschen Landsknechts um die Wende des 15. Jahrhunderts*, in: Zeitschrift für Historische Waffen- und Kostümkunde, Neue Folge 3, 1929, pp. 1–11

Dillon 1900
Harold Arthur Dillon, *On a MS. Collection of Ordinances of Chivalry of the fifteenth century, belonging to Lord Hastings*, in: Archaeologia: or Miscellaneous tracts relating to antiquity 57, 1900, pp. 29–70

Dobras 1990
Wolfgang Dobras, *Bürger als Krieger. Zur Reisläuferproblematik in der Reichsstadt Konstanz während der Reformationszeit 1519–1548*, in: Frank Göttmann (ed.), with Jörn Sieglerschmidt, *Vermischtes zur neueren Sozial-, Bevölkerungs- und Wirtschaftsgeschichte des Bodenseeraumes. Horst Rabe zum Sechzigsten* (Hegau-Bibliothek 72), Konstanz 1990, pp. 232–264

Egg 2000
Erich Egg, *Paul Dax*, in: *Allgemeines Künstlerlexikon. Die bildenden Künstler aller Zeiten und Völker*, vol. 24, Munich – Leipzig 2000, pp. 568–569

Erasmus 1997
Erasmus, *The Education of a Christian Prince*, translated by Neil M. Cheshire and Michael J. Heath, with the Panegyric for Archduke Philip of Austria, translated by Lisa Jardine, edited by Lisa Jardine, Cambridge 1997

Exh. cat. Barcelona – Madrid 1992
Exhibition catalogue *Tapices y Armaduras del Renacimiento. Joyas de las Colecciones Reales*, Barcelona (Las Reales Ataranzas) – Madrid (Museo Nacional Centro de Arte Reina Sofia) 1992

Exh. cat. Basel 2009
Exhibition catalogue *Rüstung & Robe*, Basel (Museum Tinguely) 2009

Exh. cat. Berlin – New York 2011
Exhibition catalogue Keith Christiansen – Stefan Weppelmann (eds.), *The Renaissance Portrait from Donatello to Bellini*, Berlin (Bode-Museum) – New York (The Metropolitan Museum of Art) 2011

Exh. cat. Bern – Bruges – Vienna 2008–2010
Exhibition catalogue Susan Marti – Till-Holger Borchert – Gabriele Keck (eds.), *Karl der Kühne (1433–1477). Glanz und Untergang des letzten Herzogs von Burgund*, Bern (Historisches Museum) – Bruges (Bruggemuseum and Groeningemuseum) – Vienna (Kunsthistorisches Museum) 2008–2010

Exh. cat. Innsbruck 2005
Exhibition catalogue Wilfried Seipel (ed.), *Wir sind Helden. Habsburgische Feste in der Renaissance*, Innsbruck (Ambras Castle) 2005

Exh. cat. London 2009
Exhibition catalogue Graeme Rimer – Thom Richardson – J. P. D. Cooper, *Henry VIII Arms and the Man 1509–2009*, London (Tower of London, The White Tower) 2009

Exh. cat. Munich 2009
Exhibition catalogue Christof Metzger, *Daniel Hopfer. Ein Augsburger Meister der Renaissance. Eisenradierungen. Holzschnitte. Zeichnungen. Waffenätzungen*, with contributions by Tobias Güthner, Achim Riether and Freyda Spira, Munich (Staatliche Graphische Sammlung) 2009

Exh. cat. New York 1998
Exhibition catalogue Stuart W. Pyhrr – José-A. Godoy, *Heroic Armor of the Renaissance. Filippo Negroli and his contemporaries*, with essays and a compilation of documents by Silvio Leydi, New York (The Metropolitan Museum of Art) 1998

Exh. cat. Nuremberg 2015–2016
Exhibition catalogue Jutta Zander-Seidel, *In Mode. Kleider und Bilder aus Renaissance und Frühbarock*, Nuremberg (Germanisches Nationalmuseum) 2015–2016

Exh. cat. Rome 1969
Exhibition catalogue Nolfo di Carpegna, *Antiche armi dal sec. IX al XVIII già Collezione Odescalchi*, Rome (Palazzo Venezia) 1969

Exh. cat. Vienna 1990
Exhibition catalogue *Roberto Capucci. Roben wie Rüstungen. Mode in Stahl und Seide einst und heute*, Vienna (Kunsthistorisches Museum) 1990

Exh. cat. Vienna 2000
Exhibition catalogue Wilfried Seipel (ed.), *Kaiser Karl V. (1500–1558). Macht und Ohnmacht Europas*, Vienna (Kunsthistorisches Museum) 2000

Exh. cat. Vienna 2013
Exhibition catalogue Sabine Haag – Katja Schmitz von Ledebur (eds.), *Kaiser Karl V. erobert Tunis. Dokumentation eines Kriegszuges in Kartons und Tapisserien*, Vienna (Kunsthistorisches Museum) 2013

Exh. cat. Washington 2010
Exhibition catalogue Álvaro Soler del Campo, *The Art of Power. Royal Armor and Portraits from Imperial Spain / El arte del poder. Armaduras y retratos de la España Imperial*, Washington D.C. (National Gallery of Art) 2010

Feest 2012
Christian Feest, *Der altmexikanische Federkopfschmuck in Europa*, in: Sabine Haag – Alfonso de Maria y Campos – Lilia Rivero Weber – Christian Feest (eds.), *Der altmexikanische Federkopfschmuck*, Altenstadt 2012, pp. 5–28

Ffoulkes 1912
Charles Ffoulkes, *The Armourer and his Craft from the XI^th to the XVI^th century*, London 1912

Fink 1963
August Fink, *Die Schwarzschen Trachtenbücher*, Berlin 1963

Foronda y Aguilera 1914
Manuel de Foronda y Aguilera, *Estancias y viajes del Emperador Carlos V desde el día de su nacimiento hasta el de su muerte [...]*, [Madrid] 1914

Frank 1967–1974
Karl Friedrich von Frank, *Standeserhebungen und Gnadenakte für das Deutsche Reich und die österreichischen Erblande bis 1806 sowie kaiserlich österreichische bis 1823, mit einigen Nachträgen zum "Alt-Österreichischen Adels-Lexikon" 1823–1918*, 5 vols., Schloss Senftenberg 1967–1974

Franz 1953
Günther Franz, *Von Ursprung und Brauchtum der Landsknechte*, in: Mitteilungen des Instituts für Österreichische Geschichtsforschung 61, 1953, pp. 79–98

Friedensburg 1892
Walter Friedensburg (ed.), *Nuntiaturberichte aus Deutschland nebst ergänzenden Actenstücken. Erste Abtheilung 1533–1559*, vol. 2: *Nuntiatur des Morone 1536–1538*, Gotha 1892

Friedensburg 1893
Walter Friedensburg (ed.), *Nuntiaturberichte aus Deutschland nebst ergänzenden Actenstücken. Erste Abtheilung 1533–1559*, vol. 4: *Legation Aleanders 1538–1539. Zweite Hälfte*, Gotha 1893

Frieder 2008
Braden Frieder, *Chivalry & the Perfect Prince. Tournaments, Art, and Armor at the Spanish Habsburg Court* (Sixteenth Century Essays & Studies, vol. 81), Kirksville, Missouri 2008

Fugger – Birken 1668
Johann Jakob Fugger – Sigmund von Birken, *Spiegel der Ehren des Hoechstloeblichsten Kayser- und Koeniglichen Erzhauses Oesterreich oder Ausführliche GeschichtSchrift von Desselben / und derer durch Erwählungs- Heurat- Erb- und Glücks-Fälle ihm zugewandter Käyserlichen HöchstWürde, Königreiche [...]*, Nuremberg 1668

Gamber – Beaufort 1990
Ortwin Gamber – Christian Beaufort, with Matthias Pfaffenbichler, *Kunsthistorisches Museum, Wien, Hofjagd- und Rüstkammer (ehem. Waffensammlung), Katalog der Leibrüstkammer, II. Teil. Der Zeitraum von 1530–1560* (Führer durch das Kunsthistorische Museum, no. 39), Busto Arsizio 1990

Grancsay 1950
Stephen V. Grancsay, *The Interrelationships of Costumes and Armor*, in: The Metropolitan Museum of Art Bulletin, New Series, vol. 8, no. 6, Feb. 1950, pp. 176–188

Groemer 2010
Karina Groemer, *Prähistorische Textilkunst in Mitteleuropa. Geschichte des Handwerkes und der Kleidung vor den Römern*, with contributions by Regina Hofmann-de Keijzer and Helga Rösel-Mautendorfer (Veröffentlichungen der Prähistorischen Abteilung des Naturhistorischen Museums, vol. 4), Vienna 2010

Habich 1929–1934
Georg Habich (ed.), *Die deutschen Schaumünzen des XVI. Jahrhunderts*, 2 parts in 5 vols., Munich 1929–1934

Hampe 1918
Theodor Hampe, *Allgäuer Studien zur Kunst und Kultur der Renaissance*, in: *Festschrift für Gustav von Bezold zu seinem 70. Geburtstag* (Mitteilungen aus dem Germanischen Nationalmuseum, 1918/19), Nuremberg 1918, pp. 3–105

Hampe 1927
Theodor Hampe (ed.), *Das Trachtenbuch des Christoph Weiditz von seinen Reisen nach Spanien (1529) und den Niederlanden (1531/32). Nach der in der Bibliothek des Germanischen Nationalmuseums zu Nuremberg aufbe-wahrten Handschrift* (Historische Waffen und Kostüme, vol. II), Berlin – Leipzig 1927

Hampel-Kallbrunner 1962
Gertraud Hampel-Kallbrunner, *Beiträge zur Geschichte der Kleiderordnungen mit besonderer Berücksichtigung Österreichs* (Wiener Dissertationen aus dem Gebiete der Geschichte, vol. 1), Vienna 1962

Haupt 1991
Herbert Haupt, *Das Kunsthistorische Museum. Die Geschichte des Hauses am Ring. Hundert Jahre im Spiegel historischer Ereignisse*, with an essay by Wilfried Seipel, Vienna 1991

Heinz 1975
Günther Heinz, *Das Porträtbuch des Hieronymus Beck von Leopoldsdorf*, in: Jahrbuch der kunsthistorischen Sammlungen in Wien 71, 1975, pp. 165–310

Hlobil – Petrů 1999
Ivo Hlobil – Eduard Petrů, *Humanism and the Early Renaissance in Moravia*, Prague 1999

Hochstetter 1885
Ferdinand von Hochstetter, *Ueber mexikanische Reliquien aus der Zeit Montezumas in der k.k. Ambraser Sammlung*, in: Denkschriften der kaiserlichen Akademie der Wissenschaften, phil.-hist. Classe 35, 1885, pp. 83–104

Hormayr 1815
Joseph Freiherr von Hormayr (ed.), *Archiv für Geographie, Historie, Staats- und Kriegskunst* 6, 1815

Izquierdo 1992
Francisco Fernández Izquierdo, *La Orden militar de Calatrava en el siglo XVI. Infraestructura institucional. Sociología y prosopografía de sus caballeros* (Biblioteca de historia, vol. 15, edited by Manuel Espadas Burgos et al.), Madrid 1992

Kästner 2004
Sabrina Kästner, *Entstehungsgeschichte der Jeans* bzw. *Verbreitungsgeschichte der Jeans ab 1902*, in: Doris Schmidt (ed.), *Jeans. Karriere eines Kleidungsstückes* (Studienreihe Mode- und Textilwissenschaften, vol. 2), Hohengehren 2004, pp. 1–16 and 17–38

Keegan 2004
John Keegan, *A History of Warfare*, 2nd edition, London 2004

Keller 1859
Adelbert von Keller (ed.), *Die Geschichten und Taten Wilwolts von Schaumburg* (Bibliothek des Litterarischen Vereins in Stuttgart, vol. L), Stuttgart 1859

Krause 2011/2012
Stefan Krause, *Der Augsburger Druckgraphiker Daniel Hopfer (1471–1536) als Waffendekorateur*, in: Jahrbuch des Kunsthistorischen Museums Wien 13/14, 2011–2012, pp. 52–75

Krünitz 1773–1858
Johann Georg Krünitz, *Oeconomische Encyclopädie oder allgemeines System der Land-, Haus- und Staats-Wirthschaft: in alphabetischer Ordnung*, 242 vols., Berlin 1773–1858

Lanz 1844–1846
Karl Lanz, *Correspondenz des Kaisers Karl V. Aus dem königlichen Archiv und der Bibliothèque de Bourgogne zu Brüssel*, 3 vols., Leipzig 1844–1846

LaRocca 2004
Donald J. LaRocca, *Monsters, Heroes, and Fools. A Survey of Embossed Armor in Germany and Austria, ca. 1475 – ca. 1575*, in: *A farewell to arms, studies on the history of arms and armour. Liber Amicorum in honour of Jan Piet Puype, former senior curator of the Army Museum Delft*, Delft 2004, pp. 35–55

Leidinger 1912
Georg Leidinger (ed.), *Miniaturen aus Handschriften der Kgl. Hof- und Staatsbibliothek in München*, vol. 3: *Turnierbuch Herzog Wilhelms IV. von Bayern*, Munich 1912

Leitner 1880–1882
Quirin von Leitner, *Freydal. Des Kaisers Maximilian I. Turniere und Mummereien. Herausgegeben mit Allerhöchster Genehmigung seiner Majestät des Kaisers Franz Joseph I. unter der Leitung des K.K. Oberstkämmerers, Feldzeugmeisters Franz Grafen Folliot de Crenneville von Quirin von Leitner. Mit einer geschichtlichen Einleitung, einem facsimilirten Namensverzeichnis und 255 Heliogravuren*, Vienna 1880–1882

Lhotsky 1941–1945
Alphons Lhotsky, *Festschrift des Kunsthistorischen Museums zur Feier des fünfzigjährigen Bestandes. Zweiter Teil: Die Geschichte der Sammlungen*, Vienna 1941–1945

Liebmann 1965
Michael Liebmann, *Ein Bildnis des Pfalzgrafen Ottheinrich von Georg Pencz in der Ermitage*, in: Pantheon 23, 1965, pp. 156–162

Loschek 2005
Ingrid Loschek, *Reclams Mode- und Kostümlexikon*, 5th updated and enlarged edition, Ditzingen 2005

Lübbeke 1991
Isolde Lübbeke, *The Thyssen-Bornemisza Collection. Early German Paintings. 1350–1550*, translated by Margaret Thomas Will, London 1991

Luchner 1958
Laurin Luchner, *Denkmal eines Renaissancefürsten. Versuch einer Rekonstruktion des Ambraser Museums von 1583*, Vienna 1958

Mailles [1527]
Jacques de Mailles, *La Très joyeuse, plaisante et récréative hystoire composée par le loyal serviteur [...]*, Paris [1527]

Mann 1962
James Mann, *Wallace Collection Catalogues. European Arms and Armour*, London 1962

Mazal 1993
Otto Mazal, *Kodikologische und paläographische Beschreibung des Croy-Gebetbuches*, in: *Das Croy-Gebetbuch. Codex 1858 der Österreichischen Nationalbibliothek in Vienna*, annotated by Otto Mazal and Dagmar Thoss, Lucerne 1993, pp. 125–142

Meinhardt – Kröher 1976
Der Schwartenhals. Lieder der Landsknechte, collected from primary and secondary sources, edited, selected, written and illustrated by Albert Meinhardt, introduction and edited by Heinrich Kröher, Witzenhausen 1976

Merkel 2012
Kerstin Merkel, *Neue Beobachtungen zur Kleidung der Naumburger Stifterfiguren*, in: Hartmut Krohm (ed.), *Der Naumburger Meister. Forschungen und Beiträge zum internationalen wissenschaftlichen Kolloquium in Naumburg vom 05. bis 08. Oktober 2011*, Petersberg 2012, pp. 188–203

Messling 2008
Guido Messling, *Jörg Breu the Elder and the Younger* (The New Hollstein German engravings, etchings and woodcuts 1400–1700), 2 vols, edited by Hans-Martin Kaulbach, Ouderkerk aan den Ijssel 2008

Müller 2002
Christian Müller (ed.), *Urs Graf. Die Zeichnungen des Kupferstichkabinetts Basel* (Öffentliche Kunstsammlung Basel. Kupferstichkabinett. Beschreibender Katalog der Zeichnungen, vol. III: Die Zeichnungen des 15. und 16. Jahrhunderts, Teil 2B), with essays by Ulrich Barth and Anita Haldemann, Basel 2002

Mur i Raurell 1998
Anna Mur i Raurell, *Rocandolfo al Servicio de Carlos V: Wilhelm von Rogendorf, comendador de Otos (1481–1541)*, in: Anuario de estudios medievales 28, 1998, pp. 363–387

Neidhart 1993
Herbert Neidhart, *Aus der Geschichte Pöggstalls: Die Herren von Roggendorf*, in: Das Waldviertel. Zeitschrift für Heimat- und Regionalkunde des Waldviertels und der Wachau 42 (53), 1993, pp. 47–55, 126–141, 235–245

Nell 1914
Martin Nell, *Die Landsknechte. Entstehung der ersten deutschen Infanterie* (Historische Studien, no. 123), Berlin 1914

Patterson 2009
Angus Patterson, *Fashion and Armour in Renaissance Europe. Proud Lookes and Brave Attire*, London 2009

Pfaffenbichler 2014
Matthias Pfaffenbichler, *Die Harnischgarnitur im 16. Jahrhundert*, in: exhibition catalogue Peter Jezler – Peter Niederhäuser – Elke Jezler, *Ritterturnier. Geschichte einer Festkultur*, Schaffhausen (Museum zu Allerheiligen Schaffhausen) 2014, pp. 103–113

Philadelphia 1951
The Vienna Art Treasures February 9 – March 30, 1952, in: The Philadelphia Museum Bulletin 47, no. 232, Winter 1951, pp. 19–31

Philipp 2011
Marion Philipp, *Ehrenpforten für Kaiser Karl V. Festdekorationen als Medien politischer Kommunikation* (Kunstgeschichte, vol. 90), Berlin 2011 [= PhD thesis University of Heidelberg 2010]

Pirckheimer 1998
Willibald Pirckheimer, *Der Schweizerkrieg. De bello Suitense sive Eluetico*, in lateinischer und deutscher Sprache, newly translated and annotated by Fritz Wille, Baden 1998

Portisch – Riff 1986
Hugo Portisch, *Österreich II*, vol. 2: *Der lange Weg zur Freiheit*, introduction by Gerd Bacher, photo documentation by Sepp Riff, Vienna 1986

Portisch – Riff 1989
Hugo Portisch – Sepp Riff, *Österreich I. Die unterschätzte Republik. Ein Buch zur gleichnamigen Fernsehdokumentation*, 2nd edition Vienna 1989

Post 1928
Paul Post, Ein *Frührenaissanceharnisch von Konrad Seusenhofer mit Ätzungen von Daniel Hopfer im Berliner Zeughaus*, in: Jahrbuch der Preußischen Kunstsammlungen 49, 1928, pp. 167–186

Procházka 1902
Alois Procházka, *Starobylé náhrobní kameny, pamětní desky a erby na Vyškovsku*, Blažovice 1902

Rapp Buri – Stucky-Schürer 2011
Anna Rapp Buri – Monica Stucky-Schürer, *Burgundische Tapisserien*, Munich 2001

Reichs-Abschiede 1747
Neue und vollstaendigere Sammlung der Reichs-Abschiede, welche von den Zeiten Kayser Conrads des II. bis jetzo, auf den Teutschen Reichs-Taegen abgefasset worden, sammt den wichtigsten Reichs-Schluessen, so auf dem noch fuerwaehrenden Reichs-Tage zur Richtigkeit gekommen sind, 4 parts [edited by Heinrich Christian von Senckenberg and Johann Jacob Schmauß], Frankfurt/Main 1747

Reichstagsakten 1896
Deutsche Reichstagsakten unter Kaiser Karl V. (Deutsche Reichstagsakten. Jüngere Reihe), vol. 2, edited by Adolf Wrede, Gotha 1896

Reilly 1813
Franz Joh[hann] Jos[eph] v. Reilly, *Skizzirte Biographien der berühmtesten Feldherren Oesterreichs von Maximilian dem I. bis auf Franz den II. In Verbindung mit der Geschichte ihrer Zeit und mit ihren echten Abbildungen auf sechzig Kupfertafeln*, Vienna 1813

Reitzenstein 1951
Alexander Freiherr von Reitzenstein, *Die Augsburger Plattnersippe der Helmschmid*, in: Münchner Jahrbuch der bildenden Kunst 2, 1951, pp. 179–194

Reverseau 1982
Jean-Pierre Reverseau, *Musee de l'Armee Paris. Les armes et la vie*, Paris [et al.] 1982

Rogg 2002
Matthias Rogg, *Landsknechte und Reisläufer: Bilder vom Soldaten. Ein Stand in der Kunst des 16. Jahrhunderts* (Krieg in der Geschichte [KriG], edited by Stig Förster, Bernhard R. Kroener, Bernd Wegner, vol. 5), Paderborn et al. 2002

Romean 1878
M. J. Romean, *La très joyeuse, plaisante et récréative histoire du gentil seigneur de Bayart composée par le loyal serviteur*, Paris 1878

Roo 1621
Gerardus de Roo, *Annales, Oder Historische Chronick Der Durchleuchtigisten* Fürsten *vnd Herren Ertzhertzogen zu Oesterreich Habspurgischen Stammens [...]*, Augsburg 1621

Rosenauer 2003
Artur Rosenauer (ed.), *Spätmittelalter und Renaissance* (Geschichte der bildenden Kunst in Österreich, vol. 3), Munich et al. 2003

Rothe 2009
Johannes Rothe, *Der Ritterspiegel*, edited, translated and annotated by Christoph Huber and Pamela Kalning, Berlin – New York 2009

Rublack – Hayward 2015
Ulinka Rublack – Maria Hayward, *The first Book of Fashion. The Book of Clothes of Matthäus & Veit Konrad Schwarz of Augsburg*, London et al. 2015

Runciman 1951
Steven Runciman, *A History of the Crusades*, vol. 1: *The First Crusade and the Foundation of the Kingdom of Jerusalem*, Cambridge 1951

Rupprich 1956
Hans Rupprich (ed.), *Dürer. Der schriftliche Nachlass*, vol. 1, Berlin 1956

Sabean 1972
David Warren Sabean, *Landbesitz und Gesellschaft am Vorabend des Bauernkrieges. Eine Studie der sozialen Verhältnisse im südlichen Oberschwaben in den Jahren vor 1525* (Quellen und Forschungen zur Agrargeschichte, founded by Günther Franz and Friedrich Lütge, edited by Wilhelm Abel and Günther Franz, vol. XXVI), Stuttgart 1972

Sacken – Groll 1859–1862
Eduard von Sacken – Andreas Groll, *Die vorzüglichsten Rüstungen und Waffen der k.k. Ambraser Sammlung. In Original-Photographien von And[reas] Groll. Mit historischem und beschreibendem Text von Dr. Ed[uard] Freih[err] v. Sacken*, 2 vols., Vienna 1859–1862

Schnitzer 1999
Claudia Schnitzer, *Höfische Maskerade. Funktion und Ausstattung von Verkleidungsdivertissements an deutschen Höfen der Frühen Neuzeit* (= Frühe Neuzeit, vol. 53, Studien und Dokumente zur deutschen Literatur und Kultur im europäischen Kontext), Tübingen 1999

Schoch – Mende – Scherbaum 2002
Rainer Schoch – Matthias Mende – Anna Scherbaum (ed.), *Albrecht Dürer. Das druckgraphische Werk*, vol. II.: *Holzschnitte und Holzschnittfolgen*, Munich et al. 2002

Schönherr 1884
David Schönherr (ed.), *Urkunden und Regesten aus dem K.K. Statthalterei-Archiv in Innsbruck*, in: Jahrbuch der kunsthistorischen Sammlungen des Allerhöchsten Kaiserhauses 2, 1884, pp. I–CLXXII

Schrenck von Notzing 1603
Jakob Schrenck von Notzing, *Der Aller Durchleuchtigsten vnd Großmächtigten Kayser, [...] Königen vnd Ertzhertzogen, [...] Fürsten [...] warhafftige Bildtnussen, vnd kurze Beschreibungen jhrer [...] fürnembsten thaten vnd handlungen [...] Deren Waffen vnd Rüstungen [...] von weilandt dem Durchleuchtigsten Fürsten vnnd Herrn [...] Ferdinanden Ertzhertzogen zu Osterreich [...] in dem Fürstlichen Schloß Ombraß [...] auffbehalten werden [...]*, Innsbruck 1603 [German translation of the 1st edition published in Latin in 1601]

Schrenck von Notzing 1981
Jakob Schrenck von Notzing, *Die Heldenrüstkammer (Armamentarium Heroicum) Erzherzog Ferdinands II. auf Schloß Ambras bei Innsbruck. Faksimiledruck der lateinischen und der deutschen Ausgabe des Kupferstich-Bildinventars von 1601 bzw. 1603*, introduction, edited and annotated by Bruno Thomas, Osnabrück 1981

Schultz 1888
Alwin Schultz, *Der Weisskunig nach den Dictaten und eigenhändigen Aufzeichnungen Kaiser Maximilians I. zusammengestellt von Marx Treitzsauerwein von Ehrentreitz* (= Jahrbuch der kunsthistorischen Sammlungen des Allerhöchsten Kaiserhauses 6), Vienna 1888

Schwennicke 1992
Detlev Schwennicke (ed.), *Europäische Stammtafeln. Stammtafeln zur Geschichte der europäischen Staaten*, founded by Wilhelm Karl Prinz zu Isenburg, continued by Franz Baron Freytag von Loringhoven, Neue Folge vol. XII, Marburg 1992

Schwennicke 1995
Detlev Schwennicke (ed.), *Europäische Stammtafeln. Stammtafeln zur Geschichte der europäischen Staaten*, founded by Wilhelm Karl Prinz zu Isenburg, continued by Franz Baron Freytag von Loringhoven, Neue Folge vol. XVI, Berlin 1995

Simmel 1895
Georg Simmel, *Zur Psychologie der Mode. Sociologische Studie*, in: Die Zeit. Wiener Wochenschrift für Politik, Volkswirtschaft, Wissenschaft und Kunst 5, 1895, no. 54 (October 12, 1895), pp. 22–24. See also idem, *Soziologische Ästhetik* (Klassiker der Sozialwissenschaften, edited by Klaus Lichtblau), Wiesbaden 2009, pp. 49–55

Skjelver 2010
Danielle Mead Skjelver, *"There I, Paul Dolnstein, saw action." The sketchbook of a warrior artisan in the German Renaissance*, PhD thesis University of North Dakota, Grand Forks 2010

Spallanzani – Bertelà 1992
Marco Spallanzani – Giovanna Gaeta Bertelà, *Libro d'Inventario dei beni di Lorenzo il Magnifico*, Florence 1992

Stapleford 2013
Richard Stapleford, *Lorenzo de' Medici at home. The Inventory of the Palazzo Medici in 1492*, edited and translated by Richard Stapleford, University Park, Pennsylvania 2013

Staudinger 1984
Anton Staudinger, *Austrofaschistische "Österreich"-Ideologie*, in: Emmerich Tálos – Wolfgang Neugebauer (eds.), *"Austrofaschismus". Beiträge über Politik, Ökonomie und Kultur 1934–1938*, 4th expanded edition Vienna 1984, pp. 287–316

Strobl 1961
Alice Strobl, *Das K.K. Waffenmuseum im Arsenal* (Schriften des Heeresgeschichtlichen Museums in Vienna, vol. 1), Graz – Köln 1961

Terjanian 2012
Pierre Terjanian, *The art of the armorer in late medieval and Renaissance Augsburg: The rediscovery of the Thun sketchbooks*, in: Jahrbuch des Kunsthistorischen Museums Wien 13/14, 2011/2012, pp. 298–395

Terlinden 1960
Vicomte Terlinden, *La Politique Italienne de Charles Quint et le "Triomphe" de Bologne*, in: Jean Jacquot (ed.), *Fêtes et cérémonies au temps de Charles Quint. IIe Congrès de l'Association Internationale des Historiens de la Renaissance (2e Section), Bruxelles, Anvers, Gand, Liège, 2–7 septembre 1957*, Paris 1960, pp. 29–43

Thomas 1938
Bruno Thomas, *Harnischstudien III: Stilgeschichte des deutschen Harnisches von 1530–1560*, in: Jahrbuch der kunsthistorischen Sammlungen in Vienna, Neue Folge vol. 12, 1938, pp. 175–202

Thomas 1977
Bruno Thomas, *Der Turiner Prunkharnisch für Feld und Turnier B2 des Nuremberger Patriziers Wilhelm Rieter von Boxberg – Ein Meisterwerk von Kolman Helmschmid zu Augsburg um 1525*, in: Jahrbuch der kunsthistorischen Sammlungen in Wien 73, 1977, pp. 137–154

Thomas – Gamber 1976
Bruno Thomas – Ortwin Gamber, *Kunsthistorisches Museum, Wien, Waffensammlung. Katalog der Leibrüstkammer, I. Teil: Der Zeitraum von 500–1530* (Führer durch das Kunsthistorische Museum, no. 13), Vienna 1976

Veblen 1899
Thorstein Veblen, *The Theory of the Leisure Class*, New York et al. 1899. See also idem, *The Theory of the Leisure Class*, introduction, edited and annotated by Martha Banta, Oxford – New York 2007

Waldis 2011
Burkard Waldis, *Esopus, 400 Fabeln und Erzählungen nach der Erstausgabe von 1548*, edited by Ludger Lieb, Jan Mohr and Herfried Vögel, 2 vols., Berlin 2011

Warhafftige berichtung 1527
Warhafftige vnd kurtze berichtung Jnn der Summa: wie es yetzo im Tausent fünffhundert siben vnd zwentzigsten iar / den vi tag May / durch Römischer Keyserlicher / vnd Hispanischer Königlicher Maiestet kriegßuolck / Jnn eroberung der Stat Rome ergangen ist biß auff den. xxi. tag Junij, Zwickau 1527

Weber 2002
Matthias Weber, *Die Reichspolizeiordnungen von 1530, 1548 und 1577. Historische Einführung und Edition* (Ius Commune. Veröffentlichungen des Max-Planck-Instituts für Europäische Rechtsgeschichte Frankfurt a. M. Sonderhefte. Studien zur Europäischen Rechtsgeschichte, vol. 146), Frankfurt/Main 2002

Weber-Unger 2011
Simon Weber-Unger (ed.), *Gipsmodell und Fotografie im Dienste der Kunstgeschichte 1850–1900*, Vienna 2011

Wiesflecker 1971
Hermann Wiesflecker, *Kaiser Maximilian I. Das Reich, Österreich und Europa an der Wende zur Neuzeit*, vol. 1: *Jugend, burgundisches Erbe und Römisches Königtum bis zur Alleinherrschaft 1459–1493*, Vienna 1971

Williams 1974
Alan R. Williams, *The metallographic examination of a Burgkmair etching plate in the British Museum*, in: Journal of the Historical Metallurgy Society 8, 1974, pp. 92–94

Williams 2003
Alan R. Williams, *The Knight and the Blast Furnace. A History of the Metallurgy of Armour in the Middle Ages & the Early Modern Period* (History of Warfare, vol. 12), Leiden – Boston 2003

Wilson 2003
Elizabeth Wilson, *Adorned in Dreams: Fashion and Modernity*, New Brunswick – New Jersey 2003

Zajic 2012
Andreas Zajic, *Rog(g)endorf*, in: Werner Paravicini (ed.), *Höfe und Residenzen im spätmittelalterlichen Reich. Ein dynastisch-topographisches Handbuch*, vol. 4: *Grafen und Herren*, 2nd part, edited by Jan Hirschbiegel, Anna Paulina Orlowska and Jörg Wettlaufer (Residenzenforschung, vol. 15.IV/2), Ostfildern 2012, pp. 1207–1226

Zander-Seidel 1990
Jutta Zander-Seidel, *Textiler Hausrat. Kleidung und Haustextilien in Nuremberg von 1500–1650* (Kunstwissenschaftliche Studien, vol. 59). Munich 1990

Zijlma 1996
Robert Zijlma, *Gordian Sanz to Hans Schäufelein* (The New Hollstein German engravings, etchings and woodcuts 1400–1700, vol. 42), edited by Tilman Falk, Roosendaal 1996

Zincgref 1626
Julius Wilhelm Zincgref, *Der Teutschen Scharpfsinnige Kluge Sprüch Apophthegmata genannt*, Strassbourg 1626

Zincgref 2011
Julius Wilhelm Zincgref, *Gesammelte Schriften*, vol. IV: *Apophthegmata teutsch*, 2 vols., edited by Theodor Verweyen, Dieter Mertens and Werner Wilhelm Schnabel (Neudrucke deutscher Literaturwerke, Neue Folge edited by Hans-Henrik Krummacher, vol. 57), Berlin – Boston 2011

Zúñiga 1989
Don Francés de Zúñiga, *Crónica burlesca del Emperador Carlos V.*, introduction, edited and annotated by José Antonio Sánchez Paso, Salamanca 1989

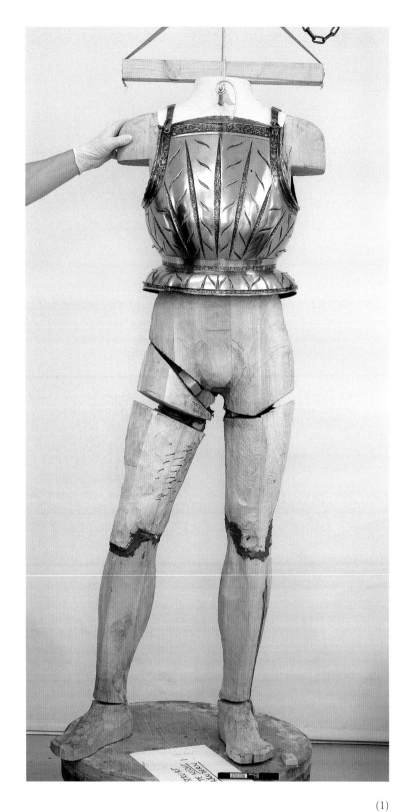

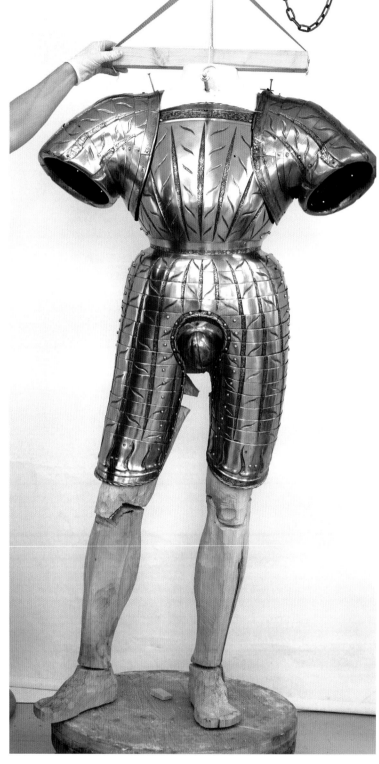

(1)

(2)

Photo documentation: assembling the new display
figure for the Rogendorf armour, Conservation
Studio of the Collection of Arms and Armour,
Kunsthistorisches Museum Vienna, 2015
(© KHM-Museumsverband)

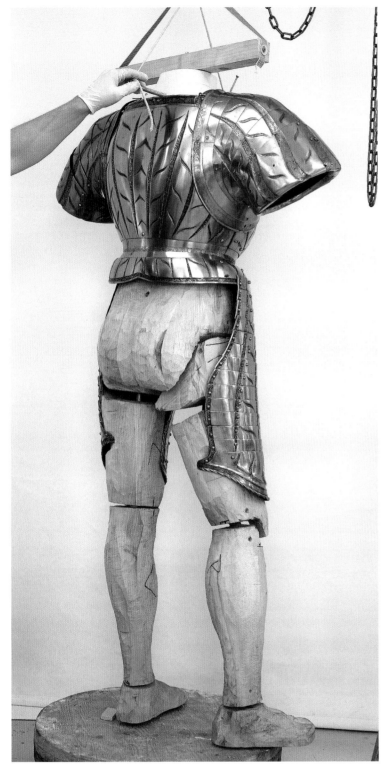

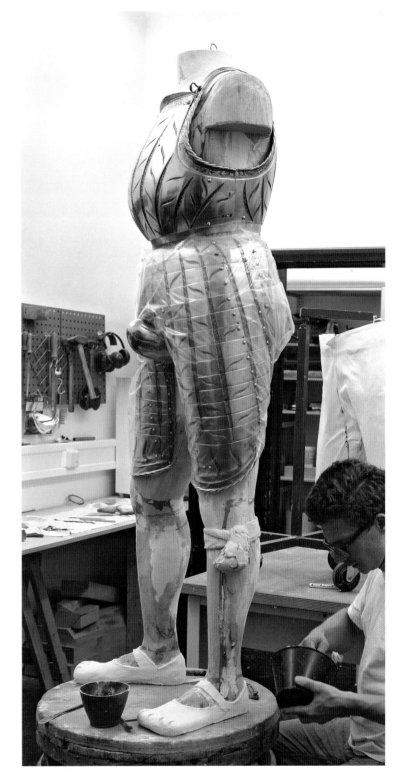

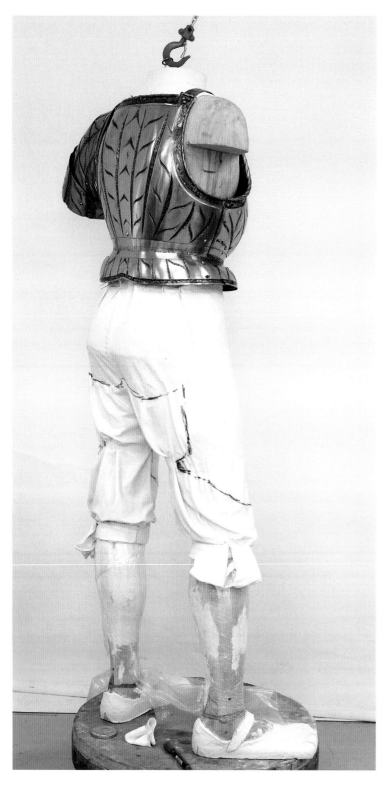

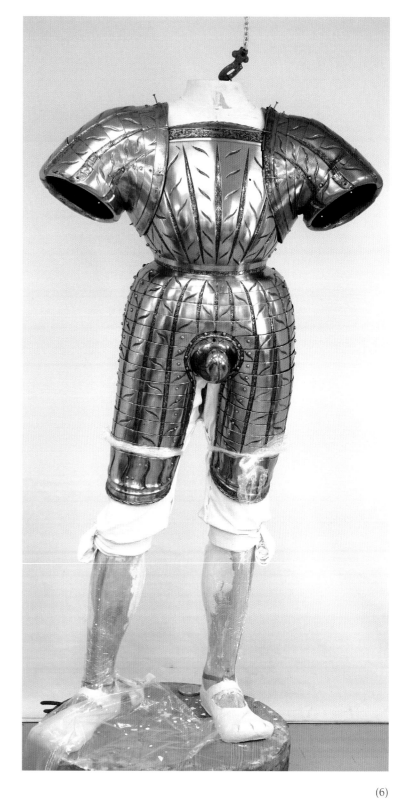

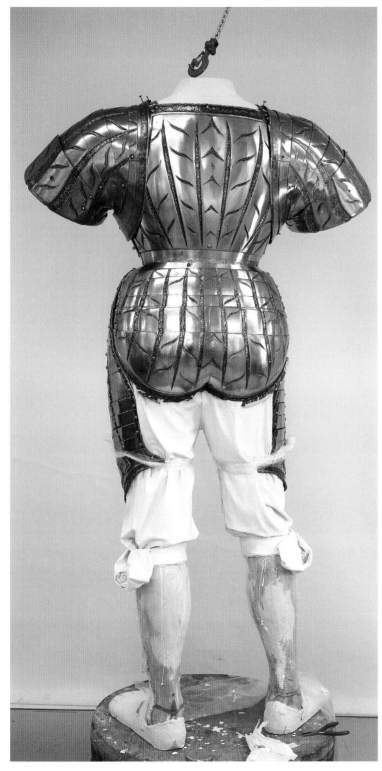

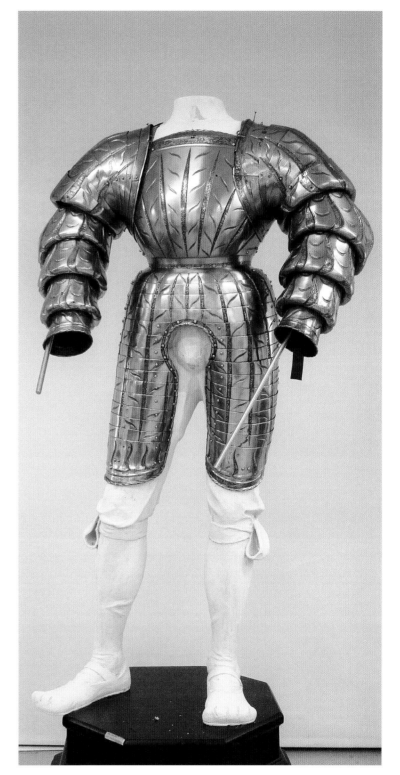

(7)

(8)

Acknowledgements

Christa Angermann, Christian Beaufort-Spontin, Annemarie Bönsch, Dirk Breiding, Tobias Capwell, Petra Fuchs, Michaela Gregor, Gabriele Helke, Manfred Hollegger, Johanna Kopp, Johann Kräftner, Otto Krause, Thomas Kuster, Donald LaRocca, Kerstin Merkel, Guido Messling, Christof Metzger, Eva Michel, Anna Mur i Raurell, Caridad Nieto-Diaz, Bernhard Ortner, Angus Patterson, Matthias Pfaffenbichler, Franz Pichorner, Stuart W. Pyhrr, Annette Schäfer, Katja Schmitz-von Ledebur, Thomas Schnaitt, Susan Sigfried, Danielle Mead Skjelver, Jonathan Tavares, Pierre Terjanian, Alan Williams, Heinz Winter, Andreas Zajic, Stefan Zeisler.

We also want to thank Alexander Rosoli for the excellent photographs of the restored armour.

And, last but not least, we are deeply grateful to Tobias Capwell for his constructive criticism, and to Agnes Stillfried for translating the text into English.

Imprint

Media-owner and publisher:
Sabine Haag
Director-general of the Kunsthistorisches Museum
Burgring 5, 1010 Vienna

Concept, author and editing:
Stefan Krause

Head of Publications:
Franz Pichorner

Translations:
Agnes Stillfried

Copyediting and proofreading:
Annette Van der Vyver

Creative Director:
Stefan Zeisler

Graphics:
Johanna Kopp

Illustrations:
Photographic Direction:
Stefan Zeisler
Photographs:
Alexander Rosoli
Andreas Uldrich
Photo Processing:
Sanela Antic

Image rights:
The image rights belong to the institutions listed
in the captions.
Photographs of the Landsknecht armour of Wilhelm
von Rogendorf: © KHM-Museumsverband

Cover illustration:
Landsknecht armour of Wilhelm von Rogendorf,
detail. Kolman Helmschmid, etched by Daniel
Hopfer. Augsburg, dated 1523. Vienna, Kunst-
historisches Museum, Collection of Arms and
Armour, inv. no. A 374 (© KHM-Museumsverband)

Printing:
Druckerei Walla, Vienna

Short Title:
Stefan Krause, Fashion in Steel. The Landsknecht
Armour of Wilhelm von Rogendorf, Vienna 2017

ISBN 978-0-300-23086-4
Library of Congress Control Number: 2017940504

1st edition 2017
Printed in Austria

© KHM-Museumsverband, 2017
All rights reserved.

Yale

Distributed by Yale University Press
302 Temple Street
P.O. Box 209040
New Haven, CT 06520-9040
yalebooks.com/art

GERDA HENKEL STIFTUNG

Printed with the support of the
Gerda Henkel Stiftung, Düsseldorf

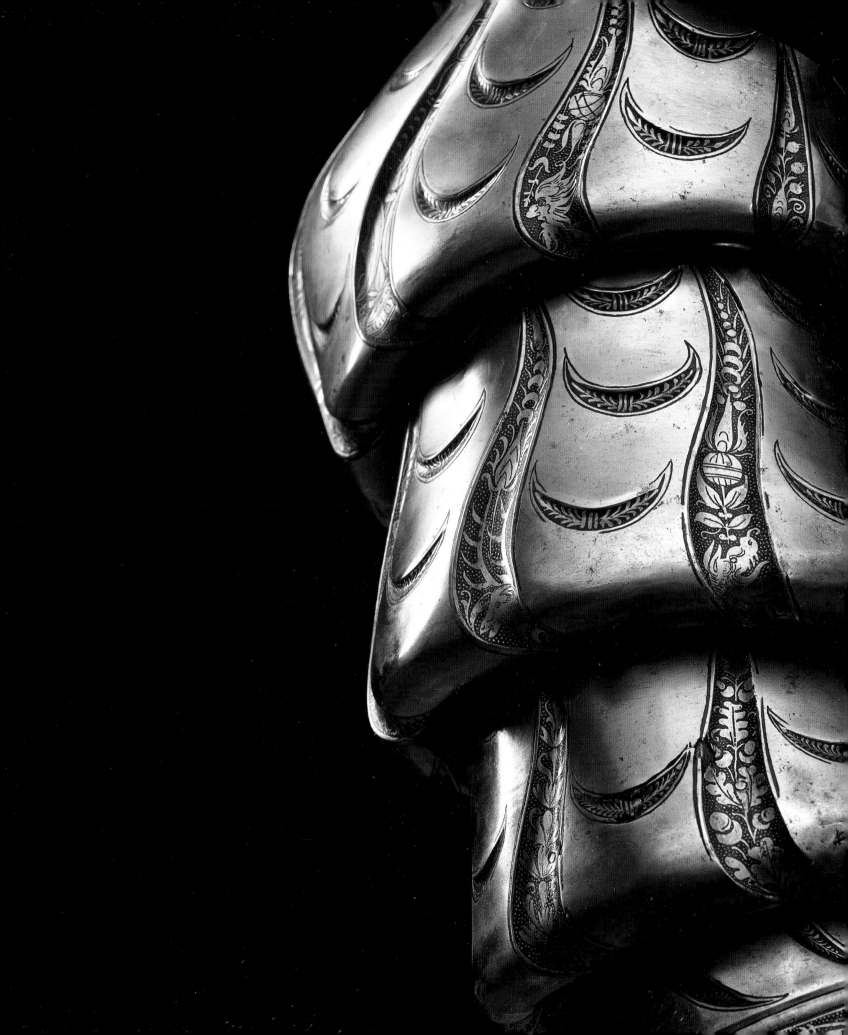